SOTHEBY'S
GREAT
SALES

Edited by Catherine Chester

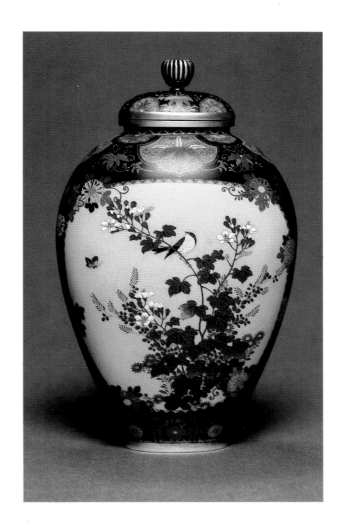

BARRIE & JENKINS
LONDON

First published in Great Britain in 1989 by
Barrie & Jenkins Ltd
289 Westbourne Grove, London W11 2QA
in association with Sotheby's

Designed by Clare Clements

Typeset by DP Photosetting, Aylesbury, Bucks
Printed and bound in Italy by ArtiGrafiche Motta

British Library Cataloguing in Publication Data

Sotheby's great sales.
 1. Art objects. Auctions
 1. Sotheby Parke Bernet Group
 380.1'457

ISBN 0 7126 2137 7

SOTHEBY'S
GREAT
SALES

CONTENTS

During the past year many astounding works of art passed through Sotheby's auction rooms. As well as individual works of art, Sotheby's attracted many superb collections: the Bernat Collection of Qing Imperial porcelain and pieces realised $8.1 million in Hong Kong while world records for Impressionist and contemporary paintings were established at the sales of the Ganz collection in New York ($48.5 million) and the British Rail Pension Fund in London (£35.2 million). Equally memorable were the sales in New York of the Jaime Ortiz-Patino Collection ($67.8 million) and the first part of the Bradley Martin Library ($11.6 million).

The London sale of the William Waldorf Astor Collection of Manuscripts, set new auction price records for English, Flemish and Italian illuminated manuscripts (£6.3 million) while in Monaco we sold the second part of the Jeanson Library – a remarkable collection of books on ornithology and many fine Old Master and 19th century drawings of birds (£2.6 million).

A vast range of fascinating objects has been seen at Sotheby's salerooms, including the original manuscript of *The Trial* by Franz Kafka which was sold for £1.1 million – over four times the previous record for any modern writer; a royal console table made for Marie-Antoinette's private apartment in Versailles which achieved a world record price of £1.6 million; a Cycladic marble head of a goddess from the Early Bronze Age; a previously lost Canaletto, and the most complex of the Cartier Portico Mystery Clocks.

Our sale in Moscow of Russian Avant-Garde and Soviet Contemporary artists, the first international art auction ever to take place in the USSR, was certainly one of the high points of the season. The Elton John Collection attracted worldwide publicity for what was a most colourful and spectacular production.

Sotheby's Great Sales is a celebration of the most valuable, spectacular and unusual objects to have passed through the salerooms in the past year. It conveys the excitement of the saleroom and presents an informative and lively review of the 1988–1989 season at Sotheby's.

Michael Ainslie

Some fifteen years ago I was part of a team of Sotheby's experts running one of our 'Discovery Days' in a hotel in Exeter. In response to advertisements and publicity, owners of works of art brought in their possessions for free advice and valuation. Over a thousand people appeared and BBC Bristol came down and filmed the event for a news item. Four years later the formula was used by the same producer for the pilot of a series that was expected to run, at best, for six programmes. We are now in the twelfth series.

TREASURE TROVE

David Battie

While the series is running, our counters in London and in the regions, which are open every weekday for free evaluation, see a boost in the number of clients. Their opening words are often: 'I saw one of these on the *Antiques Roadshow* on Sunday.'

The programme draws heavily on Sotheby's expertise and among those who regularly appear are Christopher Payne (furniture); Hilary Kay and Bunny Campione (toys); Lars Tharp, Gordon Lang and myself (ceramics and oriental works of art); Peter Waldron (silver); Lady Victoria Leatham and George Archdale (miscellaneous). The whole 'roadshow' team meets up for dinner the evening before the recording and a popular pastime is guessing whether the day is going to be heavy or light and what the standard is going to be. There is little consistency, but certain patterns do appear. The old county towns such as Bath or Bristol which one might expect to produce numbers of high quality and high value objects often do not. The probable explanation for this is that they have been 'raped and pillaged' for their antiques for a century or more and there is either little left or the owners know what they have and do not need the *Antiques Roadshow* to tell them. On the other hand, the Liverpools and Birminghams produce crowds 5,000 strong and inevitably amongst those 15,000–20,000 objects there must be twenty-five worth recording. There is some conformity to expected regional variations. For example, port cities such as Liverpool and Bristol have an above average number of oriental objects brought home in the eighteenth and nineteenth centuries by sailors. Scotland, from whence came many of the explorers, administrators and ships' captains during the last century, also boasts a strong oriental flavour. Sotheby's has numerous offices round the country and the experts are all familiar with the strength of their own region. No matter where they are, there is a wealth of material, for Britain is very lucky – our domination of the world stage over much of the last four hundred years has ensured an unrivalled accumulation of works of art. We have been a nation of explorers, traders, administrators and warriors. Wherever we went, we brought back treasures, some paid for but much returning as victor's booty. Few other countries in the world have been without a foreign invasion for the best part of a thousand years. William the Norman was the last to conquer the English. Much of the fighting over continental Europe was conducted with Britain heavily involved, consequently, after the defeat

David Battie giving valuations at Sotheby's front counter.

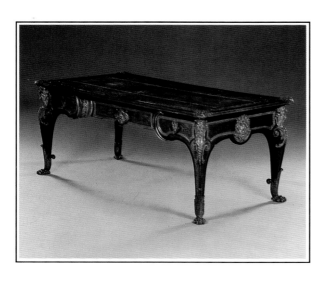

A late Louis XIV Boulle Bureau Plat attributed to André Charles Boulle, circa 1710. Sold in London in June 1988 for £638,000 ($1,205,820). It came from a country house in Hampshire.

of Napoleon, quantities of Napoleonic and pre-Revolution works made their way across the Channel.

The Industrial Revolution also played a large part in our artistic inheritance by making Britain the wealthiest nation on earth. When the vast collections of the French aristocracy were broken up after the Revolution, British collectors and agents immediately absorbed the best of what was available. The result is that a visit to a French château can be an empty experience; its paintings, furniture and works of art are more likely to be found distributed round British museums, private collections or The National Trust.

Very little war booty was collected and retained by the humble foot soldier. Little was bought by the able-bodied seaman, the clerk in India or the ordinary working man at home. The dissemination of works of art down through the social strata has largely been brought about by the changes in fashion. When a new style such as the rococo or neo-classicism emerged, the wealthy country house owner would change not only the decoration of the house but also much of his furniture and works of art. Unlike today, the rejected pieces had no value, no market existed to dispose of them. They disappeared into attics or servants' bedrooms where they can occasionally still be found today. Periodic clear-outs spread these objects down to the servants. A much heard phrase at our counters is: 'It was given to my grandmother while she was in service.' This, I am sure, can be interpreted in some cases as: 'It left with my grandmother.'

For these reasons we see extraordinary works of art owned by the most unlikely people. Pensioners with worries about next winter's heating bills are amazed to find themselves owners of pots, pictures or furniture worth tens of thousands of pounds.

In the *Antiques Roadshow*, owners play a large part in the success of each recording. Curiously, the cameras seem to be less daunting to them than a radio microphone. A relaxed and practised expert telling them about their favourite antique is likely to produce real and immediate reactions. This spontaneity is at the heart of the programme's success and if the first shoot fails for some reason, the second attempt never has the same freshness. The four to five thousand people who queue for an *Antiques Roadshow*, sometimes for more than three hours, are generally interested in what they are told about their objects and cliché though it may be, saving the price until the end for maximum reaction is the best formula.

The programme can use only about twenty people in each town and those that fail to appear are unfailingly good-tempered and grateful for the minute or less of expert's time that they get. On one occasion I spotted a large leather-covered box leaving a queue with its owner who had tired of waiting and was going home. The box was of a type which usually heralds an interesting contents, so I left the table and sped off in pursuit. I persuaded her to return and the box contained the best Viennese enamel plaque I had ever seen. It was so good that we decided to record the piece and she was duly overwhelmed when I quoted £8,000 on it. Today it would probably make double that.

10

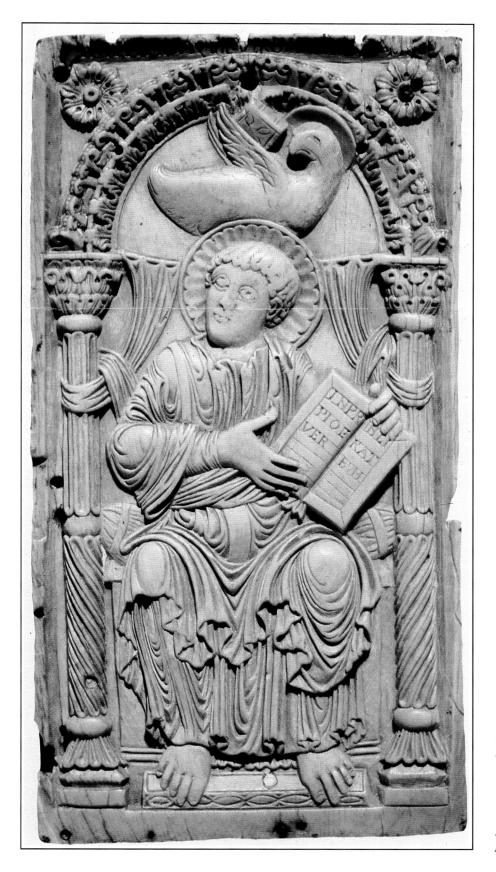

A Carolingian ivory plaque of St John the Evangelist from a 9th-century Bible cover. Sold in London in December 1977 for £280,500. It was discovered on an Antiques Roadshow *programme.*

The *Antiques Roadshow* can be a salutary lesson for those of us more accustomed to Bond Street estimates. We are so used to letting down clients lightly when they appear at our counters with something of too small a value for us to handle (under £200). 'I'm afraid that it is only worth about £100' trips all too lightly from the lips. 'I had no idea it could be worth so much' is regularly the response. Not infrequently, the sudden discovery that they are now the owners of an expensive work of art poses serious problems for them. They cannot afford the insurance premiums or even risk having a valuable piece in a small house with children around.

The BBC has, quite rightly, to maintain absolute impartiality and the experts are forbidden to disclose for whom they work. Approaches for advice on selling have to be made through the producer who provides a list of all possible alternatives. The most frustrating result of the ban is that it makes it impossible for those of us engaged in writing books or undertaking research on a particular subject to have photographs taken or borrow the piece for further investigation. Despite the occasional frustration, the *Antiques Roadshow* is a continual learning process for us and every so often valuable and unrecorded documentation, such as the Rockingham porcelain design book, appears. If a piece is unwrapped which we decide should be recorded, the owner is booked in for a recording slot that may be several hours hence.

Queuing for hours under hot lights can lead to frayed tempers and very occasionally an owner, who has had a contrary opinion from another source, will argue his case, sometimes vehemently. Sadly they are never prepared to do so before the cameras. The most common misconception relates to the age of a piece. How often do we hear over the counter in Bond Street: 'I know it's over a hundred years old. It belonged to my grandmother and she was ninety when she died and her mother had it before her.' They have no way of knowing that their statement is true, it can only be hearsay. What is more, great-granny might well have bought it in 1958 brand new. A common mistake is to add together the ages of the previous owners, arriving very rapidly at one hundred years, whereas a generation is usually reckoned at twenty-five years. The hundred-year threshold has become fixed in the minds of the public as being of major significance. The government definition of an antique as a hundred years old is used for charging import duty – an antique escapes. Sotheby's does not use the word – we sell works of art; they may be a thousand years old, they may only be ten. I have a horrible vision of a family gathering around their wardrobe to celebrate its centenary in the belief that it has suddenly become valuable.

The programme has been responsible for an increased awareness about works of art amongst the public. More people are inspired to collect and far fewer sell cheaply to the first person who gets his foot in the door. It is less likely that a family will send Aunt Matilda's possessions to the tip when she expires: more often they will call in Sotheby's or send us photographs. Almost daily the unlikely happens. Some years ago a lady brought in a box of miscellaneous items which we patiently sifted through and none of which proved to have any value. As she turned to leave she remembered a small plaque in her handbag which her daughter had asked her to bring in. It was only a few inches square and apparently black carved wood. We took it for further inspection and after cleaning, a Carolingian ivory plaque from a ninth-century Bible cover was revealed. It sold for over a quarter of a million pounds. Her daughter had bought it at a jumble sale for 2s. 6d (25p).

The lively and varied contribution of Scottish artists to British painting in the last 100 years has long been appreciated in their native country. Sotheby's once again focused on their work with the annual sale at Gleneagles Hotel which was held on 30 August 1988. Over the last twenty years these sales, traditionally on view both in London and Scotland, have greatly widened interest in a school of painting whose strength lies first in its independent provincialism and later in its cosmopolitan sophistication.

THE COLOURISTS

Susannah Pollen

Born in Glasgow and trained in Edinburgh, William McTaggart (1835–1910) subsidized his student days as a portrait painter, journeying through Scotland and Ireland recording wealthy sea captains and merchants. His works of the 1860s, in common with many of his contemporaries, show a strong illustrative bias, taking subjects from Longfellow and Tennyson. However, with his early understanding of Pre-Raphaelitism, his paintings after 1869 become independent of literary inspiration and begin to rely on serious and continuous spells of work in the open air. His greatest inspiration was found in the coastal landscape of Scotland.

Adrift was begun in 1870 at Tarbert, for McTaggart a place which was clearly a rich source of pictorial subject. It shows that incident is still a strong element in his work of the early 1870s, linking him to the traditional line of Scottish genre painting. However, there is an unusual energy in his treatment of four children tugging at huge oars in an attempt to land their raft out of a sudden squall, that sets McTaggart apart from his more conventional contemporaries. The small studies for *Adrift*, such as *Wet and Windy-Looking up Loch Fyne* (collection of the Artist's Trustees), testify to what is increasingly his overriding interest – landscape, the effects of weather, the movement of the clouds and water. From this time McTaggart emerges as the most advanced landscapist of late nineteenth-century Scottish painting. *Children on the Bents*, painted nearly twenty years after *Adrift*, shows beautifully the extent of his development. He had abandoned the need to finish larger pictures in his Edinburgh studio and was now painting almost entirely outside. His rapid execution often enabled him to finish a painting within one day. The integration of figure and landscape is nearly complete – at times the children are indistinguishable from the dunes that they cavort in. The subtlety of his colour, now much lighter in palette, and the painterly quality of his stroke has understandably encouraged the term 'Impressionist'. Yet McTaggart was independent of developments in painting outside his own work. He was unaware of Durand-Ruel's Impressionist exhibitions of the 1870s and 1880s and his biographer J. L. Caw records that he did not see his first Monet until 1902.

Francis Campbell Boileau Cadell (1883–1937) was anything but an isolated provincial. His training at the Académie Julian in Paris between 1899 and 1903 left him with a strong taste for the life and art of the Continent and he did not return to Scotland until 1909. In 1910 his sponsor Sir Patrick Ford, who was later to be of such encouragement to John Lavery, financed a trip to Venice. This produced the shimmering, rapidly painted panels of which *Florians, St Marks, Venice* is a perfect example. It was sold in April 1988 for a world record auction price for the artist of £44,000.

Adrift *by William McTaggart, RSA, RSW, signed and dated 1870–71, oil on canvas, 101.5 by 142cm. Sold in Scotland on 30 August 1988 for £44,000 ($78,760).*

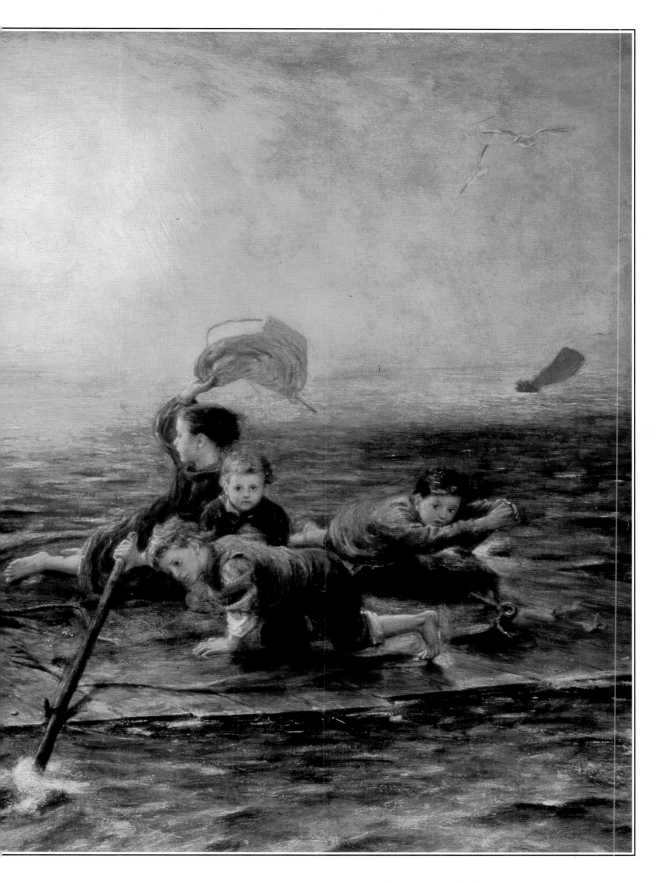

Children on the Bents *by William McTaggart, RSA, RSW, painted* circa *1888, signed, oil on canvas, 61 by 76cm. Sold in Scotland on 30 August 1988 for £35,200 ($63,008).*

Opposite:
Florians, St Marks, Venice *by Francis Campbell Boileau Cadell, RSA, RSW, signed and dated –10, oil on canvas, 46 by 37.5cm. Sold in Scotland on 26 April 1988 for £44,000 ($76,120).*

In 1910 Roger Fry staged his remarkable Post-Impressionist exhibition at the New Grafton Gallery. Three years later the Society of Scottish Artists included in its annual exhibition a number of works by Gauguin, Cézanne, Van Gogh, Severini and Matisse. Cadell's *Afternoon* belongs to the same year and is a superb indication of his maturity. Its dazzling use of bright flashes of lime, pink and orange against a startling white background shows that Cadell had, in terms of colour, learned the lessons of recent French painting arguably better than any contemporary British painter. In Scottish painting he was not alone and, together with Samuel Peploe, John Duncan Fergusson and Leslie Hunter, came deservedly to be known as one of the Colourists. It is a painting by Peploe that holds the world record for any work by a Colourist.

The Scottish Colourists' international appeal is not hard to understand. The freshness of their palette and their virtuosity and delight in handling of paint have begun to attract a new generation of collector. Between them they took up the tradition of McTaggart, applied the lessons of the French and produced some of the finest Post-Impressionist work in Britain.

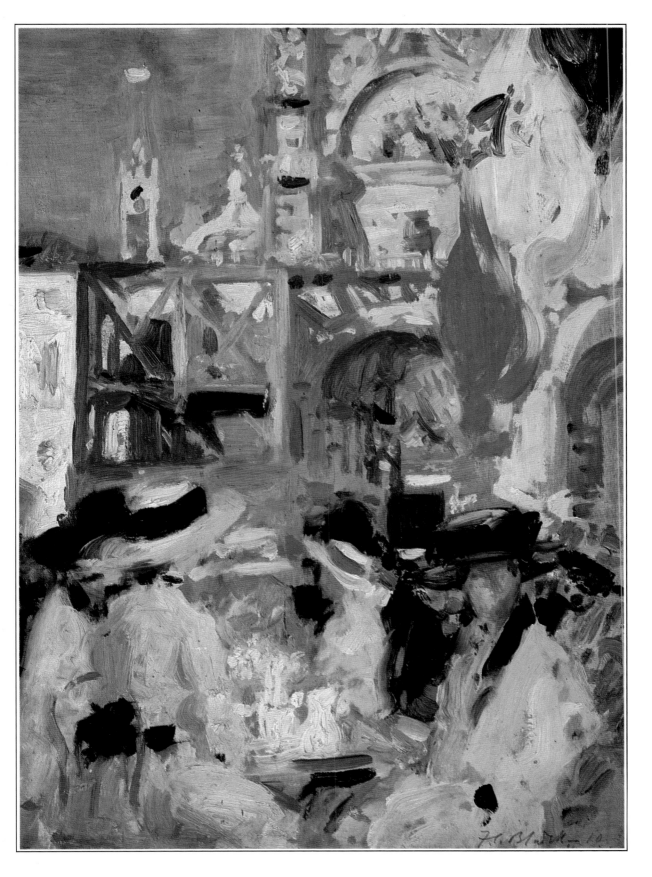

Afternoon *by Francis Campbell Boileau Cadell, RSA, RSW, signed and dated 1913, oil on canvas, 101.5 by 127cm. Sold in Scotland on 30 August 1988 for £214,500 ($383,955).*

Overleaf:
Still Life With Tulips and Oranges *by Samuel John Peploe, RSA,* circa *1924–1925, oil on canvas, 61 by 51cm. Sold in Scotland on 30 August 1988 for £76,000 ($136,040).*

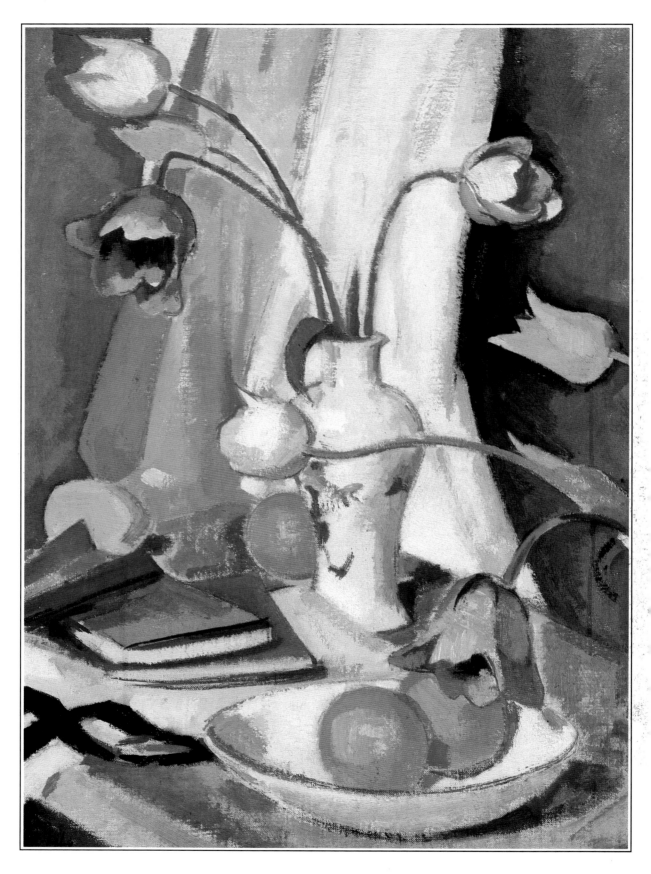

On a sultry Sunday afternoon in June 1988, two curators from the Andy Warhol Foundation for the Visual Arts made a startling discovery. Cleverly concealed between two filing cabinets in a storage room of the Warhol townhouse, was a horde of jewellery and watches. Warhol, it seemed, had outwitted the rigorous efforts that had been made to ensure that nothing was overlooked in cataloguing his vast collection for the sale in April 1988.

HIDDEN TREASURE ON 66TH STREET

As part of this process, the principal rooms of the house had been completely emptied and everything was thoroughly searched. All that remained were Warhol's personal effects, photographs, archival material and his own work. That June weekend, having emptied the drawers, the curators began dismantling the filing cabinets. To their amazement, they found a compartment filled with sachets of unmounted gemstones, designer jewellery and watches.

The 'remains' of Warhol's collection were auctioned in December 1988 for $1.6 million. In style, many of the pieces were completely in keeping with his taste for the bold, overscaled designs of the 1940s. Of interest as well were contemporary designs by Elsa Peretti and Schlumberger for Tiffany & Co. Among the watches were two exceptionally large models by Cartier and a fine collection by Rolex, Patek Philippe and Vacheron & Constantin.

No one will ever be sure of Warhol's motive in hiding this jewellery, but its discovery was certainly in keeping with the character of a man who thrived on secrecy and surprises.

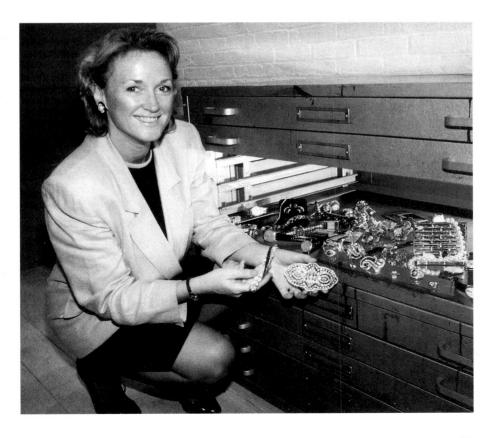

Jacqueline Fay, vice president of Sotheby's Jewellery Department with a selection of jewellery hidden by Andy Warhol.

21

A MARBLE BUST OF CHRIST BY CACCINI

Gordon Balderston

In 1859 a wealthy monk from the Dominican confraternity at Santa Maria Novella in Florence, conceived the idea of re-designing the interior of the church. Fra Damiano Beni was in charge of the *spezieria*, the monastery's lucrative and ancient establishment for the sale of herbal remedies and drugs. His personal wealth and influence were sufficient to win the Grand Duke of Tuscany's approval for his plan and work began that year on the internal fabric of the building. Fra Damiano's intention was to strip the interior of all the church's monuments, painted decoration and architectural details which did not conform to the Gothic austerity of the original thirteenth-century church.

Under the supervision of the architect, Enrico Romoli, nearly all the Renaissance and later works of art were removed from their settings and dismantled by the following year. In 1860, after the expulsion of the Grand Duke from Florence, the project was halted by the popular new government of Baron Ricasoli. However, Santa Maria Novella as it stands today, stripped of its monuments, bears witness to the industrious pursuit of Fra Damiano's vision in those two years and to the tardiness of Baron Ricasoli's intervention.

The works of art dismantled from Santa Maria Novella were sold off to interested parties as early as 1859. The Victoria and Albert Museum in London acquired at that time a massive Florentine Renaissance marble balcony which had served as a singing gallery in the church.

Another admirer of Florentine sculpture from Santa Maria Novella was John Leslie, MP. He was a frequent visitor to Italy and an avid collector. The notes he kept on the works of art in his collection reveal that he had acquired a marble bust of Christ by Francavilla from Santa Maria Novella in 1876. As with the other works of art he purchased in Italy, the bust was taken back to Castle Leslie, the home he had built in about 1870 on the site of the ancient family seat at Glaslough in Ireland. The house reflects his love of Italy and includes several momentoes of his travels, of particular interest is the cloister inspired by the one Michelangelo had designed for Santa Maria Degli Angeli in Rome. The bust remained at Castle Leslie until last year, when John Leslie's descendant, Sir John Leslie, 4th Baronet, requested Sotheby's to sell it at auction in London. The key to the success of the sale was John Leslie's note concerning the provenance.

Santa Maria Novella is a huge church and it housed many monuments, so the task of confirming the provenance and establishing the identity of the sculptor seemed daunting. John Leslie had provided details of the provenance and also an attribution to Pietro Francavilla (1548–1615), an assistant to the great Medici court sculptor Giambologna. Nevertheless, while the style of the bust was characteristic of the Giambologna school in general, there were few convincing stylistic analogies with known works by Francavilla; nor was there any documentary evidence of Francavilla having executed a marble bust of Christ for the church.

At this stage one of the few people qualified to help with further research was Herbert Keutner, an eminent art historian specializing in Giambologna and a resident of Florence. He kindly responded to a letter of enquiry that 'the provenance is correct, the attribution wrong'. He went on to attribute the bust to Giovanni Battista Caccini, a contemporary of Francavilla and to give

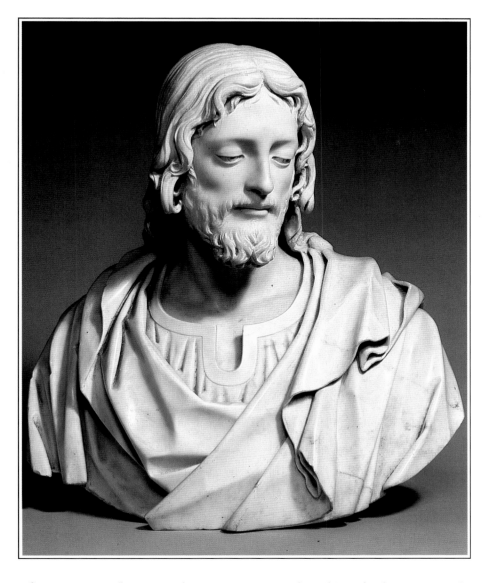

references to mid-nineteenth-century sources describing the bust *in situ* in Santa Maria Novella.

'On the next pilaster of the central nave, there is a marble tabernacle, executed from a design by Buontalenti, with a marble bust of Christ carved by Caccini.' Thus wrote G. François in his guide-book to Florence of 1850. Other guide-books of the 1840s describe the interior of the church, so that it was possible to build up a picture of two marble tabernacles housing oil paintings which faced each other on the fourth pilasters of the nave. One was surmounted by a bust of the Virgin, the other by the bust of Christ. Caccini (1556–1612/13) had trained as an architect in Rome but worked in Florence as a sculptor. His patrons were the Medici and other Florentine families, producing busts and statues as required and even restorations of classical statuary. Sculptures by Caccini may still be seen in Florence in the Boboli Gardens, on the Ponte di S. Trinità and in the churches of S. Maria Maggiore, S. Michele and S. Trinità. The sale finally brought to light Caccini's bust of Christ for Santa Maria Novella for the first time in over a century.

23

KAFKAESQUE

Dr Susan Wharton

Opposite:
A page from the manuscript of The Trial *by Franz Kafka, 1914. Sold in London on 17 November 1988 for £1,100,000 ($2,123,000).*

Observant air travellers, journeying last autumn from London across the Channel or the Atlantic, may have noticed a green plastic carrier bag being carried carefully and somewhat nervously onto their flight. On one occasion they may have wondered at the presence of a television crew filming a bag which looked like a perfectly ordinary piece of hand luggage. Even if they had been able to undo the cardboard and bubble-wrap inside it, they would probably have been none the wiser. Over three hundred loose sheets of paper, torn out of the exercise books in which they were written and covered with a spidery German handwriting, would probably not have alerted many to the presence of an object which was soon to make saleroom history.

Yet that innocent-looking, green carrier bag contained the manuscript of one of the most important novels of the twentieth century – Franz Kafka's *The Trial.* It was sold in November 1988 for £1.1 million which was four times the previous record for any modern literary manuscript.

Kafka is without doubt one of the greatest novelists of modern times. Even to those who hardly know his work, the adjective 'Kafkaesque' immediately conjures up a nightmare world where the faceless bureaucrat inevitably triumphs over the individual. *The Trial* is the story of a man who is arrested for an unspecified crime and executed for it exactly one year later without ever discovering the nature of his offence. It was written in 1914 but was never published during the author's lifetime. Since its publication in 1925, it has been translated into countless languages including Japanese and was made into a film by Orson Welles in 1963.

It was only after the Second World War, however, that Kafka's work became widely known. On account of his being Jewish, his work was banned by the Nazis in 1933. Kafka's sisters perished in concentration camps and had Kafka not died of tuberculosis in 1924, he would have risked the same fate.

This manuscript was already a seasoned traveller before its arrival in London in 1988. Its odyssey began half a century ago in Prague, Kafka's home. Four years before his death in 1924, Kafka gave the manuscript of *The Trial* to his good friend Max Brod, who was also his literary executor. In March 1939, the night before the Nazis entered Prague, Brod left the city on his way to Palestine, taking all Kafka's manuscripts in his hand luggage and thereby saving them from certain destruction. In the 1950s, at the time of the Suez crisis, Brod again feared for their safety and sent them to neutral Switzerland for safe-keeping. Having arrived in London to be catalogued for the sale, the manuscript of *The Trial* then set off on its travels once more. It was taken to Japan and Hong-Kong, Germany, Austria and New York, to be examined and marvelled at by specialists and non-specialists alike, before the sale in London on 17 November. In December it set off on its final journey to the German Literary Archive in Marbach near Stuttgart. Now at long last, Kafka's manuscript has reached its final resting place.

A photograph of Franz Kafka, taken in 1914 at the age of thirty at about the time he wrote The Trial.

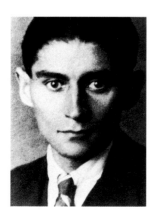

der ... und das schon seit Jahren. In ihrer Meinung würde er nicht
sinken, wie auch sonst ein ... Schaden gelitten hatte. Vielleicht war
es ein gutes Zeichen; denn er ... gerade vor der Abfahrt davon über-
zeugt hatte, daß er ... noch immer einen Beamten, der ... wie
dem Gericht Verbindungen hätte, einen ... ohne jede Entschuldigung und ...
dürfte ... Das allerdings, was er
gern ... hätte, hätte er nicht tun dürfen, ... zwei
laute Schläge auf seine bleichen runden Wangen zu geben, ...
... nicht
nur Kullych, sondern auch Rabensteiner und Kaminer. ...
... Er glaubt sie seit Jahren gehabt zu haben, ihr Erscheinen
in Frl. B. Zimmer hat ihn zwar nicht auf sie aufmerksam
gemacht, sein Plan aber ist älter. ...
... in der letzten Zeit leidet er fast an diesem Plan, denkt er
... nicht befriedigen ... ihnen beim Kommen,
... niedrigsten Beamten ... minderwertig, sie werden
nicht vorwärts ... unter dem Druck der Dienstjahre
und auch hier langsamer als irgendjemand, es ist infolgedessen
... immer sich ihnen ein Hindernis in den Weg zu legen,
... von fremder Hand ... Hindernis kann ... sein
wie Kullych ... Rabensteiner Faulheit und Kaminer
... Das einzige, was man gegen sie unter-
nehmen könnte, wäre ... ihre Kündigung zu veran-
lassen, das wäre ... leicht zu erreichen, ein paar Worte K's.
gegen den Direktor würden genügen, aber dazu scheint K.
... Vielleicht würde er es tun, wenn der D.D., der offen
oder gehen alles bevorzugt, was K. ... sich für die Drei einsetzen
würde, aber merkwürdiger Weise macht hier der D.D. eine
Ausnahme und will den ... was K. will. Er hat schon wegen öfters
beim K. die Entlassung ... dieses oder jenes der Drei angeregt

BY THE SEA

To our eyes, the full satin skirts and top hats of these sun worshippers look distinctly out of place. But in the mid-1870s such elaborate costumes were the last word in chic. Describing Kaemmerer's *The Beach at Schevenigen*, the critic, Edward Strahan, observed, 'Here we have the belles and dandies from all Dutchland, as well as those from France and Britain ... the freshest flounces and modes of 1874 are displayed on the hired garden-chairs.' Even the artist is present, as Strahan notes, 'At the

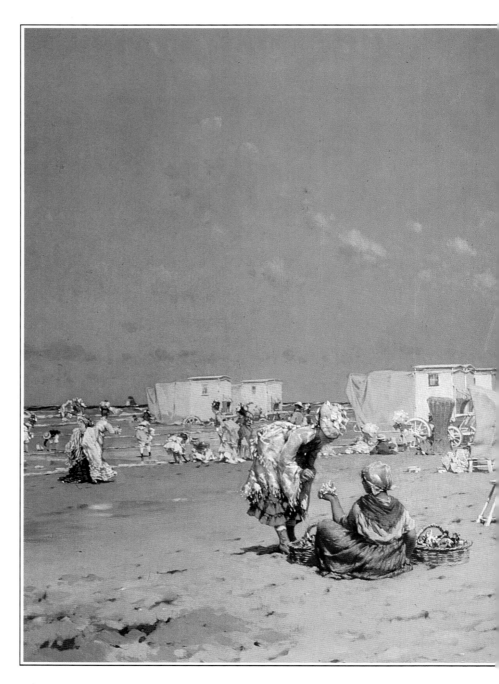

The Beach at Schevenigen, Holland *by Frederik Henderik Kaemmerer, 1874, oil on canvas, 69.8 by 139.7cm. Sold in New York on 27 October 1988 for $1,320,000 (£717,391).*

right I recognize my fellow pupil at Gérôme's, Frederik Henderik Kaemmerer, in a smart suit of light flannel and a very noble hat, caressing a cane and taking in the whole scene with a creator's eye.'

After he moved to Paris in 1865, Kaemmerer, a Dutch landscape painter, turned to elegant genre scenes. His work and that of his fellow salon painters held tremendous appeal for the newly-wealthy American industrialists. This painting was acquired from Kaemmerer by the Corcoran Gallery of Art in Washington and it clearly reflects the taste of the founder, William Wilson Corcoran. Originally purchased for $3,000 in 1874, *The Beach at Schevenigen* achieved $1,320,000, the highest price ever paid for the artist's work.

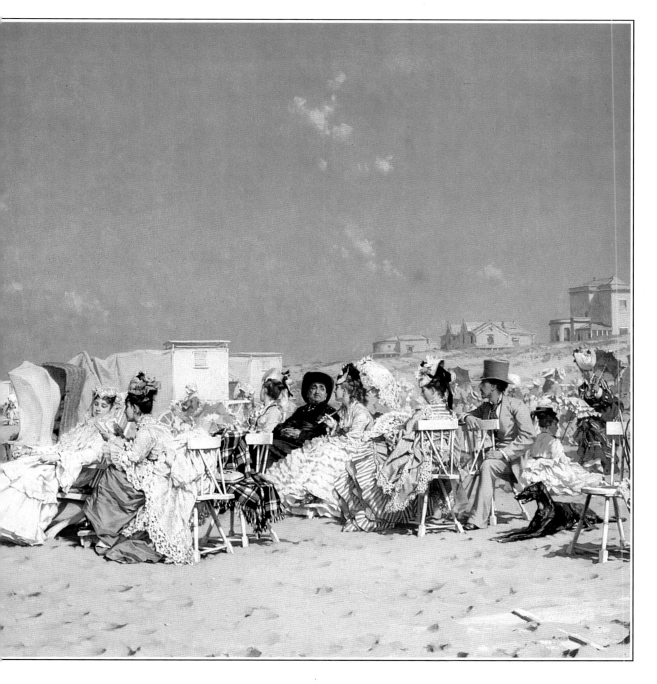

THE PENNY POST

Richard Ashton

On 6 May 1840 one of the most significant cultural revolutions of the nineteenth-century took place: the introduction of cheap postage. Pre-payment of postage fees was brought about by the issue of 'adhesive labels' to the value of 1d or 2d and thus the postage stamp was born. Prior to 1840 the cost of sending letters was prohibitive, reserved almost exclusively for wealthy individuals and members of the legal profession. Rowland Hill's campaign for cheaper postage meant that from May 1840 it was possible to send a letter, weighing up to one half ounce, anywhere in the British Isles for one penny. The entire population now had the opportunity to communicate by post which resulted in many more people wanting to learn how to read and write.

Concurrent with this issue was the release of printed pictorial envelopes, designed by William Mulready R.A. However, Mulready's design was ridiculed to such an extent that only six days after their official issue and use, Rowland Hill was forced to write in his diary that he feared they would have to be substituted 'for some other stamp'. Such was the ridicule, that private 'caricature' envelopes were designed, produced and published by Fores, R.W. Hume, John Leech, John Menzies, J.W. Southgate, William Spooner and others well-known in the Victorian world of art, publishing and printing.

Albeit unwittingly, Mulready and the caricaturists developed a new sphere of artistic expression. Pictorial envelopes in a great variety of design and purpose were published with an emphasis on political themes. Later, stamps with beautiful envelopes were used for advertising such commodities as *Baylis's Sphinx brand patent needles and small wares, Fields Candle Works* and *Sanders American Boot Stores*.

As a natural progression, hand-drawn envelopes soon made their appearance, usually sent within families and circles of friends. Often the illustrations on the envelopes revolved around current political events, which can be ascertained by the subject matter, but others will always remain a mystery, their significance known only by the sender and recipient. Most of these envelopes were trimmed and consigned to the Victorian scrap book. Occasionally complete examples do come on to the market where their value is dependent on subject and quality of execution.

Sotheby's was surprised and delighted when a series of thirty-six such envelopes, painted by George Henry Edwards betweeen 1882 and 1913, were consigned for sale in 1988. Edwards was a Bristol watercolourist who worked from 4 Camden Studios in Camden Street, North London. He exhibited at the Royal Academy and Royal Institute where on one occasion Queen Alexandra bought one of his paintings. Apart from his work in oils and watercolours he also illustrated books and the *Boy's Own*.

Most hand-drawn envelopes were by amateurs and it is most unusual to find examples painted by a professional. Great imagination went into Edward's designs, the vast majority of which were sent to members of his family to celebrate their birthdays. To his brother, E. Henry Edwards, he sent *Hoisting the Flag, Railway Terminus, Erecting a Weather-vane* and *The Red Chevalier*. To his nephews, possibly twins, went matching *Jester* envelopes.

It was, however, to his sister 'Miss Edwards' that we find what many today

Opposite:
Four watercolour covers illustrated by George Henry Edwards, sent from London to Miss Edwards in Bristol. Sold in London on 9 May 1988 for prices up to £2,750 ($4,868) for Posting a Letter *(bottom left).*

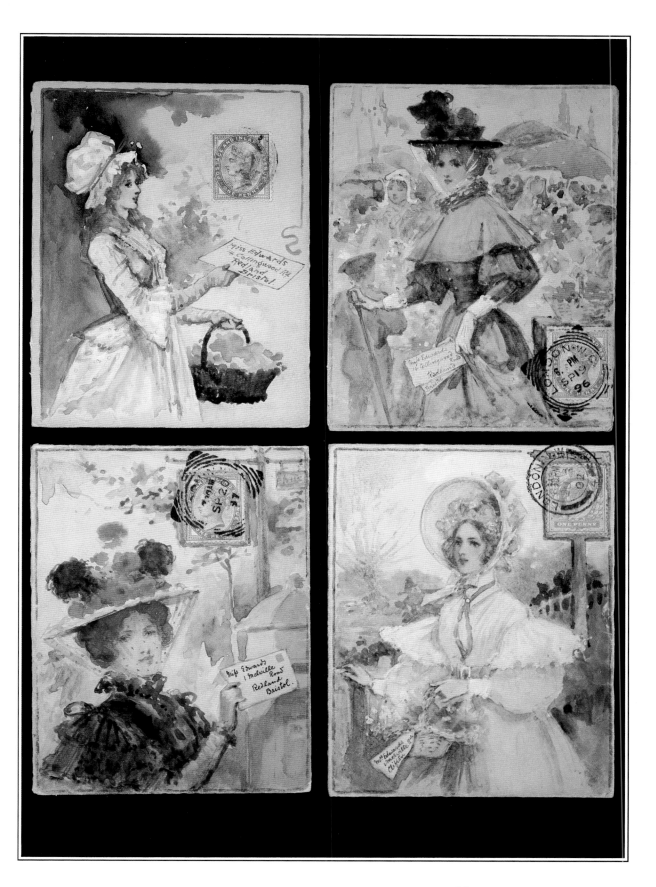

POST OFFICE
LETTER BOX
Nº I
MILES FURLONGS YARDS
3 213
FROM THE GENERAL POST OFFICE

The new Post Office letter box at the corner of Fleet Street and Farringdon Street in London, 1855.

Young Woman in Violet *by George Henry Edwards, 3 June 1896, watercolour cover sent from London to Miss Edwards in Bristol with 1881 1d lilac.*

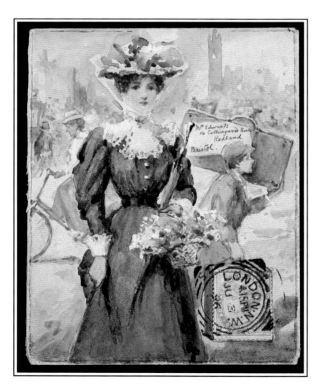

consider to be the pinnacle of Victorian envelope illustration. Featured throughout is a beautiful auburn-haired woman believed to be his sister Dora. She is seen in stylish outfits of the day – in wonderful gowns of violet, pink and yellow. Some of the envelopes include everyday scenic backgrounds while others depict her posting a letter or 'waiting by the garden gate'.

The work of George Henry Edwards was recognised as something very special when, on 9 May 1988, amidst fierce competition, the envelopes realised a total of £25,465 at auction in London. Envelopes measuring little more than 95 by 120mm fetched up to £2,970 each. Sadly the practice of illustrating envelopes in this fashion was curtailed by the Post Office in the early years of this century. Such was the inventiveness of artists that often the addressee's details were contained in a panel no more than 10 by 11mm which resulted in problems for both the Post Office sorters and postmen.

However, those envelopes that do survive are now highly prized by collectors and will remain with us as a lasting link with the Victorians.

The 'Golden Aussie' one of the largest and most remarkable gold nuggets in existence, was discovered by Jack Bray, a pensioner from Kalgoorlie, Western Australia on 12 August 1980.

The actual site of the discovery was about 45 kilometres east of Coolgardie at Feynville, Western Australia. Bray had prospected at this location previously, both alone and with two friends, without success. Subsequently, the three men returned to the area to try a patch with the help of a grader to shift alluvial heaps. After several small nuggets were unearthed, his friends moved on while Bray decided to persevere. On the fourth day, with the assistance of a metal detector, he discovered this massive gold nugget about fifteen to twenty centimetres below the surface. It had a fineness of 94.582%, weighing 267.5 Troy ounces (22¼ pounds) and measuring 29cm long by 16cm wide.

As could be expected, Jack Bray and the 'Golden Aussie', so-called because it resembled a map of Australia, received much publicity. As late as seven years after the discovery, Australia featured the 'Golden Aussie' on the reverse of the gold coins included in their 1987 *Two-Coin Proof Sets* issued by the Perth Mint.

THE 'GOLDEN AUSSIE'

A large free-form gold nugget. Sold in New York on 6 June 1989 for $308,000 (£184,431).

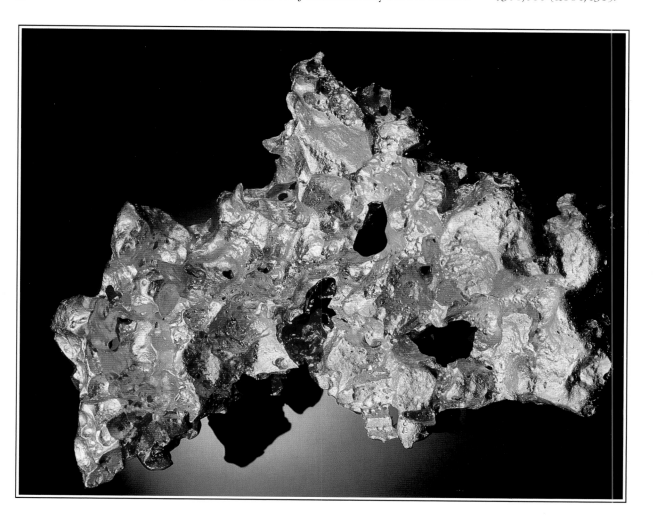

PORTICO MYSTERY CLOCKS BY CARTIER

'**M**arvels of the clockmaker's art, unreal and seemingly woven from moonbeams' was one critic's appraisal of Cartier's Portico Mystery Clocks when they were first displayed in 1925.

These elegant timepieces, on which jewelled hands glide across a crystal face with no apparent connection to the clock's movement, were a French invention of the 1870s. Just after the turn of the century, Louis Cartier began to collaborate with master horologist Maurice Couet and their designs soon became 'musts' for millionaires and royalty.

The six Portico Mystery Clocks, created between 1923 and 1925, were their culminating achievement and it is a testament to the clocks' perfection that all six survive today. Clock No. 1 is in the Cartier Museum Collection and Nos. 2, 4, 5 and 6 are in private hands. Clock No. 3 was sold to an American private collector in October for the record price of $660,000.

Executed in a dramatic design of onyx and rock crystal, enhanced with gold and diamond detailing, each clock took up to a year to complete. Every part was handmade and the hands were works of art in themselves, requiring the most intricate skills of the Cartier jewellers. As Sylvie Raulet, author of *Art Deco Jewellery*, has observed: 'The hands of the most gorgeous clocks – the "mystery clocks" – were wrought and chased into miniature works of art; with Cartier they became diamond-covered snakes or a fire-breathing dragon uncoiling in the centre of the dial, its head marking the hours, its tail the minutes.'

Of the two men, Maurice Couet provided the technical brilliance. Early in his association with Cartier, he mastered the illusion created by mounting each hand on a transparent disk attached by a shaft to the movement in the base. With the Portico series, the 'Mystery' was carried to new heights as the crystal itself was suspended on a gold chain. In fact the links conceal a single axle that connects both disks to the movement above.

In design, these clocks combine the Art Deco and Oriental elements that pervaded Cartier pieces throughout the 1920s. Of all the Portico clocks, the Oriental influence is strongest in No.3. Ferocious Chinese lions stand guard at the base of the columns and above the dial is a frieze carved with Chinese fretwork and in the centre is a stylized *Shou*, the symbol of long life. These elements are incorporated in a rectilinear design where onyx and rock crystal create a typical black and white Art Deco colour scheme, highlighted by the soft pink of the rose quartz columns.

The Cartier firm really worked as a collective and it is thus impossible to attribute the design to any individual. It is known, however, that Charles Jacqueau, the most brilliant of the designers, was particularly fascinated by the Orient and the most adept in the Art Deco style. Certainly, he must have been at least influential in the creation of these clocks which are destined, according to Diana Scarisbrick, the well-known writer on jewellery, for 'the highest place in the artistic achievements of our century'.

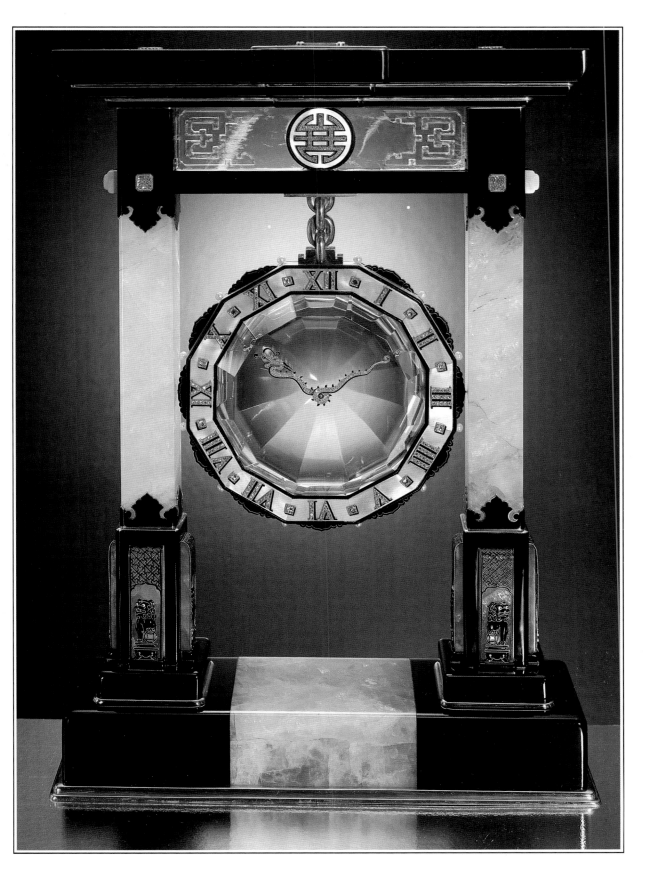

'THE MIRROR OF WATER'

Michel Strauss

A study of water lilies floating on a pond, the water suffused with colour by the reflection of the sky and trees, *Nymphéas* by Claude Monet, was a departure in Monet's art. This painting, one of an extensive series of water lily paintings grew out of his studies of Rouen Cathedral which he painted in varying lights and climatic conditions.

'The water flowers are far from being the whole scene; really they are just the accompaniment,' said Monet. 'The essence of the motif is the mirror of

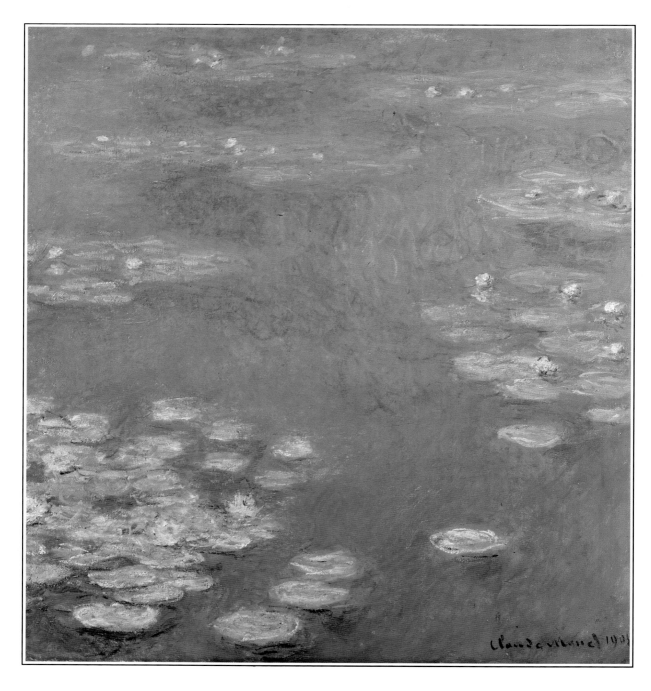

water the appearance of which alters at every moment, thanks to the patches of sky which are reflected in it and which give it its light and movement.' In the early spring of 1907 Monet wrote to the Durand-Ruel Gallery proposing an exhibition of his recent water lily paintings. The suggestion was accepted, however, as the year progressed he became increasingly dissatisfied with the work he was producing. Having destroyed at least thirty canvases, the exhibition planned for May was postponed until the following year. In the spring of 1908, Monet, plagued with doubts and suffering from tiredness and dizziness, delayed the opening of the exhibition yet further. Later in the year he travelled to Venice and on his return to Giverny saw his previous work in a more favourable light and consequently finally agreed to go ahead with the exhibition. In a letter to Durand-Ruel he wrote: 'In any case you can absolutely count on me. I will be ready as my journey to Venice had the benefit of making me see my canvases in a better light. I have put aside all those which do not merit being exhibited and the rest will make, I believe, a far from banal exhibition.' Indeed the exhibition was a resounding success and extended by a week.

The forty-eight paintings in the exhibition were regarded by the critics and by Monet himself as a single concept rather than as individual works. It was Monet who insisted on changing the title from *Les Reflets* to *Les Nymphéas Série de Paysages d'Eau.*

The critic Jean-Louis Vaudoyer wrote enthusiastically that 'None of the earlier series can, in our opinion, compare with these fabulous *Water Landscapes* which are holding spring captive in the Durand-Ruel Gallery. Water that is pale and dark blue, water like liquid gold, reflects the sky and the banks of the pond. Among the reflections pale water lilies and bright water lilies open and flourish. Here, more than ever before painting approaches music and poetry.'

Monet's biographer and distinguished critic, Gustave Geffroy, speculated that the artist would have wanted to decorate a circular room, hung all around with paintings of water and flowers, a room empty of furniture with only a solitary dining table standing in the middle. In fact this was a concept that Monet was already thinking of and which a few years later was to become a reality when he created his Décorations for the two oval rooms in the Orangerie in Paris.

Once Upon a Time

Michael Heseltine

'That was my downfall' commented Morton E. Wise when describing how he started to collect children's books. A chance purchase of a volume illustrated by Arthur Rackham in 1976 whetted his appetite and having enquired about similar books he was directed to three of the leading specialist booksellers in the United States. The Rackham was soon overshadowed by some of the most desirable children's books of all periods including well-known characters like Goody Two-Shoes and Christopher Robin, as well as many other forgotten favourites of the nursery. The titles purchased over the subsequent ten years formed a select but wide range of juvenile literature and the most recent in a series of major collections to be sold at Sotheby's. The first of these collections was that of F.R. Bussell, which comprised about 1,200 items and was sold as one lot for £2,400 in 1945. The collection was greatly expanded by its eventual owner, the American, Edgar Oppenheimer, and subsequently returned to Sotheby's where approximately 3,500 items were sold in a series of seven sales between 1974 and 1982 which totalled about £250,000. Fables, fairy tales, nursery rhymes, moral stories, picture books and educational works were all represented in the Wise collection, together with some related illustrated books and American classics. The 540 items arranged in 207 lots realised £156,970.

The huge difference in the average price for books in the two collections can be accounted for partly by rising values. However, the great success of the Wise sale was principally due to the selective buying of the owner and his concentration on major works. In contrast, the Oppenheimer collection had taken many more years to assemble, but included a comprehensive range of books of varying importance and rarity. As one would expect, huge quantities of children's books have been 'read to pieces', lost, or wilfully destroyed by their young owners, but there are still surprisingly large numbers of early children's books that have survived and enthusiasts are still able to build up large collections of interesting books for fairly modest sums. Many of the quite important and attractive nineteenth-century titles are still available within the £20–£80 price range. Major classics, rare works or books in fine condition which made up the Wise collection are very much more expensive. It is extraordinary that in spite of his high standards, Wise assembled so many important books in such a relatively short time.

First editions are of as much importance to enthusiasts in this field as they are to other book collectors. Many of the most sought-after childrens' books appeared for the first time in very small editions and neither author nor publisher anticipated their popularity. In some cases only a few hundred copies would have been printed, of which only a handful have survived. Yet their appeal has meant that since their first appearance they have rarely, if ever, been out of print. Obvious examples are fairy tales such as *Puss in Boots* and *Little Red Riding Hood*, which appeared in a collection of eight stories by Charles Perrault published in 1697. Surprisingly, these stories and those of his contemporaries were originally intended for the entertainment of adults at the French court. The most prolific writer was the Countess d'Aulnoy, represented in the collection by *The Diverting Works of the Countess of D'anois*, printed in London in 1707. It contains twenty tales including 'Graciosa and Percinet' and

Opposite:
Death and Burial of Cock Robin, *an early issue of this edition, first published in 1806. Sold in London on 1/2 December 1988 for £715 ($1,337).*

Who will write his epitaph?
I, said the Hare,
With the utmost care;—
"Poor Cock Robin is no more."

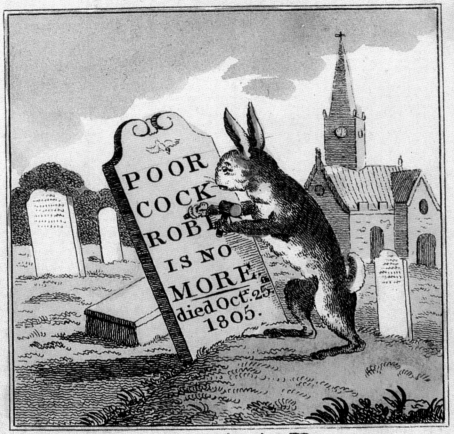

Here the timid Hare,
In characters fair,
Is writing on the stone.

'The Hobgoblin Prince', sixteen of which are printed here in English for the first time. The Wise collection also included original but long-forgotten tales such as the *Curious Adventures of a Little White Mouse*, published in about 1790. Here a wicked boy is turned into a white mouse by Fairy Fidget, but after a series of improving adventures he regains his true shape and eventually becomes King of Fairyland. The most well-loved fairytale character to appear separately in the collection was Cinderella. An edition of the story published by John Harris in 1807 is apparently the earliest written in verse. The Wise copy is one of only three known to have survived and also came from the Oppenheimer collection.

Poetry sold in December included the only known copy of a little volume entitled *King Pippin's Delight*, published *circa* 1801, and containing a series of verses which describe leap-frog, shuttle-cock, blindman's buff and other games. Among the more well-known nursery rhymes, one of the earliest was an attractive edition of the *Death and Burial of Cock Robin* published *circa* 1806, with engraved illustrations coloured by hand. This copy was issued in pictorial wrappers, a most unusual feature at that time.

Other early books of note included *The Pleasant and Instructive History of Old Goody Careful, circa* 1774. This book was hitherto unrecorded and no other titles issued by its publisher Joseph Hawkins have been traced. It was obviously an imitation of *Goody Two Shoes* represented here by an early American edition published by Isiah Thomas, 1787. Both books are typical of the stories specially written for children of the period. Others intended for adult readers, including Samuel Richardson's novels, were adapted for children later.

Comic Alphabet *by George Cruikshank, 1836, a rare copy of the first edition in hand-coloured state. Sold in London on 1/2 December 1988 for £935 ($1,823).*

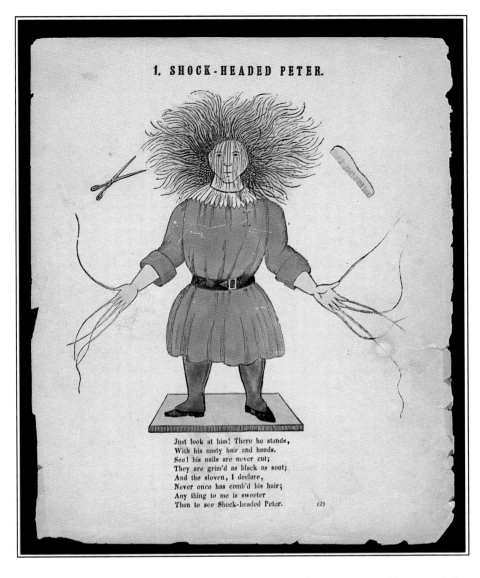

1. SHOCK-HEADED PETER.

Just look at him! There he stands,
With his nasty hair and hands.
See! his nails are never cut;
They are grim'd as black as soot;
And the sloven, I declare,
Never once has comb'd his hair;
Any thing to me is sweeter
Than to see Shock-headed Peter. (2)

The English Struwwelpeter or Pretty Stories and Funny Pictures *by Heinrich Hoffmann, first edition in English, Leipzig, 1848. Sold in London on 1/2 December 1988 for £2,640 ($5,148).*

Most popular were titles like *The Adventures of Captain Gulliver*, and the collection included the only known copy of the earliest surviving abridgement of Swift's satire.

The most famous of the English classics in the collection was undoubtedly *Alice's Adventures in Wonderland*. A presentation copy of the first published edition of 1866 was inscribed by Lewis Carroll to Edith Denman, one of the few child friends who kept in touch with the author in later life. An even more important association was to be found in a presentation copy of *Alice's Adventures Underground*, 1886. This was inscribed to Mrs Craik, author of *John Halifax, Gentleman*, whose husband negotiated the publication of *Alice's Adventures in Wonderland*. There was also strong competition for presentation copies of the tales of Beatrix Potter. A pair of first editions of *Mr Tod* and *Pigling Bland*, dated 1912 and 1913, were inscribed by the author and came complete with the accompanying autograph letters, one of which was signed 'yrs aff Peter Rabbit'. There was an appropriate hush when the bidding for a set of A.A Milne's Christopher Robin books published between 1924–1928

climbed to £5,500. Each of the four volumes was in its original dust jacket and the first contained the author's signature and an ink drawing of Christopher Robin by the illustrator Ernest Shepard. They had been estimated at £1,500–£2,000.

English editions of classic children's books from abroad attracted similar interest. The most important was the first English edition of Heinrich Hoffmann's *The English Struwwelpeter*, published in Leipzig in 1848. Many adults remember being terrified as children by the cautionary verses and gruesome illustrations, but the original German edition was such an immediate success that it sold out in four weeks. It was quickly translated into several other languages and was a particular favourite in England. Pinocchio took much longer to achieve the same popularity. His story first appeared in Italy in 1883 and was translated into English for publication as an unassuming little volume entitled *The Story of a Puppet* in 1892. But it was not until he appeared in the Walt Disney film that he achieved star status.

As an American, Morton Wise was equally interested in the classics of his own country: English collectors had a rare opportunity to see particularly good copies of titles such as Horatio Alger's *Ragged Dick*, published in Boston in 1868. This book drew attention to the plight of vagrant children in New York at the time, the author having gleaned much of his information from the boys themselves. As a contrast to this urban tale there were copies of Joel Chandler Harris's Brer Rabbit books *Uncle Remus* and *The Tar Baby*, published in New York in 1881 and 1904, and both in virtually mint condition. During the different stages of production, changes and corrections were often made to books of this period. Those in the Wise copy of L. Frank Baum's *The Wonderful Wizard of Oz*, Chicago, 1900, were the earliest and this rare example of one of the most famous American children's books fetched £8,000.

In most successful children's books such as those by Lewis Carroll, Beatrix Potter and A.A. Milne, there is a particularly effective balance between text and illustration, but the Wise collection also contained items sought after purely for their pictorial appeal. These included a rare hand-coloured copy of George Cruikshank's panoramic *Comic Alphabet, circa* 1836, and proof impressions of his twenty-four etched plates to illustrate 'The Fairy Library', previously sold in the Oppenheimer collection. There was also determined bidding for the work of Aubrey Beardsley, which continues to attract enormous interest. The sum of £3,200 was paid for a large-paper copy of Sir Thomas Malory's *Le Morte d'Arthur*, 1893–1894. This edition contains Beardsley's first commissioned work, a profusion of full-page illustrations, decorative borders and ornamental initials. This copy was accompanied by the portfolio of unused designs for the book published in 1927.

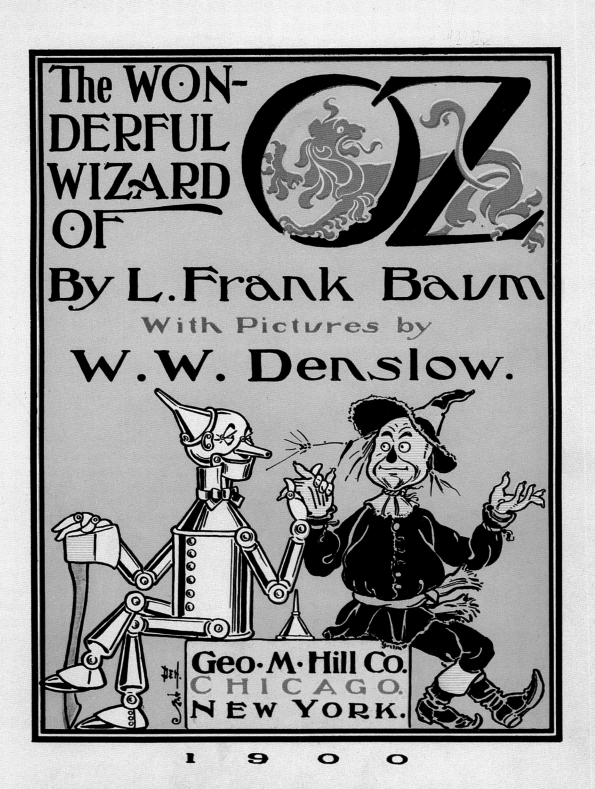

MISTAKEN IDENTITY

James Rylands

Among the many and varied items included in the Sale of Garden Statuary at Sotheby's, Sussex in May 1989, was an interesting selection of cast iron garden ornaments.

One piece in particular required a certain amount of detective work and so far, even after the sale, not all the questions have been answered. The piece under debate was a two-foot-high cast iron model of a dog seated in a begging position. It was consigned for sale from a modest garden in Surrey, with no provenance and had been valued by a local dealer at a few hundred pounds. The base is stamped 'Coalbrookdale' signed E. Landseer Sc., titled 'Tip' and dated 1842.

Coalbrookdale in Ironbridge, Shropshire, was one of the largest English foundries and was founded in the eighteenth century by the Darby family. The foundry reached its zenith in the second half of the nineteenth century when it was producing large quantities of cast iron architectural fittings, as well as a wide range of garden furniture, fountains, figures and smaller indoor pieces. Some of these pieces are stamped with the company's name, although Coalbrookdale's stamping policy appears to have been largely arbitrary.

Edwin Landseer, Court painter and favourite artist of Queen Victoria, immortalized many of the Queen's pets in paint, but is perhaps most well-known for the *Monarch of the Glen* and for modelling the lions in Trafalgar Square.

Although Landseer's signature immediately suggested a royal connection, there is no reference in the Coalbrookdale archives connecting Landseer with the foundry. It is known, however, that Francis Darby, the owner of the company, was fond of dogs and knew Landseer and other leading artists of the time. Queen Victoria was also a great dog lover and at one stage the Royal Kennels housed over one hundred dogs, many of them mongrels.

Research in the Royal Archives, revealed that Prince Albert gave the Queen two Belgian spaniels for her birthday on 24 May 1842, one of which was called Tip. This initially seemed to solve the problem except that the dog in question is not a Belgian spaniel, but appears to be a terrier.

The answer was eventually found in one of Landseer's paintings entitled *Islay, Tilco, a Red Macaw and Two Love Birds* executed in 1839, which clearly shows the same dog in a very similar begging pose. Islay was a Skye terrier, known to be a favourite of the Queen, who through her admiration for the breed was largely responsible for introducing Skye terriers to England. Landseer's paintings, in which Skye terriers featured, drew public attention to the breed.

As well as the oil paintings there are also etchings of Islay by Landseer and by the Queen herself, in which medium she had been coached by Landseer and George Hayter.

The mystery still remains as to why the piece had been erroneously titled, since if it was to preserve the identity of a royal dog, it would certainly not have been titled with the name of another royal pet. The answer probably lies in a simple mistake by a modeller for the foundry who mistook one dog for another. Sadly, due to lack of documentary evidence, it is unlikely that we shall ever know the answer.

*A Coalbrookdale figure
of a Skye terrier titled
Tip, 1842, signed
E. Landseer, 60cm high.
Sold in Sussex on 30 May
1989 for £10,450
($17,556).*

A Fine Vintage

Stewart Skilbeck

When Enrico Marchesano of Milan took delivery of his supercharged Bugatti Type 35c in March 1928, his only interest was in acquiring a car which would take him as quickly as possible on his regular trips on the dusty roads between Bulgaria and Italy. The whining of the Supercharger and the crackle of the exhaust gave adequate warning of approach from two valleys away and no doubt Enrico drove the car in a style which suited its former competition history. Prior to his ownership the car is believed to have been a works team car driven with some success in Grand Prix in Italy and subsequently in hill-climbs by Count Trossi.

Its distinctive red livery reflected its Italian ownership, eschewing the traditional Bugatti blue of so many examples of the marque. The car passed through the hands of four more Italian owners and as with most sporting cars, had a tough life, driven to the limit when the occasion allowed or demanded, especially when pursued by one of those aggressive Alfa Romeo 8c drivers.

Little could Enrico have realised that some sixty years on his beloved red Bugatti would still excite the sporting motorist and be held in such esteem by the devoted followers of artist, engineer and designer Ettore Bugatti.

In 1938 this car came to England and was acquired shortly after the war by Bugatti enthusiast, Alan Haworth, a Lancashire industrialist. It did not go into retirement, however, and was actively used in sprints, hill-climbs and short circuit races organised by the Bugatti Owners Club, the Vintage Sports Car Club and other local clubs, achieving considerable success in the capable hands of its cigar-smoking owner.

Registered GNE 801, the car became affectionately known as 'Genie' and saw regular road use in the Lancashire Pennines until the death of its owner in 1988. It was then bequeathed to the Bugatti Trust and subsequently offered for sale by Sotheby's in the Drill Hall of the Honourable Artillery Company in March 1989, some sixty-one years after Enrico Marchesano first sat behind the wheel.

Genie shared the stage with five other Bugattis including two others from the Haworth stable, a Type 37 Grand Prix Special and a more formal Type 57c coupé with English coachwork by James Young.

International buyers had flown in or were eagerly hanging on the end of telephone lines as the sale warmed up with motoring accessories and automobile art. Picnic sets, once a basic necessity of the motorist in the days of far-flung hostelries and regular roadside breakdowns, now attract serious interest from those who seek all period accessories to go with their cherished cars. A wicker motoring picnic set from the 1920s rocketed to a top bid of £650. A 1910 motor car interior vanity set by G. Keller realised £3,000. Gobbo, an American car radiator mascot designed by L.V. Avonson in 1909 was no doubt grinning with some amusement when the hammer fell at £1,000 against a top estimate of £300. A silver presentation cigar box, presented to Sir Malcolm Campbell by the Royal Automobile Club in 1935, to commemorate the World Land Speed Record of 301.129 m.p.h at Utah Salt Beds, achieved £2,400.

In sharp contrast to the field of Bugattis, one of the early lots was the 1950 AKH Supercharger Special sports car, built by Alan Haworth to his own design. For £4,600, the new owner acquired a unique sports car with still more development potential after some thirty-nine years.

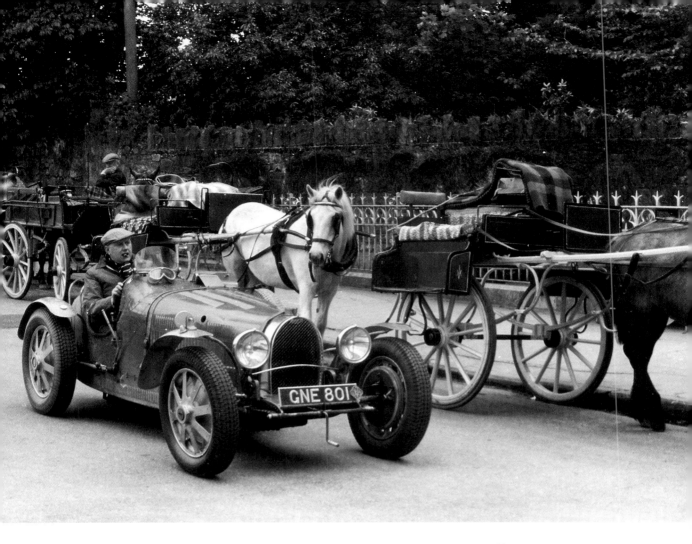

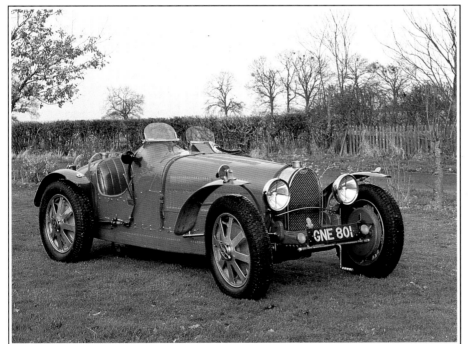

Above:
Alan Haworth in the 35c
Bugatti at Killarney
during an international
rally in 1923.

A 1928 Bugatti Type 35c
Grand Prix two seater.
Sold in London on 20
March 1989 for
£506,000 ($915,860).

45

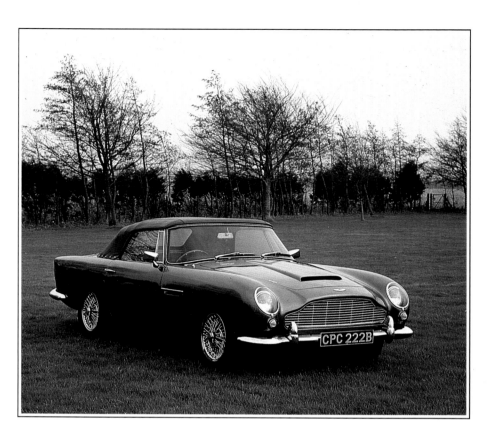

A 1964 Aston Martin DB5 Drophead Coupé. Sold in London on 20 March 1989 for £200,200 ($346,346).

Haworth's Bugatti Type 57c, another Supercharged car and something of a wolf in sheep's clothing, may have appeared rather formal but the bidding reflected the car's performance. Setting off at a brisk pace it soon achieved its saleroom estimate of £140,000. Thereafter, bidding slowed with the English collectors battling it out in a hushed saleroom – the bidding ended at a record £300,000 – earning the successful purchaser and the auctioneer a round of applause.

A horde of Bugatti spares which had been stored away in the Haworth cellars appeared to the uninitiated to be little more than scrap metal. However, a large Supercharger suitable for a Type 35 Bugatti brought the hammer down at £9,000 and one bidder left the room triumphantly clutching a camshaft which had been removed from his car some twenty or more years ago. Axles, wheels, magnetos, headlamps and radiators were eagerly snapped up by bidders keen to complete their own restoration projects.

And yet the drama of the day was not over and it remained for a British sports car to steal the final thunder. A 1964 Aston Martin DB 5 Drophead Coupé had drawn much attention before the sale, attracting covetous glances from Aston Martin chief Victor Gauntlett amongst others. Bidding was keen in the room and on the telephone and the car was knocked down to its new owner for an auction record price of £182,000.

As the cars filtered out into the dense London traffic on the backs of transporters, it was a far cry from the dusty roads of Italy used by Enrico Marchesano. Nevertheless whiffs of Castrol R racing oil and the distinctive aroma of 'well sat in' leather upholstery still lingered in the hall of the Honourable Artillery Company.

In the summer of 1921 Picasso and his wife Olga rented a villa in Fontainebleau after the birth of their son Paulo. Picasso's preoccupation with volume and classical Greek themes at this period resulted in the creation of figures resembling a race of giantesses, strongly modelled by light. Resting or standing like painted statues, a series of colossal heads lacking in expressive quality, these works are endowed with a strong, sculptural quality. They were directly influenced by classical Greek sculpture in which the eyes, nose and mouth were modelled in a rigid and stylized fashion. This female head, executed in 1921, appears in several other works, in particular as the woman on the left of his great composition, *Three Women at a Spring*, also painted at Fontainebleau.

HEAD OF A WOMAN BY PICASSO

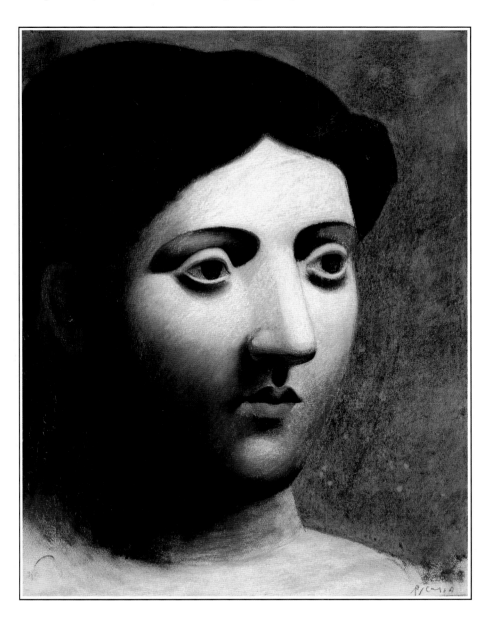

Tête de Femme *by Pablo Picasso, 1921, pastel, 62 by 48cm. Sold in London on 29 November 1988 for £4,070,000 ($7,895,800).*

AT THE MOVIES

Ronald Varney

Proving once again the enchanting power of Hollywood, three old and unprepossessing objects – a book, a hat and a piano – stole the show during the December 1988 Collectors' Carrousel in New York. What made these objects so special and determined the extraordinary prices they commanded, was their association with three of the most popular films of all time.

The book was a 231-page screenplay: Clark Gable's personal presentation copy of the script for *Gone With the Wind.* In his most famous role, Gable played the rakish, dashing gunrunner Rhett Butler opposite Vivien Leigh's fiery Scarlett O'Hara. The special leather-bound copy of the script, embossed on the cover with Gable's name below the film's title, was dated 27 November 1937. It was illustrated with seventeen black and white photographs from the film, showing cast and crew behind the scenes of this spectacular production.

When *Gone With the Wind* was released in 1939 after three years of back-breaking production, the American press went into a prolonged swoon. Typical was *The Hollywood Spectator.* 'There are hills of velvety softness and warmly rich hues which roll back from the foreground action, sunshine sifting through trembling tree leaves, hoe armed men tilling the soil of tilted fields – a succession of Corots, Van Dycks, Rembrandts, serving as background across which a gripping story moves ...'

John Robshaw of Sotheby's with the Hollywood memorabilia.

Seventeen writers and four directors were used and discarded in the monumental task of translating Margaret Mitchell's 1,037-page novel into a screen epic. A bitter casting war was fought in Hollywood for the female lead of Scarlett, but the casting of Rhett was never really in doubt. The public wanted only one actor, Clark Gable. Acquiring his services, however, proved a daunting task for producer David O. Selznick.

Metro-Goldwyn-Mayer, the biggest and most prestigious studio in Hollywood at that time, had Gable locked tightly under exclusive contract and refused to release him to do the film. Selznick considered Ronald Coleman, Erroll Flynn and Gary Cooper for the role. But in the end he went to studio mogul Louis B. Mayer and cut one of the most legendary deals in the history of Hollywood. In return for Gable, Selznick gave MGM distribution rights for *Gone With the Wind* as well as 50 per cent of the film's profits.

Gable's copy of the script would almost certainly have been lost had he not given it away to an MGM secretary he was dating at the time. After holding on to this personal treasure for nearly fifty years, the former secretary contacted Sotheby's about consigning the script for sale. 'She sent me several

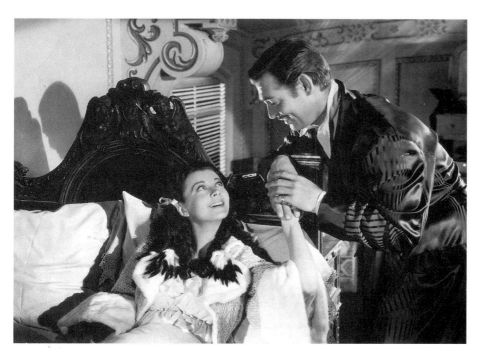

Clark Gable and Vivien Leigh starring in a scene from Gone With the Wind, *1937. Clark Gable's leather-bound copy of the movie script was sold in New York on 16 December 1988 for $77,000 (£40,104).*

photographs of herself and Clark Gable,' says Dana Hawkes, the Sotheby's Collectibles expert in New York, 'then she sent several newspaper articles which had appeared in Los Angeles recently which told the story of her relationship with Gable.' The saleroom buzzed with excitement as bidding on the Gable script quickly soared above its estimate of $4,000 to achieve $77,000.

The hat in the sale with its menacing circular brim and conical crown, measuring fourteen inches high and trailing a long, black, silk scarf, was worn by actress Margaret Hamilton in her unforgettable role as the Wicked Witch of the West in *The Wizard of Oz.*

This famous black hat dates from about the same time as the Gable script. The hat was made by the celebrated MGM Wardrobe Department, which created costumes for the film's cast of Munchkins, flying monkeys and other exotic creatures. In a departure from custom, the MGM Wardrobe Department neither purchased nor borrowed anything from stock – each and every costume in *The Wizard of Oz* was made expressly for the movie. The critics apparently did not appreciate this effort, saying the film had a gaudy, over-produced look about it. One critic wrote: 'It weighs like a pound of fruitcake soaking wet.'

After the filming, the Wicked Witch's Black Hat was sent to an MGM warehouse and forgotten. But in May 1970, after the studio had changed hands and the new owners needed to raise money to pay off an enormous debt, some 30,000 costumes and props, representing nearly fifty years of film-making, were sold at public auction in Los Angeles. During the 'Star Wardrobe' section of this eighteen day extravaganza, Dorothy's ruby slippers from *The Wizard of Oz* were sold for $15,000 while the Black Hat fetched $33,000.

The piano, painted crudely in green and beige, possessing only fifty-eight keys and standing a mere forty-two inches high, was the main prop from the famous Parisian flashback scenes in *Casablanca.* It was on this battered, almost child-sized piano that actor Dooley Wilson played and sang the haunting tune *As Time Goes By* to the lovers Humphrey Bogart and Ingrid Bergman. 'With the whole

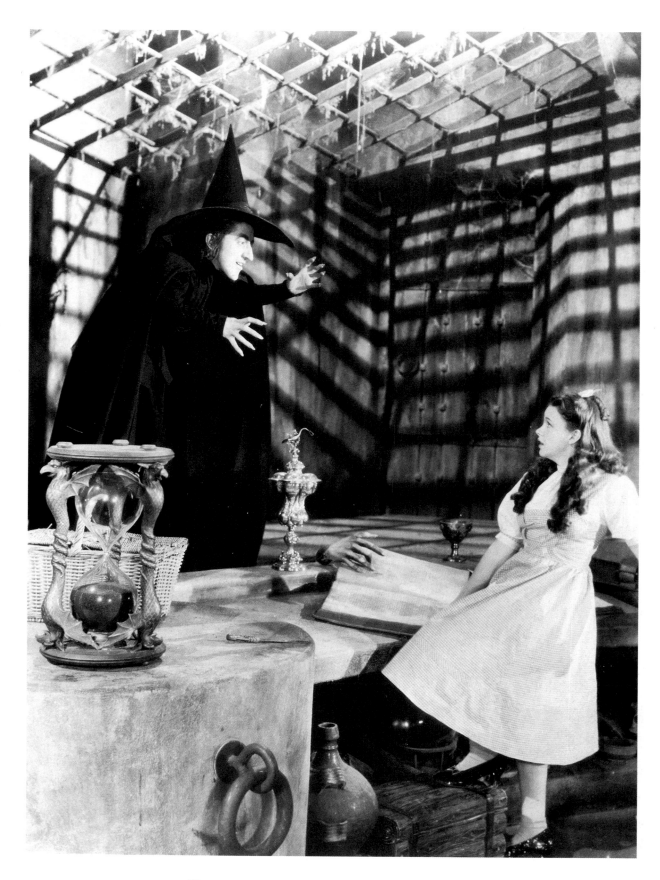

world crumbling we pick this time to fall in love' Ilsa sighs wistfully to Rick.

The *Casablanca* piano, like the Black Hat from *The Wizard of Oz*, narrowly escaped oblivion. The consignor, Dr Gary Milan, bought it from a prop house about seven years ago for less than $1,000 intending to use it for spare parts. But like a good detective playing a hunch, he stripped away several layers of paint and found a piano that looked familiar. His instincts were confirmed after research into the Warner Brothers' archives proved that his piano was the same one used in *Casablanca*.

Casablanca's enduring power was confirmed by the sale of lot 500: a 'standee' which was used to promote the film's premiere and illustrates the lovers Bergman and Bogart quickly sold for $7,000. Nine stemware glasses used as props in Rick's Café, doubled their estimate at $3,025.

During the spirited, at times furious, bidding for these pieces, an air of old-time movie nostalgia seemed to waft over the saleroom. It was as if some of the film-making magic from the Forties and Fifties – the days when musicals and melodramas were churned out week after week on the great sound stages and backlots of studios like Warner Brothers, Paramount and MGM – had briefly come back to life. Film historian David Shipman has written, 'It is extraordinary that material so artificial should become so holding and moving.'

Opposite:
The original hat worn by the Wicked Witch of the West in The Wizard of Oz, *MGM, 1939, 34cm high. Sold in New York on 16 December 1988 for $33,000 (£17,188).*

The piano and bench from the Paris scene in Casablanca, *Warner Bros, 1942–43, 106.7 by 102.3cm. Sold in New York on 16 December 1988 for $154,000 (£80,208).*

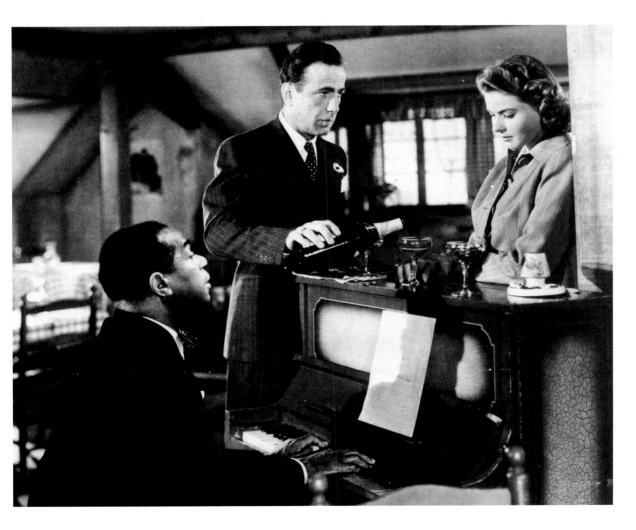

A New Dawn in Soviet Art

Matthew Cullerne Bown

The auction of avant-garde and contemporary Soviet art held by Sotheby's in July 1988 in Moscow, took place just over a year after the Soviet's own first attempt to sell the work of their young artists in this way. That event was vigorously conducted by a man who specialized in selling horses. Despite his charmingly forceful manner, many lots were unsold. Most people attending had no intention of buying: they were simply curious to see this unwonted commercial enterprise, taking place in a refurbished palace on Karl Marx Street. As a social event, however, it was a triumph: Raisa Gorbachev paid it a visit. Auctions had acquired *cachet*; it remained to make them effective.

Both the above-mentioned auction and that held by Sotheby's are clear signs that a new dawn is breaking in Soviet art, characterized by official tolerance of all sorts of styles and tendencies which were once opposed by the authorities. Pride is now taken in artists who were previously excluded from favour. The content of Sotheby's auction provided a concise overview of this movement. It allowed one to outline the descent and development of ideas from artists who emerged in the early 1960s to those who have begun to make a name in the 1980s.

In the years after Stalin's death in 1953, the Soviet art world polarized. The nonconformist, or unofficial artists who emerged made work that was resolutely opposed to the prevailing norms. The first coherent manifestation of nonconformism was an informal studio run in the late 1950s and early 1960s by Eli Belyutin in Moscow's Arbat. Belyutin was also a teacher at the Polygraphic Institute, a leading art school. Like so many pioneers of that time, he wore two hats, one official, the other unofficial, and in this way the cultural Establishment already began to lose the monolithic quality which Stalin had prized.

Two artists associated with Belyutin in those days were Ilya Kabakov and Vladimir Yankilevski, both now in their fifties. Yankilevski took part in the famous Manezh exhibition of 1962, where the sculptor Ernst Neizvestny and Mr Khruschev had a blazing row. Kabakov and Yankilevski typify the two main ways in which nonconformist artists strove to create an alternative to the unquestioning social enthusiasm of Soviet art of the period.

Yankilevski's work represents a withdrawal from overt social engagement in favour of spiritual contemplation. The core of his work over the last twenty-five years is a body of large triptychs. The complex interrelation of different parts of a painting helps Yankilevski present what he calls 'the simultaneity of various existential states in one work'. This presentation is always highly metaphorical, as close to surrealism as to simple narrative. Yankilevski's art seeks, ultimately, to transcend the

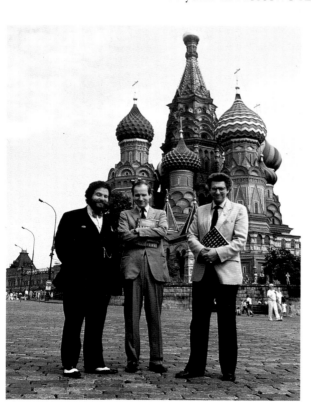

Lord Gowrie (Chairman), Simon de Pury (Deputy Chairman), and Peter Batkin (Deputy Director) standing in Red Square before Sotheby's first sale in Moscow.

intellect. This unites it with a recurrent mystic yearning in Russian art, originating with the tradition of icon-painting imported from Byzantium.

Other artists of Yankilevski's generation, such as Dimitri Plavinski and Vladimir Nemukhin, make work which demands an equally metaphorical reading. His influence can also be seen on younger artists. Evgeni Dybsky, like an icon-painter working with a template sanctified by usage, returns always to the landscape of the Crimea for inspiration. Dybsky's understanding of the spiritual mission of Russian art is combined with an awareness of the central tenet of Western Modernism, that of the canvas-as-object. This combination makes him one of the most highly developed of young Russian artists.

While the auction afforded a view of this meditative tendency in contemporary Russian art, it also presented the work of artists who have chosen to engage explicitly with the challenges posed by Communist ideology. Ilya Kabakov recognizes the demand, deeply rooted in Russian culture, for art which operates in an avowedly social context. He has chosen to use for his own ends some of the stereotypical means of expression which permeate Soviet visual art. Paradoxically, these very stereotypes – dry academic paint-handling, for example, and the combined use of image and text – are conventionally the vehicles for the kind of unsophisticated, but pervasive, proselytism which Kabakov is at such pains to counteract.

Kabakov also counters lack of sophistication. His utterances are Aesopian. He is an intellectual – a role he vindicates by the concerned and influential nature of his art. But for all his ceaseless attempt to define the nature of his relationship to the Soviet State, Kabakov's art draws on a reserve of simple human experience. He sometimes returns, for example, to his recollection of life in communal apartments during the 1950s as a source for the snatches of dialogue in his paintings. This enables him to avoid the dryness which must otherwise attach to such an astringent critique.

Many young artists are indebted to Kabakov. Vadim Zakharov contrives equally enigmatic, if less sedate, fragments of text, and seems to aspire to the same kind of oracular persona as Kabakov possesses. The exploitation by

The Answers of the Experimental Group by Ilya Kabakov, oil, alkit enamel and handwritten text in black ink on board, signed and dated, 147 by 370cm. Sold in Moscow on 7 July 1988 for £22,000 ($37,840).

53

*Grisha Bruskin standing
in front of his work in
Moscow's international
trade centre, the
Sovincentr.*

Kabakov, and spiritual *confrères* such as Erik Bulatov, of some of the clichés of Soviet art has paved the way for younger artists. Grisha Bruskin is ironically fired by the ubiquitous cheap statuary, expressing ideals of health, beauty and moral achievement, which peppered the Soviet Union during his childhood.

While Kabakov, Yankilevski and others represented one pole of Soviet art in the difficult decades of the 1960s and 1970s, the diametrically opposed ice-cap was beginning to thaw. The narrow boundaries of official art were being pushed wider and wider. The auction allowed us to see the work of some of the pioneers of this process, one which has continued to the point where, today, the old official-unofficial distinction is often difficult to justify.

The occasional figure, such as Ilya Tabenkin, already stood out in the 1960s as someone following his own lonely path. Born in 1914, he attended art school in Samarkand, that being where the Surikov Institute removed to during the War, and emerged from painting conventional realist pictures in the 1950s to create his own intimate, poignant world. Around 1970, Nataliya Nesterova, Tatiana Nazarenko and Arkadi Petrov were among those ambitious painters who found a way out of the thickets of academic technique and hackneyed subject-matter by turning to neglected aspects of the Russian artistic heritage. They were inspired variously by folk-art, serf-painting, popular religious imagery, and even, in Petrov's case, by the sentimental effusions of Russian kitsch.

All this bespeaks a self-absorption which is indeed one of the traits of Russian art, and has been ever since the ascetic manner of Byzantium arrived many centuries ago. Even so, artists in Moscow and Leningrad, in the so-called European part of Russia, are acutely aware of their cultural proximity to the West. They realize that much of their practice is coloured by what they have

Line *by Alexander Rodchenko, dated 1920 on the reverse, oil on canvas, 58.5 by 51 cm. Sold in Moscow on 7 July 1988 for £330,000 ($567,600).*

Opposite:
Composition *by Alexander Rodchenko, gouache on heavy paper, signed and dated '16, 27 by 20cm. Sold in Moscow on 7 July 1988 for £198,000 (($340,560).*

shared, at one time or another, with Europe, be it the academic technique of Socialist Realism or the striving towards abstraction in the Revolutionary period.

The movements of this period – Constructivism, Suprematism, Rayonism, Cubo-Futurism – are the best-known manifestations of Russian art in the West. This is understandable in view of the influence artists such as Malevich, Tatlin and Rodchenko have exerted on the development of Western art. The auction, by prefacing the sale of contemporary paintings with a selection of work by Rodchenko, Stepanova, Udaltsova and others, implicitly raised the question: what is the relationship of artists today to the art of the avant-garde?

All manner of artists owe it an obvious stylistic debt. Edward Steinberg is an excellent example (his father actually attended one of the VKhUTeMas, the revolutionary art schools of the 1920s). But even in his case it is clear that the debt to Suprematism is not acknowledged in the purely formal terms of, say, Frank Stella, but on a metaphorical level as well. The form of a cross, familiar from the work of Malevich, is re-invested in Steinberg's work with religious significance, as an element in his lament for the passing of traditional Russian village life.

However, for many artists the era of the avant-garde has a broader

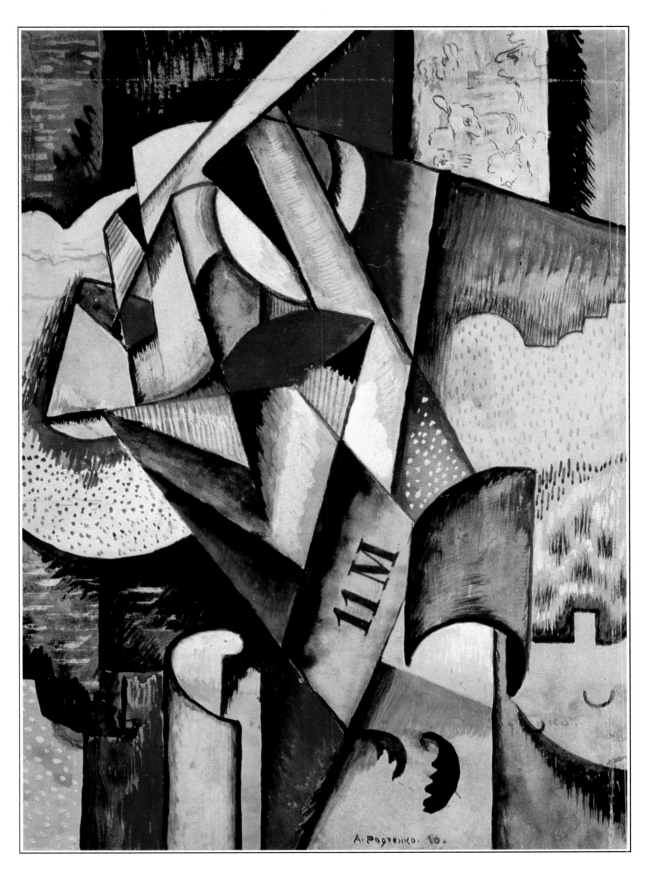

significance. It was an era of enormous creative vitality, of great idealism, a period when artistic and social ideas were bandied about with an adventurousness that has not been seen since. It was also the one time in their history when Soviet artists participated fully in the cultural life of Europe as a whole. The decade or so before Stalin's suffocating curtain began to fall is now widely extolled in the USSR as a Golden Age of Soviet art.

Vadim Zakharov is one of a number of young artists who perform collectively as the self-styled Club of Avant-Gardists. They attempt to animate the contemporary art-world with some of the anarchic energy of the Revolutionary period. Their performances are often extremely satirical at the expense of the Soviet government. In a similar vein, if one considers Sergei Shutov's exuberant paintings and installations in the light of the Soviet art-world's former ethical sobriety, they imply not only an artistic, but a social iconoclasm, a challenge to moral austerity.

Developments today suggest that an age analogous to the 1920s, allowing creativity to burgeon in an international context, could come again to Soviet art after a hiatus of more than half a century. As far as one or two artists of the older generation are concerned, notable among them Ivan Chuikov, an internationalist instinct, a peculiarly Western flavour of artistic ideas, has always been cherished. But it is the younger generation, artists such as Irina Nakhova, Svetlana Kopystianskaya and her husband Igor and Sergei Volkov, who seem most emphatically to demand an international arena for their work. The auction was a landmark on the road taking Soviet art in that direction.

Opposite:
Restored Painting: No 5 *by Igor Kopystiansky, signed and dated 1987, 195 by 155cm. Sold in Moscow on 7 July 1988 for £44,000 ($75,680).*

Fundamental Lexicon *by Grisha Bruskin, oil on thirty-two canvases, each signed, dated 1986 on the reverse, overall size 220 by 304cm. Sold in Moscow on 7 July 1988 for £242,000 ($416,240).*

A Gentleman from Baltimore

Susan Gerwe Tripp

During his lifetime, James Rawlings Herbert Boone became something of a legend in Baltimore. His grand house, Oak Hill, with the peacocks strutting on the lawn, was the home where he was born and died. The vision of a tall, elegant figure cloaked always in a cape while strolling the grounds, remains in the minds of those who knew Oak Hill in his day.

Built at the turn of the century, Oak Hill was surrounded by rolling landscape, punctuated by exquisite vistas and views that Mr Boone particularly enjoyed. Inside, the generously proportioned rooms held a wealth of treasures, pieces Mr Boone and his wife had inherited from their families and the fruits of their own fifty years of joint collecting. The collection formed by James R. Herbert Boone was dispersed in a series of auctions at Sotheby's New York and London, in the autumn of 1988.

After their marriage, Herbert Boone and his wife, Muriel Wurtz Dundas Boone, spent much of the 1930s abroad, based in London, and in Rome where they rented Villa Madama. During these travels they acquired the majority of the English and continental furniture and decorative works of art that they installed at Oak Hill. In the 1950s the Boones purchased a Hawaiian retreat and extended their collecting interests to Oriental art, assembling a substantial group of Chinese and Japanese porcelain, jades and Japanese prints. Oak Hill, however, remained their primary residence and by the time of Herbert Boone's death in 1983, it contained the best of the collection, including objects from the Boones' other houses.

Mr and Mrs Boone took enormous pride in their British ancestry and in many ways Oak Hill resembled an English country house. Family portraits, both inherited and acquired, hung throughout the house, and objects that evoked the Grand Tour covered tables and chimney-pieces. Naturally, the most important pieces were found in the principal rooms: the panelled central hall, the dining room, the library, the drawing room and the music room. No space, however, was overlooked. A fine collection of copper moulds hung in the kitchen and even the bathrooms had a special character, one set with Persian tiles, another with delft and a third with Japanese *imari*. The library reflected the Boones' wide-ranging interests in literature, history and art, and included several sets of John Gould's bird books handsomely bound in green morocco gilt. Religious pieces abounded in Oak Hill. Mr Boone was a devout Roman Catholic and he surrounded himself with crucifixes of every conceivable design; Italian silver and bronzes, Flemish ivories and South German staghorn. These were largely restricted to the family bedrooms but his broader interest in religious art was evident throughout the house. A Ming wood Bodhisattva rested in the library and a large blanc-de-chine figure of the goddess Guanyin greeted visitors in the entrance hall. Most exceptional are the three thirteenth-century Seljuk lustre-painted mihrab tiles from

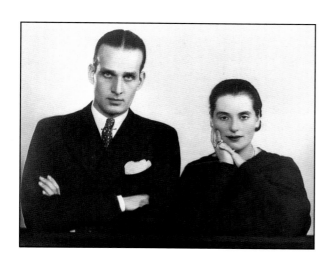

Mr and Mrs James R. Herbert Boone, circa *1930.*

Kashan with relief inscriptions from the Qur'an. Overall, the effect achieved throughout the house was one of richness and harmony.

Herbert Boone was always tenacious in the pursuit of desired objects. In 1935, for example, the Boones were alerted by a London gallery to the forthcoming sale of George Romney's portrait of *The Children of Charles Boone, Esq.* When they learned that the bid was not successful, the Boones called London from Rome to insist that the picture must be theirs. The Boones' agent tracked down the buyer, who ultimately agreed to part with the portrait and thereafter *Miss Boone and Master Boone* hung over the mantelpiece in the library at Oak Hill.

Herbert Boone graduated from the Johns Hopkins University in 1921 and at his death made the university the beneficiary of his estate. His appreciation of history, sensitivity to art and understanding of the significance of the written word led him to stipulate that his gift was to be devoted to the support of the Humanities. The proceeds from the sale of Oak Hill and its contents will be used to create The Herbert and Muriel Boone Endowment Fund for the Humanities. Herbert Boone's house and its contents, which were his passion and joy, have now passed into history, but the memory of Herbert Boone and his legacy of generosity will endure at the Johns Hopkins University forever.

The front Hall at Oak Hill, home of Mr and Mrs James R. Herbert Boone.

Overleaf:
Portrait of Philip Herbert, 4th Earl of Pembroke and 1st Earl of Montgomery *by Sir Anthony Van Dyck, oil on canvas, 133.5 by 108cm. Sold in London on 16 November 1988 for £462,000 ($877,800).*

61

The recent discovery of this unassuming little tea-bowl caused great excitement among connoisseurs of European porcelain. Signed and dated 1749, it is an important document for the pioneering achievements of the first decade at Vincennes.

The small porcelain works in the Château de Vincennes, started around 1738, began selling ceramics only a few years later. Rapidly proving a worthy rival to the Prussian Meissen and with considerable royal support, the factory moved to expensive new premises at Sèvres in 1756. Financial ruin directly resulted, ironically paving the way for an even more glorious future. The acquisition of the whole factory by Louis XV provided financial backing to support the impossibly high standards for which the factory was soon the envy of Europe.

Especially famous were the rich background colours and the quality of painting. The experiments of Jean-Jacques Bailly, Jean-Matthias Caillat, Pierre-Antoine-Henry Taunay and others in the mid to late 1740s led to the development of the famous *bleu céleste* and *rose pompadour* early in the following decade. As Erikson and De Bellaigue explain in their standard work *Sèvres Porcelain* (1987): 'Thanks to the interest in experimentation shown by a number of painters, the factory came relatively quickly to have at its disposal a large number of colours in many shades.' Tangible and dated proof of their palette is provided by a cup with colour samples, or *inventaire*, in the Musée National de Céramique at Sèvres, inscribed '*inventaire Fait ce 29 Août 1748. A Vincennes. Taunay fils*'.

The cup in the February sale was thus a second *inventaire*. It is divided into four lobes, one of which is signed '*Armand L'Ainée, ce 9 Juillet 1749*'. Armand has been identified as Louis-Denis Armand, the elder of two brothers at Vincennes bearing the same name. Recorded as a painter of birds and landscapes, he joined the factory in November 1745, having worked previously as a court painter on *vernis martin* furniture in the chinoiserie style.

The other three lobes of the tea-bowl are painted with patches of colour, each identified by a number, letter or verbal description. The gradations in the patches are almost certainly to test how colours hold together when shaded or laid on thickly.

The identifications were presumably for Armand's reference on his work bench, as a guide to what was available. The notations are also now of great potential interest in relating surviving porcelain to descriptions in the very full sales' and other records at the factory.

As Sèvres porcelain is date-coded, it should be possible to track pieces back to these documents, but they are not always consistent in their verbal descriptions of colour. The factory's coding system, on the other hand, also used in the records, is much more reliable. The coding on the tea-bowl may therefore prove a valuable bridge between the records and the objects.

A documentary Vincennes tea-bowl, signed Armand L'Ainée and dated 1749. Sold in London on 23 February 1988 for £19,800 ($36,828).

SCANDINAVIAN PAINTINGS

Alexander Apsis

One of the most rapidly developing areas in the art market is for ninteenth-century paintings. This may seem surprising as some of the most famous and sought after artists have for a long time been from this period, such as Monet, Renoir and Van Gogh. Both collectors and art historians, however, are beginning to discover that it is a much wider and more varied field than previously recognised. Schools that as recently as ten years ago were virtually unknown internationally, such as the Italian Macchiaioli and the school of Barcelona, have been the focus of ever increasing attention.

A dramatic example of this development has been the international growth of interest in nineteenth- and early twentieth-century Scandinavian paintings. It is difficult to believe that Sotheby's Sale of Danish Paintings in November 1984 was the first such sale ever organised outside Scandinavia. In 1987 Sotheby's organised its first Scandinavian paintings sale, again the first outside Scandinavia. As a result of the great success of this sale, and the increasing demand from international collectors, these sales have now become an annual event.

Sotheby's third such sale on 14 March 1989 was the most successful ever, with a number of world record prices being established. The star of the sale was Anders Zorn's watercolour, *In Scotland (Mrs Symons)*. Zorn was the most important Swedish artist at the turn of the century, comparable in style to the American John Singer Sargent and the Spaniard Joaquin Sorolla y Bastida. *In Scotland*, his finest watercolour to appear on the market in modern times, was sold for £902,000, a world record. An indication of how rapidly this market has developed is shown by the example of the history of another Zorn watercolour, *A portrait of Carl de Falbe with a Saint Bernard at Luton Hoo*. It sold for £12,000 at Sotheby's in 1979 and was sold again in Sotheby's, New York in October 1988 for $704,000.

The best Scandinavian pictures incorporate the principal elements of the most avant-garde paintings of their era, while at the same time having their own distinctive quality. Hugo Birger's *In the Garden* was a good example of how the international collector often has a different perspective from the local. *In the Garden* sold for £57,200 which seems extremely high when compared with his local prices in Sweden. The international collector, however, did not look at it as a painting by Hugo Birger but as an impressionistic work executed in Barbizon in 1878. When compared to similar French works the price appears extremely reasonable.

With works of all styles and subjects, ranging from the Neo-Classical to Cubism, and from flower still-lives to landscapes, portraits and genre scenes, Scandinavian paintings have a universal appeal. As more and more collectors become familiar with these works, the prospect is for an ever-growing interest in this relatively new collecting field.

Opposite:
In Scotland (Mrs Symons) *by Anders Zorn, 1887, signed watercolour, 100 by 66cm. Sold in London on 14 March 1989 for £902,000 ($1,650,660).*

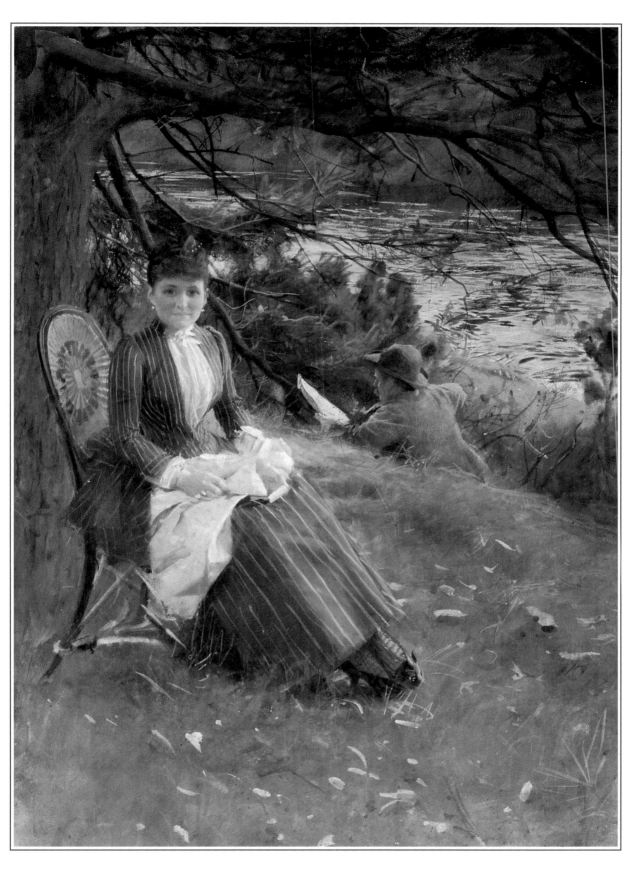

In the Garden *by Hugo Birger, signed and dated* Barbizon '78, *oil on canvas, 52 by 63cm. Sold in London on 14 March 1989 for £52,000 ($95,160).*

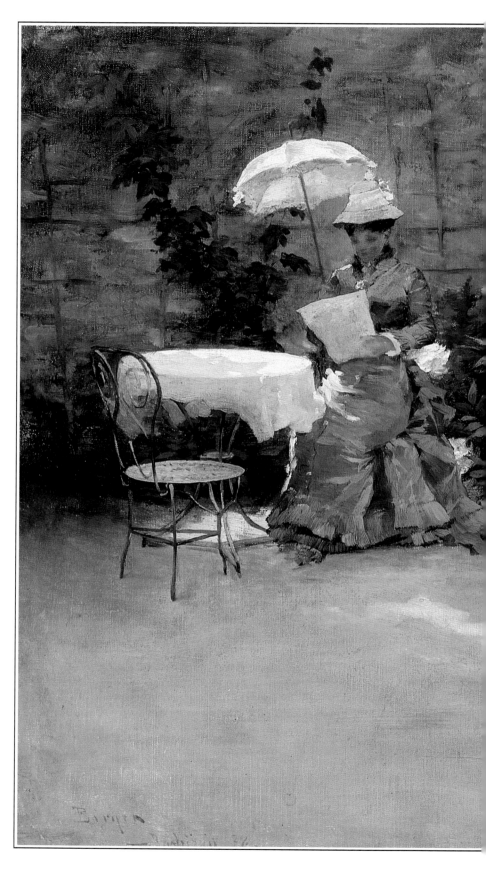

'MEN AT REST – FIRING STOPPED'

Mary-Jo Kline

A pencilled note on a slip of faded yellow paper, approximately 8 by 10 inches, captures the drama of one of the most famous events in American history. Robert E. Lee's surrender to Ulysses S. Grant at Appomattox Courthouse, Virginia on 9 April 1865 was a moment which marked the symbolic, if not the actual, end of the American Civil War. In his message, Lee requested a 'suspension of hostilities' until a formal surrender could be arranged. The page bears not only Lee's words but also an endorsement by General Edward O.C. Ord, Commander of the Northern Infantry: 'April 9th 11.55am the within read – acted on … men at rest – firing stopped.'

Lee's decision to surrender came after a desperate flight following the fall of the Confederate capital at Richmond on 2 April. Pursued by Union armies, Lee vainly sought a route of escape to the west. His last chance was to reach a rail line south of Appomattox Courthouse on 9 April, Palm Sunday. The arrival of Ord's infantry reinforcements that morning convinced Lee that his cause was hopeless and he sent word to Grant that he was ready to surrender.

It was nine o'clock in the morning when Lee dispatched his first message to Grant, but almost three hours passed before it was received. Long before Grant learned of his triumph, the news spread along the Confederate and Union lines. Flags of truce fluttered on both sides and the firing gradually died away. Unfortunately, neither Union nor Confederate field commanders were sure whether Lee's offer of surrender allowed any of them to declare a ceasefire. Lee's note to Grant had not mentioned a cessation of hostilities and Grant's whereabouts remained a mystery.

Daring cavalry officers like General Philip Sheridan and his protégé, George Armstrong Custer, were ready to renew the fight but after four years of leading footsoldiers to bloody battle, Ord was eager for an end to war. Fortunately, Ord outranked Sheridan and a temporary ceasefire came in the west and at the Union lines to the east commanded by George Meade. Lee, riding west to find Grant, learned of their reservations and prepared a second message to Grant that he would reassure them.

One copy of the request went east to Meade, the second was carried west to Ord. A two-hour ceasefire was declared and quiet descended over the battlefields as officers and men waited for some word from Grant. Although a messenger delivered Lee's original 'surrender' message to Grant on the road shortly before noon, two more hours elapsed before any Union general received Grant's authorization to declare a ceasefire. In the meanwhile, the 'suspension of hostilities' inspired by Lee's pencilled notes did its work. The men of the grandly named Armies of Northern Virginia, of 'The James' and of North Carolina were 'at rest'.

When Grant and Lee finally met in Wilmer McLean's house in Appomattox Courthouse shortly after two o'clock, that 'rest' became peace. Grant did not withdraw the generous terms that he had

The Surrender of General Lee, *19th century lithograph.*

extended the day before and Lee accepted them with grace and with gratitude. An hour and a half later, Lee rode back to his own lines to begin disbanding his army.

Another seven weeks passed before the last remnant of the Confederate armies surrendered, but the process of healing and reunification of the nation began on the morning of 9 April when men of good will on both sides turned their energies from war to peace.

The document that commemorates this event, the 'Ord' copy of Lee's note, came to auction through a combination of idiosyncratic military filing, family pride and archival detective work. Grant's wartime staff often saved original documents as souvenirs after sending 'true copies' to Washington for filing. General Meade's copy was duly forwarded to the War Department and was for many years proudly displayed in the 'Treasure Room' of the National Archives. Ord's copy, perhaps because of its 'Duplicate' heading, never found a place in official files and was later given to William Silliman Hillyer, a friend of Grant and one of his wartime aides.

The note remained among Hillyer's personal papers, which were deposited at the Alderman Library at the University of Virginia by his descendants in 1985. Once Ervin Jordan, the Civil War specialist at the library, had determined its authenticity and historical significance, the family decided to offer it for sale. The new owner is Malcolm Forbes, the famous American publisher and founder of the Forbes Collection, which includes many of the most important documents recording the events of American history, particularly those related to the Civil War.

The letter by Robert E. Lee, Commander of the Confederate Armies, requesting a "suspension of hostilities" to General Ulysses S. Grant, Commander of the Union Armies, dated 9 April 1865. Sold in New York on 26 October 1988 for $220,000 (£119,241).

MANET
AS CARICATURIST

This grotesque figure publicly described as Polichinelle, one of the least attractive characters of the commedia dell'arte, is in fact a caricature of Maréchal MacMahon, the despised President of France of the 1870s.

At the time, Manet's intentions were clearly understood since the government prohibited distribution of the issue of *Le Temps*, the publication in which the lithograph was to have appeared and much of the edition was destroyed.

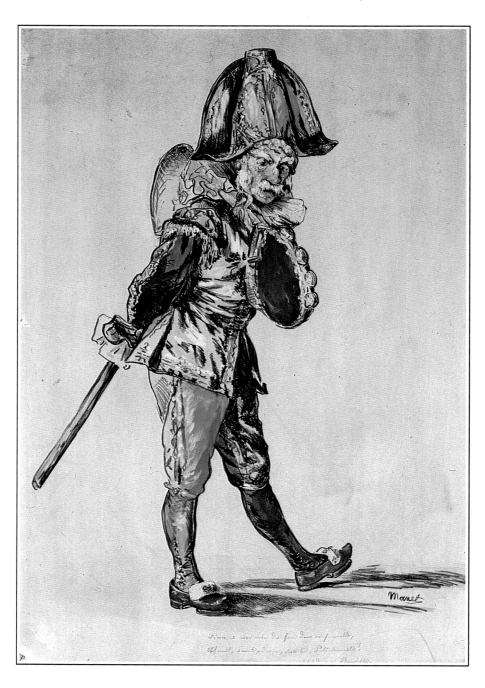

Polichinelle *by Edouard Manet, 1874, gouache and watercolour over lithograph in black, 48 by 32.4cm. Sold in New York on 13 May 1988 for $187,000 (£105,650).*

EIGHTEENTH-CENTURY FRENCH FURNITURE

Susan Morris

In eighteenth-century France, the art of furniture-making reached a pitch of excellence and sophistication which has not been surpassed since. This was partly because of enthusiastic royal patronage dating from the reign of Louis XIV. However, it was largely due to the rigid structure of the craftsmen's guilds which ensured a long and specialised apprenticeship and allowed a man to become a master of his craft. Not surprisingly, this furniture has commanded the market ever since. Sotheby's Sale of French Furniture in London in November 1988 included a group of exceptional pieces made for the French monarchy. Displaying all the innovative techniques and designs embraced by French furniture makers, the collection spanned a period from Louis XIV to the restoration of the Bourbon monarchy.

Although French furniture is today ascribed to individual craftsmen, pieces were frequently collaborations between several individuals. The skill lay in the harmony in which each man's contribution was assimilated into the piece. By the mid-eighteenth century *ébénistes* had over a hundred woods at their disposal from which to build up elaborate patterns.

From the late seventeenth century royal patronage was crucial to the development of French furniture. By the eighteenth century, however, aristocratic spending on luxury furniture was rivalled by that of the wealthy Paris bourgeoisie. Much of Louis XIV's furniture was of solid silver but was later melted down to pay for the king's disastrous military campaigns – reckoned in bullion value alone, the total melted down came to 2,505,637 *livres d'or.*

As the economy recovered, so too did royal extravagance: the rococo style flourished under Louis XV while the Court of Louis XVI favoured neo-classicism. Crown spending on furniture in the decade 1780–1790 was more than twice that of any previous decade. Marie-Antoinette was renowned for her insane profligacy with money, though there were, in fact, many to rival her. In the November sale, a royal console table made by Jean-Henri Riesener, for Marie-Antoinette's private apartment at Versailles in 1781, achieved a world record price of £1.6 million. Marie-Antoinette was particularly fond of the *cabinet-intérieur,* her refuge from the chill magnificence of the formal apartments. The majority of royal furniture was designed with an architectural setting in mind. In this room, the chimney-piece was of *griotte d'Italie* marble and the same material was used in the console table which stood under a pier glass opposite it.

The reputation of French *ébénistes* was so great that they attracted wealthy foreign buyers from all over the world, including commissions from the courts of Germany, Sweden and Russia. In 1784 Grand Duchess Maria Feodorovna and her husband, the future Emperor Paul I of Russia, travelled to Paris incognito as the Comte and Comtesse du Nord. During their stay they bought for the palace of

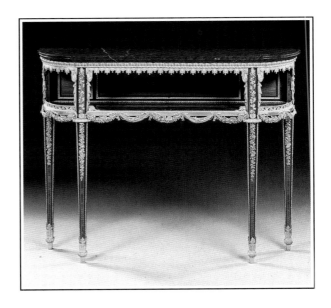

A Louis XVI console table by Jean-Henri Riesener for Marie-Antoinette's cabinet-intérieur *at Versailles in 1781, 86 by 111cm. Sold in London on 24/25 November 1988 for £1,650,000 ($3,184,500).*

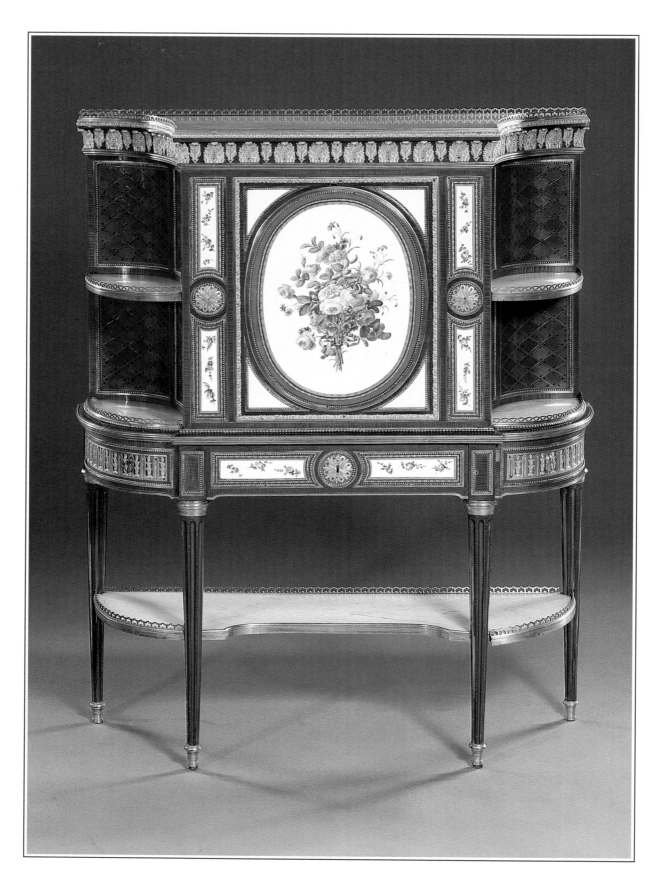

Pavlovsk an elegant Sèvres-mounted secretaire cabinet by Adam Weisweiler. Grand Duchess Maria purchased it from the *marchand-mercier* Daguerre, who also supplied furniture to the Court of Louis XVI. The cabinet remained in Russia until it was sold by the Soviet government to the firm of Duveen Brothers in the 1920s.

The *marchands-merciers* who rose to prominence during the last years of Louis 'XV's reign did not make furniture themselves. They did however greatly influence taste by orchestrating the services of top quality craftsmen in search of new styles and refinements. One development encouraged by the *marchands-merciers* was the decoration of furniture with soft-paste porcelain plaques – which were made in the royal manufactory at Sèvres. Daguerre had a virtual monopoly on buying Sèvres plaques to incorporate in furniture. These panels are used to exquisite effect in the Weisweiler cabinet.

The upheavals of the Revolution destroyed the demand for luxury furniture and although the void was filled by Napoleonic patronage, the disintegration of the guilds led to a relaxing of standards. However, even in the post-Napoleonic period, exceptional pieces of furniture could still be produced, like this gilt-bronze and glass chandelier by Claude Galle. At the time of Louis XVIII's restoration to the throne of France, he offered to the Garde Meuble de la Couronne a chandelier which corresponds in description to the one which was in the November sale. The blue lacquered metal globe, richly embellished with stars and the signs of the zodiac, was perhaps inspired by Montgolfier's hot-air balloon. Suspended from it is a glass fishbowl which can be filled with water and *Les petits poissons rouge dont le mouvement continu récrée l'oeil agréablement.* This technically accomplished, whimsical ensemble, which was exhibited at the Exposition des Produits d'Industrie Française in 1819, suggests that French furniture had lost none of its inventiveness or excellence.

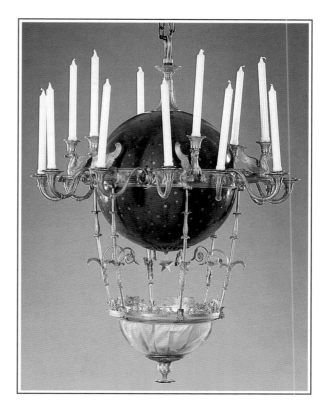

A Restauration *gilt-bronze,* tôle peinte *and glass chandelier,* circa *1819, 110cm. Sold in London on 24/25 November 1988 for £275,000 ($530,750).*

Opposite:
A Louis XVI Sèvres, porcelain-mounted secrétaire cabinet stamped A Weisweiler, circa *1784, 127.5 by 102.5cm. Sold in London on 24/25 November 1988 for £990,000 ($1,910,700).*

IMAGES
OF NAPOLEON

Lynn Stowell Pearson

One of the greatest military geniuses in history, Napoleon Bonaparte, fascinated artists throughout the nineteenth century. His campaigns provided compelling images of a fearless ruler leading his troops into battle as well as dramatic landscapes, exotic architecture and colourful costumes.

Today, Napoleon continues to fascinate collectors and there were many eager bidders for the diverse group of nineteenth-century Napoleonic paintings and sculpture offered in New York in February 1989. This 'Napoleonic event' also included a screening of Abel Gance's epic film *Napoleon*.

During his reign, Napoleon set the standards by which artists were to represent him, choosing the iconography of ancient Rome and commissioning artists like Jacques Louis David to glorify his achievements. In David's famous work *Napoleon at the Saint Bernard Pass* (now in the Château Rueil-Malmaison), Napoleon rides a dashing white horse reared up on its hind legs, just like the equestrian portraits of victorious Roman generals. In fact, Napoleon crossed the Alps on a mule.

Soon after his banishment to St Helena, the legend of Napoleon grew, fed in part by those who had followed him into exile, as narratives, notes and memoirs were published. Encouraging their endeavours, Napoleon reinterpreted his career, telling them what he wanted the world to hear. He soon claimed to be a champion of equality and liberty, insisting that his autocracy was merely a temporary necessity, justified by the dangers of civil war. Napoleon implied that he was forced, despite himself, to conquer Europe and that it was merely his enemies who blamed his wars on ambition.

In his will, Napoleon contributed to his own legacy when he stated, 'I die in the apostolic and Roman religion in which I was born ... I desire that my ashes should repose on the banks of the Seine in the midst of the French people whom I have loved so much ... [my son] must adopt my motto: "Everything for the French people"'.

The Napoleonic revival began as early as 1840, when Napoleon's body was returned to France and buried with pomp and ceremony at Les Invalides in Paris. Nearly a million spectators lined the Champs Elysées to catch a glimpse of the coffin. During the Second Empire, Napoleon III, in an effort to legitimize his own reign, commissioned artists to memorialize the great events of his uncle's career. As properly trained academic artists, they sought journalistic accuracy in charting Napoleon's successes, but in many cases they altered details or places and incorporated iconography associated with other heroes to show him to best advantage.

Most of the paintings in the February sale presented a positive view, like *Napoleon's Entry into Cairo* by Gustave Bourgain, which depicts his triumphant arrival on 25 June 1798, after a decisive victory in the Battle of the Pyramids. Here, the artist uses iconography associated with earlier heroes: Napoleon is offered palm branches, just as Christ was when he entered Jerusalem; several Egyptians kneel before their new leader, like the conquered barbarians who offered themselves to the victorious Roman emperor recorded on the Column of Trajan.

Napoleon Watching the Battle of Friedland by James A. Walker, shows him

Opposite:
Napoleon's Entry into Cairo *by Gustave Bourgain, 1884, oil on canvas, 150 by 120.6cm. Sold in New York on 22 February 1989 for $99,000 (£53,514).*

surveying his troops in action. The Battle of Friedland on 14 June 1807, was a great victory for Napoleon, who pitted 65,000 of his troops against a combined Russian and Prussian army of 83,000. In Walker's painting, the entire scene was organized to focus attention on the General. He is depicted overlooking his troops from a ridge and sitting high on his white horse apart from the rest of his generals.

Battle scenes did not provide the only drama. Laslett John Pott depicted what has been described as Napoleon's most difficult decision – *Napoleon's Farewell to Josephine, 'My Destiny and France Demand It'*. The artist chose the moment of Napoleon's and Josephine's separation on the evening of 30 November 1809. In order to legitimize his reign and establish its royal permanency, Napoleon divorced Josephine who was unable to bear him a child. He later married Archduchess Marie Louise of Austria who bore him a son. Once again the artist has evoked the greater glory of Rome – above Josephine is a bust of Napoleon, who, like the illustrious Roman emperors before him, is crowned with laurel leaves.

Moments of weakness and defeat, Napoleon's despair after the Battle of Waterloo and his sorrow when leaving for Elba, were not ignored. Unlike the many works which glorify Napoleon, François Flameng's *Napoleon After the Battle of Waterloo* is an unflattering portrait. Here he is shown as a broken man, at a Belgian inn on his retreat to Paris after losing the famous battle on 18 June 1815. The room is cold and dreary, the big open fireplace is empty; the room's only light source is a single dwindling candle. Napoleon sits forlornly at a table which isolates him from a group of aides and onlookers.

Remembered today for his military exploits, Napoleon was eulogized shortly after his death by Talleyrand, who said, 'His career is the most extraordinary that has occurred for one thousand years … he was certainly a great, an extraordinary man, nearly as extraordinary in his qualities as in his career…'

Opposite:
Napoleon's Farewell to Josephine, "My Destiny and France Demand It" *by Laslett John Pott, RBA, oil on canvas, 133.3 by 93.3cm. Sold in New York 22 February 1989 for $60,500 (£32,703).*

TRICK OR TREAT

Marsha Malinowski

By nine o'clock on the evening of 30 October 1938, radio listeners across America were convinced that Martians had landed and overpowered the National Guard in a small town in New Jersey. The nationwide panic that ensued was the result not of an actual invasion but of a riveting dramatisation of H.G Wells' *The War of the Worlds*.

Written by Howard Koch and produced and directed by Orson Welles, the programme was presented by the Mercury Theatre on the Air and broadcast by CBS. The performance began with the dance tunes of Ramon Raquello and his Orchestra at the Meridian Room in New York's Hotel Park Plaza. Thirty-five seconds later, the music was interrupted by the first of many special news bulletins from the imaginary Intercontinental Radio News. Carl Philips, an imaginary reporter, venturing out to Grovers Mill, New Jersey, reported that what he saw before his eyes was not a meteorite but an unidentified flying object. On site, Philips provided his listeners with the most startling of reports:

'Ladies and gentlemen, this is the most terrifying thing I have ever witnessed … wait a minute someone's crawling out of the top! Someone or … something. I can see peering out of that black hole two luminous disks … are they eyes? It might be … [Shout of awe from the crowd] Good heavens, something's wriggling out of the shadow like a grey snake. Now it's another one and another. They look like tentacles to me. There I can see the thing's body. It's large as a bear and glistens like wet leather. But that face. It … it's indescribable. The eyes are black and gleam like a serpent. The mouth is V-shaped with saliva dripping from its rimless lips that seem to quiver and pulsate …'

And so the broadcast continued on with increasingly dramatic bulletins interrupting the music of Ramon Raquello and his Orchestra. Orson Welles played the part of Professor Pierson, the erudite astronomer from Princeton University who was called upon to explain 'scientifically' the bizarre sequence of events taking place at Grovers Mill.

The next morning Welles was denounced on the front page of the *New York Times* as the perpetrator of an elaborate Halloween hoax that had panicked the nation. The furore which persisted caused the Federal Communications Commission to enact regulations to ensure that no such programme could be broadcast without it being absolutely clear that it was fiction.

Last Halloween, the hamlet of Grovers Mill was in the news once again, celebrating the fiftieth anniversary of the broadcast. The final celebration was the December sale at Sotheby's New York, of the only surviving script of the programme. Howard Koch had retained the final working draft, amended by CBS censors attempting to curb the realism of the piece, and further annotated by Welles himself. This record of one of the greatest pranks of the twentieth century was purchased by an American private collector for $143,000.

Original radio play typescript of The War of the Worlds, *1938, written by Howard Koch, adapted from H. G. Wells. Sold in New York on 14 December 1988 for $143,000 (£73,333).*

Below:
Orson Welles directing a rehearsal of Mercury Theatre on the Air.

COLLECTING
AS AN ADVENTURE

Catherine Chester

When Elton John left his house in Windsor for a six-week recording session in the United States, he told Sotheby's he would like the house to be empty when he returned.

'Really empty?' they asked.

'Really empty,' he replied.

So Sotheby's gathered the glass by Gallé and Lalique, the extensive collection of furniture by Bugatti, paintings by Picasso and Magritte, mink framed spectacles, the sculptures both art deco and nouveau, the outrageous stage costumes, the jewellery and the Tiffany lamps. Three days later the Sotheby's team of experts left the house. It was quite bare but for his grand piano, his favourite paintings by Francis Bacon and Magritte and his prized collection of Spike Milligan 'Goon' scripts. Not exactly the action of a sentimentalist which Elton John unashamedly is. He once admitted that trying to decide whether or not to get rid of a 1970s T-shirt plunged him into a crisis of conscience.

So why did he decide to purge his home of this highly idiosyncratic collection? Elton John, born Reginald Kenneth Dwight in 1948 in Pinner, Middlesex, had, it seemed, decided to reconstruct his image and the Sotheby's sale appeared to be a public demonstration of that. The modest early success of the singer, songwriter and pianist in the Sixties grew to global celebrity and to an increasingly flamboyant style in his music, attire and taste in interior decoration.

It did, he admits, take three years to decide finally to take the step to empty his house. 'It was time to make our house into a home to live in. There was so much stuff it was like walking into a warehouse. All the possessions in the house made me feel like Citizen Kane.

Elton John likened the sale of his collection to the experience of taking a cleansing shower or 'watching his own death'. For Sotheby's it was one of the most ambitious international productions since the $25 million Andy Warhol auction in New York in April. 'It was all a bit vague at first and rather intriguing,' said Lord Gowrie, Chairman of Sotheby's (UK, Europe and the Far East). 'Then you went to the house and all became clear. It was not a shortage of money which prompted him to sell but a serious shortage of somewhere to sit. He had literally to hack his way up to bed.'

Elton John and Lord Gowrie met for the first time ten years ago when Lord Gowrie was a private dealer in contemporary art. He sold Elton John an important Francis Bacon portrait and this was one of the things he advised him to hold back from the sale. 'Such attics cleared of me! Such absences.' Lord Gowrie, the former Arts Minister under Mrs Thatcher, quotes Philip Larkin in attempting to explain the motives behind Elton John's clear-out. 'Collections, you know, are incredibly determining. They determine what curtains or carpets you have or how you decorate your pool room or den. I think Elton was looking for a different ambience, a different environment in which to live. To you or me or lesser mortals than Elton, it's the equivalent of clearing out the attic.'

Over the years Elton John put together one of the finest collections of recorded music in private hands, a fact which was much publicised. However, few people, were previously aware of the existence of Elton John the collector, filling his house with a positively weird assortment of art objects.

Opposite:
A visitor to the exhibition of the Elton John Collection in Sotheby's salerooms in London.

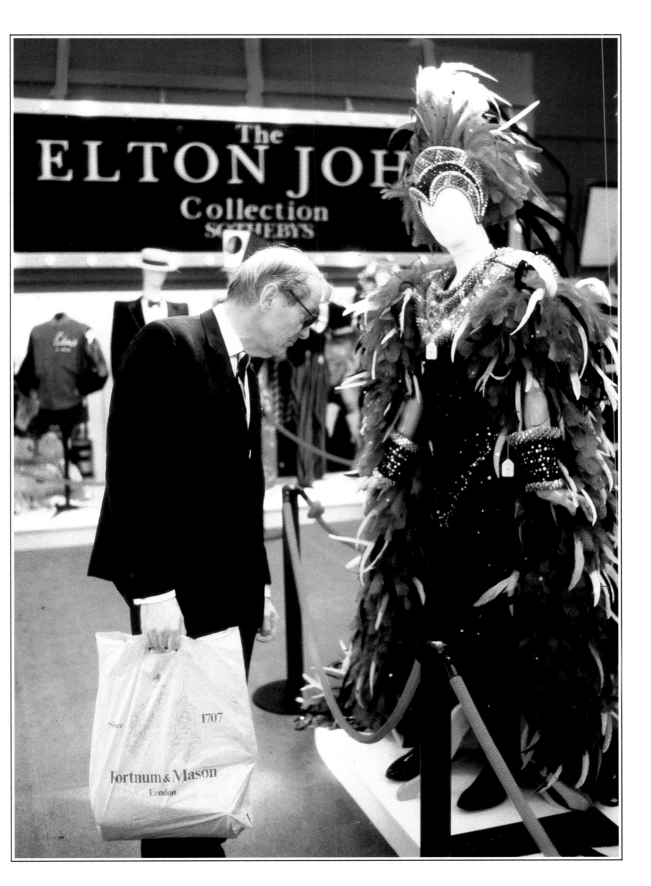

Edward Heath at the exhibition of the Elton John Collection in London.

Green Table *by Allen Jones, painted fibreglass, glass and leather accessories, 61 by 83.8 by 144.8cm. Sold in London on 8/9 September 1988 for £20,900 ($35,740).*

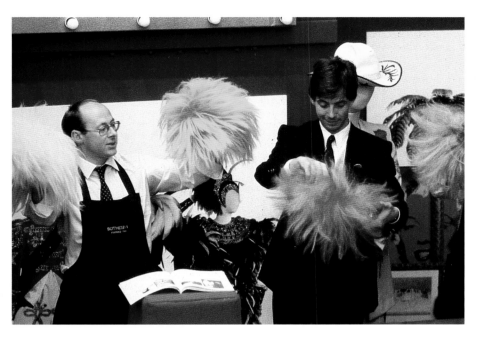

Elton John's spectacular collection of wigs (left) and glasses (below centre) about to go under the hammer.

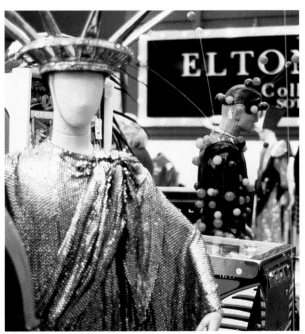

A selection of Elton John's stage costumes.

Exhibits from the Elton John Collection.

According to Elton John's art agent, Robert Key, it was not a 'collection' in any disciplined sense; it was an assemblage, a magpie's nest piled high with glamour and glitz. 'I can find something to buy anywhere in the world,' he boasts, 'and I suffered from shipping disease. Only I could buy a tram in Melbourne and have it shipped home. Then of course a lot of pieces were bought at auctions which I never went to because otherwise my hand would have been permanently up. I've always bought instinctively irrespective of whether it was a good investment. For instance, occasionally somebody might say, there is an important sale of Picasso's – you should go and buy one of them. I don't think there's much fun in that. When I first started collecting, the best investment was stamps because there was no duty on them. I can't think of anything more boring than going in and out of the country with stamps in my pocket. I never knew what I was going to buy before I bought it. Buying at auction was like an adventure. I bought on impulse. I live my life on impulse.'

Elton John claims that his hunger for unusual possessions stemmed from a lonely childhood. 'As a kid I grew up with possessions rather than friends. When I began to make money, I just bought things that I liked. But everything that I collected, the memorabilia and the art which I had liked and enjoyed has now begun to suffocate me. It sounds weird but I wanted to get rid of a little Elton in my life and everything that he had become. I began to feel like a caricature of myself. The Mozart look was okay, the punk thing was fun but after a while I felt like Tina Turner's granny. There comes a point where it doesn't seem

graceful anymore. I still want to play music but I don't want to be a Donald Duck while I'm doing it. I'm simply past sequins and feather. You need a sense of humour to wear a huge bunch of satin bananas,' he claims, 'and you need a sense of proportion to know when to wave them goodbye.'

'A psychiatrist's dream' is how he describes his Lurex cat-suits, Wurlitzer organs and glitzy glasses. 'I began wearing glasses when I was thirteen to copy Buddy Holly, after eighteen months I found I couldn't see without them.

'The clothes thing', he once declared, was very him psychologically speaking. 'Because I was always very fat when I was young, I had to buy clothes which were awful. When you're fat you can't buy nice clothes. I couldn't compete with the Bowies or the Jaggers, I hadn't the figure, I'd look like Donald Dumpling. Consequently, I went for the outrageous.'

The best of the Elton John collection toured the world and met with a reverence worthy of Chaucerian relics. From Tokyo to New York and Los Angeles to Sydney, crowds gathered to pay homage to the possessions of a pop star idol. When the artefacts returned, highlights from the collection were exhibited at the Victoria & Albert Museum. It was the first time that a Sotheby's auction has been previewed at a national museum.

On the first day of the three-day auction, enthusiasts came from all over the world to buy pieces from the Rocket Man's colourful past. The world's press and television congregated to witness the pop star's property selling at £1,500 a minute in one of the most outrageous auctions Sotheby's has ever staged. Six hundred bidders with seats reserved several months before the auction, sat in six galleries linked by closed circuit TV. Telephone lines from the USA, Japan, Australia and throughout Europe were kept open and a computerised scoreboard over the auctioneer's head converted bids into the world's major currencies. Elton John's fans with modest funds sat alongside auction room veterans eager to spend. Lawyers representing rock celebrities were poised by telephones in cities worldwide. Even Elton's parents had a friend in the New Bond Street auction room to buy a slice of their son's flamboyant past.

One of the happiest buyers was Stephen Griegs who bought the Pinball Wizard boots which Elton wore in the rock opera film *Tommy*. The boots were expected to fetch £1,200 but Stephen, a director of the firm which makes Doc Martens jubilantly splashed out £11,000. Another happy spender was Warwick Stone, owner of the Hard Rock Café chain who stayed in Hollywood while his representative spent more than £65,000 on just twenty-eight items. One of them was lot 269 – a pair of Elton John illuminated novelty spectacles. They were expected to fetch a mere £800 but Mr Stone paid £9,000. Afterwards he admitted: 'I didn't expect to spend so much on the glasses but they were the best item in the catalogue and indelibly Elton.' Other spectacles were bought by a Bond Street optician.

Stone's rival Jimmy Velvet, who is setting up the Super Star's Hall of Fame Café chain was equally pleased with his afternoon's purchases. He spent £47,000 on eleven stage costumes to decorate his restaurants in Orlando, Nashville and Memphis.

A representative of Cartier attended, buying back the company's own products including a jade lapis lazuli and royal blue enamel cigarette box for £30,200 against an estimate of £8,000. The British contingent included a white-haired lady in her eighties who bid £3,600 for a pair of silver leather platform boots with six-inch leather heels. The boots finally went to the United States for £4,950.

An assortment of artefacts from the Elton John Collection.

BEAUTY AND THE BEAST

Dr Susan Wharton

On 18 January 1989, at a modest ceremony in Geneva, a collection of twelve letters by one of Russia's greatest poets, Alexander Pushkin, was handed over to the Soviet Deputy Minister of Culture by Simon de Pury, Deputy Chairman of Sotheby's. Through the intermediary of Sotheby's, the Ministry purchased the letters with some of its commission from Sotheby's first auction in the Soviet Union, which took place in July 1987. The letters, once in the collection of Grand Duke Michael, were acquired by Serge Diaghilev and on his death in 1929 passed to his executor, the dancer Serge Lifar. Lifar himself had settled the duty payable on Diaghilev's estate and it had always been his intention that the letters should one day return to Russia. Sadly he did not live to see his wish fulfilled. The proceeds from the sale of these letters will be used to fund the Prix Lifar, an annual prize to be awarded to further the career of a talented dancer.

Autograph letters by Pushkin are of the greatest rarity and the acquisition of such a collection as this is an event of enormous cultural importance for the Soviet Union. The letters are addressed to Pushkin's fiancée Natalia Gontcharova, one of the most beautiful Russian women of her day and to her mother, with whom Pushkin did not get on. After much hesitation on the part of Natalia's mother, who had hoped to find a rich husband for her daughter, Natalia and Pushkin were formally betrothed on 6 May 1830. In September that year Pushkin travelled to his family's estates in Boldino, central Russia, expecting to stay only a few days, in order to conclude some financial business concerning his forthcoming marriage. Instead, an epidemic of cholera kept him in quarantine for three months.

The letters are written during this epidemic and bear the marks of the disinfection process which was used at the time on letters arriving from infected areas. They convey vividly Pushkin's frustration at being unable to rejoin his beloved in Moscow. His isolation and the difficulty of communicating with Natalia, inevitably lead him to wonder whether she still loves him and whether her mother has turned her against him. The series of obstacles placed in the way of their marriage by Natalia's mother lead him to despair of their marriage ever taking place. Moscow wits, who were laying bets on whether the ceremony would ever take place, dubbed it 'the wedding of Beauty and the Beast'. They were, however, finally married in February 1831.

Natalia soon became the toast of fashionable society, attracting the attention of the Tsar himself and Pushkin constantly warned her about flirting. Tragedy finally struck when the attentions of a handsome officer, Georges d'Anthes, became too obtrusive for Pushkin to bear. He challenged d'Anthes to a duel. Both were wounded, but Pushkin's wound proved fatal. His wife did not attend his funeral and for a short time became the Tsar's mistress.

Despite Pushkin's emotional anxieties, his three months in Boldino turned out to be one of the most productive periods of his life from a literary point of view. During that time he wrote five short stories, a verse tale, four short tragedies and the final chapter of *Eugene Onegin*. By coincidence, a fine letter by Pushkin, also in French, written in 1830 to the director of the Moscow Theatre, was sold at Sotheby's, London in November 1988 for £33,000.

A portrait of Pushkin by A. O. Kiprensky, 1827.

Chambellan,

Je viens de recevoir une lettre de l'Agostini (le directeur du théatre de Moscou). Il me dit qu'il serait charmé de vous avoir à Moscou — mais qu'il ne peut vous proposer que les conditions que nous avons acceptées à Petersbourg — C'est une rivalité de capitales. Je suis fâché, Monsieur, que mon intervention n'ait pas produit un meilleur effet.

Je vous salue de tout mon cœur.

A. Pouchkine

20 juillet
(1834.)

SALE IN THE FORBIDDEN CITY

In the summer of 1988, Sotheby's became the first auction house to hold a sale in the People's Republic of China. Proceeds from this historic auction of Chinese and Western contemporary art were donated to help restoration works on both the Great Wall of China and the City of Venice. The sale took place in the Hall of Ancestors in the Forbidden City – the culmination of a four-day programme of cultural and social events, including luncheon in the Summer Palace and a Venetian masked ball.

It was conducted in Chinese currency, the yuan, and realised £274,000 (1,805,300 yuan). Items in the sale included works donated by internationally known artists, galleries and Parisian couturiers and design houses. Arman's untitled contribution to the sale – pieces of a violin and cello on board had been created the night before the sale in the Great Hall of the People to the sound of Beethoven's Quartet No. 15 played by a Chinese string quartet.

The work by César, also created specially for the sale, was *Compression of Chinese Flags* which after competitive bidding was bought by a Chinese collector. One of the more exotic pieces to be sold was a Hermès saddle of blue suede. Covered with printed silk it depicted the Venetian explorer Marco Polo, whose achievement in setting up the first trade routes between China and the West, inspired the design.

Untitled *by Arman, 1988, pieces of violin and cello on board. Sold in Beijing on 5 June 1988 for 230,000 yuan (£34,748; $63,241).*

CAMILLE

Dans la Prairie, a picture of the artist's wife, painted in the summer of 1876 in the meadows near Monet's home in Argenteuil, achieved £7 million over its estimate to make it at £14.3 million the third highest price paid for a picture at auction and a record price for an Impressionist. The crowd in the packed saleroom sat in tense silence for seven minutes as bids came in from opposite ends of the world via the telephone.

The paintings of 1876, one of Monet's most productive periods of artistic achievement, are mainly centred around his family and reflect a quality of peace and contentment. His life was further enhanced by his growing financial success, with regular sales to friends and patrons. Monet, his wife Camille and son Jean moved to Argenteuil in 1871, a small town close to Paris, perhaps on the recommendation of his friend Edouard Manet. His decision to leave Paris in 1871 was largely taken to avoid the tremendous changes and rebuilding going on in the city, following the Franco-Prussian War.

The paintings of this period, as exemplified by this work, are full of colour and light and can be seen as the culmination of his full Impressionist style. In June 1876 Monet wrote to one of his patrons, Georges de Bellio, explaining that he was painting 'a whole series of rather interesting new things'. In previous years while at Argenteuil, Monet had painted many scenes of the town, the streets, the houses, the river and the bridges, but by 1876 Argenteuil was undergoing more and more industrial and suburban development. This was probably the reason he spent more time painting on his own property.

His wife was the principal subject of these pictures: he painted her seated in their garden, reading in a meadow or carrying a parasol to shield herself from the summer sun. While these are intimate pictures, what Monet really wanted to achieve was the harmony of the figure and nature. This is clearly to be seen in *Dans la Prairie*. He has submerged her in the wild grasses and flowers of the meadow. We only know that the figure is Camille because of her broadly painted, distinctive profile, her features fixed in an expression of passive tranquillity. As further evidence of his intentions, Monet did not mention Camille's name in the title of this and other pictures.

The painting was included in the Third Impressionist Exhibition which opened at 6 Rue le Peletier in Paris in April 1877. This was the first time the group of painters had exhibited their work using the then controversial word 'Impressionist'. The largest exhibitor was Monet, represented by thirty pictures, mostly painted in the previous year. From contemporary descriptions of the exhibition it is clear that the majority of the pictures had been put in white frames and were hung against dark walls. This spectacular exhibition showed the Impressionists in their full maturity and was hailed as an unqualified success.

George Rivière, a friend and early champion of the Impressionists, went almost overboard when he raved, 'What enchantment, what remarkable works, what masterpieces accumulated in the rooms of Le Peletier. Nowhere, nor at any other time, has such an exhibition been offered to the public'.

Dans la Prairie was bought before the exhibition by the critic, Théodore Duret, one of the earliest collectors and enthusiasts of Impressionist paintings.

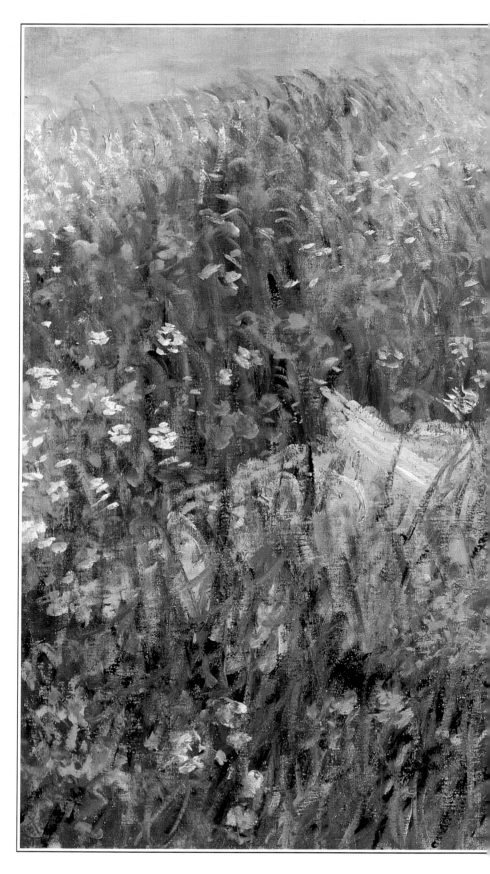

Dans la Prairie by Claude Monet, 1876, oil on canvas, 60 by 82cm. Sold in London on 28 June 1988 for £14,300,000 ($24,903,450).

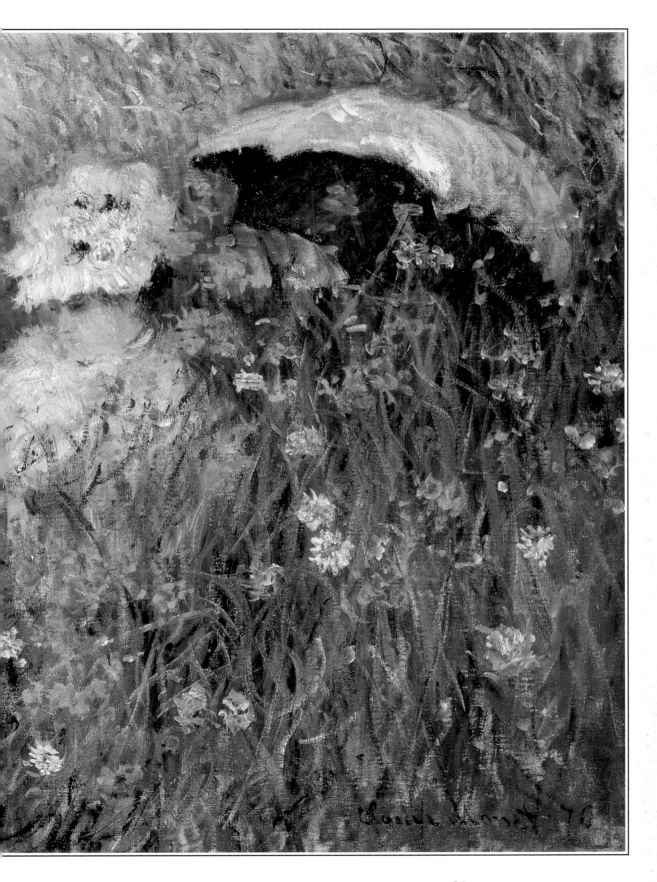

THE CAMERA
AND THE AVANT-GARDE

By its nature, photography is a medium for experimentation. This characteristic has never been more fully exploited than in the work of the avant-garde photographers of the Twenties and Thirties. It is, then, especially appropriate that an important private collection of their images was included in the New York sale which marked the 150th anniversary of the invention of the medium.

Convinced that photography was the medium that most fully embraced contemporary aesthetic explorations, these collectors especially sought out the images that extended the boundaries of such investigations. Each photographic work they chose explores facets of the 'New Vision' of the avant-garde during those two critical decades. The ninety photographs encompass work informed by the design tenets of the German *Bauhaus*, the subconscious explorations of the French Surrealists, and the industrial motifs of the New York Modernists. The visual vocabulary, including images constructed from geometrical volumes and unusual vantage points, experiments with typography and collage, glistening machine-forms, and the pure 'light abstractions' of photographs.

The images were selected from an art-historical perspective and consequently they are often by artists who worked in other media as well as in photography. The collection included works by Laszlo Moholy-Nagy, Man Ray, Charles Sheeler, Berenice Abbott, Werner Rohde, Walter Peterhans and Maurice

Toter Hase *by Walter Peterhans,* circa *1929, silver print, 21.5 by 23.5cm. Sold in New York on 26 April 1989 for $29,700 (£16,319).*

Untitled *by Maurice Tabard, 1930, photocollage, 30.5 by 23.5cm. Sold in New York on 26 April 1989 for $31,900 (£17,527).*

Untitled (Architectural Study) *by Walker Evans, 1929, 5.5 by 3cm. Sold in New York on 26 April 1989 for $3,570 (£1,962).*

Tabard. In his still-life *Toter Hase* of *circa* 1929, Bauhaus photographer Peterhans combined contradictory textures and materials under a brilliant light to an effect of poetic delicacy. By contrast, Tabard's rare, *Untitled* photocollage of 1930 has an aggressive edge, incorporating both Surrealist and Dadaist elements. Tabard is known for the ingenious effects he achieved by the simplest of means. Here portions of two portraits have been juxtaposed, with an orange triangle added over the mouth to produce a startling image. In a different vein altogether are Evans's view of the *Untitled (Architectural Study)*, and Sheeler's image of the Savoy-Plaza Hotel, which exalt the pure and impersonal geometry of the city.

The sale realised over $330,000, establishing a new world record for any private collection of photographs sold at auction.

TOPAZ

Lynn Stowell Pearson

This painting was originally given a nominal value in the inventory of the paintings from the Estate of Lillian Bostwick Phipps. This is not surprising since the painting would appear to be unsigned. Examining the work at Sotheby's, Nancy Harrison, Director of the Nineteenth-Century European Paintings Department, recognized a stylized cluster of leaves, a classical motif called an anthemion, in the lower right-hand corner. The anthemion was the 'signature' of Albert Joseph Moore and further research revealed the painting to be *Topaz*, the artist's chief work of 1870. Correctly identified, the painting achieved a record price for the artist of $715,000 in May 1988.

In his work, Moore frequently incorporated both classical and decorative elements. *Topaz* is a very characteristic example, depicting two draped maidens against the backdrop of an exquisitely embroidered curtain. Inspired by classical Greek sculpture, these women evoke a moment from antiquity as they stand barefoot 'in pale silvery green robes with caps of gentle pink'. Moore first became interested in ancient art when he travelled to Rome in 1859. Back in England, he scrutinized the Elgin Marbles at the British Museum and many of the faces, poses and draperies of his earlier pictures are directly copied from those figures.

At about the same time, he was attracted to the aesthetic movement, and began producing designs for fabric, wallpaper, tiles and stained glass. This interest was reinforced by his friendship with Whistler whom he met in 1865. For the next five years the two painters worked together and their art developed along similar lines. Whistler introduced Moore to Japanese motifs and Moore reciprocated with Greek sculpture and terracottas. As a result, Moore's palette became lighter, his colours more delicate and he became more concerned with overall decorative effects and patterns. Whistler adapted classical draperies for his *Six Projects* and began using his famous W-shaped butterfly monogram shortly after Moore adopted the anthemion. By 1870, Whistler began to feel uneasy about the similarities in their work and abandoned classical subject matter to focus on the 'here and now'. Moore, on the other hand, painted Grecian figures for the rest of his life.

The two men remained good friends and Moore continued to explore the theory that a painting should be, in Whistler's words, 'an arrangement of line, form and colour'. This principle is perfectly expressed in *Topaz*, a delicious combination of aesthetic elements that is essentially without a subject. Uninterested in narrative content, Moore was reluctant even to title his paintings. 'You can call it what you like', he told one patron. If he did choose a title, he usually confined himself to one word. *Azaleas*, painted in 1868, is one of the first of his deliberately 'subjectless' paintings. Like *Beads* of 1875 and *Sapphires* of 1877, *Topaz* was named after a gemstone, an allusion to the necklace worn by one of the maidens.

Topaz by Albert Joseph Moore, 1879, oil on canvas, 91.4 by 43.2cm. Sold in New York on 24 May 1988 for $715,000 (£423,077).

IZNIK TILES

Professor John Carswell

A single Iznik tile of the type in the October sale would have aroused considerable interest, but the appearance of a complete set of eight was unprecedented. Such a series of tiles, bearing the names of Allah, Muhammad, the four Caliphs: Abu Bakr, Umar, Uthman and Ali, and the two sons of Ali and Fatima: Hasan and Husayn, represent the complete canon of early Islam. The sequence would have been used architecturally as a religious focus, probably inserted for maximum effect in the pendentives supporting the central dome of a mosque. Although the tiles were conceived as a set, they were not simply stamped out of a uniform mould; individual variations show that each tile with its scalloped frame was cut separately.

Similar sets of eight roundels with the same names of Allah, his Prophet and his immediate followers, are found in several buildings of the peak period of sixteenth-century Ottoman architecture in Istanbul, just at the end of Sultan Suleyman's reign. These buildings also share another feature in common, that they were the work of the most famous of Turkish architects, Sinan. The buildings include the tiled mosque of Rustem Pasha (1561), the great mosque in Istanbul dedicated to Sultan Süleyman himself (1550–1557) and the Selimiye mosque in Edirne (1569–1575), considered by many to be Sinan's masterpiece.

The question then arises as to which mosque might have been embellished with this remarkable series of calligraphic tiles. They are so distinguished in design that if they had still been *in situ* in this century, they would certainly have been recorded. Although no such building is known it must have been a structure of some importance, although fairly small in scale as the tiles are only

An 18th-century view of the Golden Horn and Palace of Topkapi Saray in Istanbul.

26.8cm in diameter. The date of the building would have been somewhere in the 1560s, judging from the technical characteristics of the tiles and their austere colour scheme of Arabic names in white on an ultramarine ground with touches of brilliant relief red. The building itself must have been demolished and the tiles dispersed some time during the second half of the nineteenth century.

What event at that time in Istanbul led to the destruction of a number of important buildings? The answer is the construction of the new railway line for the Orient Express, linking Paris and Istanbul for the first time. The railway terminates on the south shore of the Golden Horn at Sirkeci; the tracks snake along the Bosphorus immediately below the sea walls and fortifications of the Palace of Topkapi Saray. An old engraving shows how built up this area was before the railway came. There are a number of buildings, including the royal boathouse and several mosques, and although it can only be speculation, the tiles may well have originated from this area.

An indirect corroboration of this came from a panel of Iznik tiles in our previous April sale. These tiles of superlative and unique design came from a private collection in the United States. The only other tiles of this design – there are none in Turkey – are two single specimens also in the United States; one in the Arts Club in Providence, Rhode Island, and the other in the famous collection of Isabella Stewart Gardner in Boston which were purchased in 1885. These tiles and numerous other specimens of Iznik left Turkey at a moment when the Turks themselves were more interested in European taste than the legacy of the imperial Ottoman Empire. It was this moment that the great Western collections of Iznik pottery were formed by Frederick du Cane Godman and Calouste Gulbenkian. Thus it is an interesting paradox that the introduction of Western technology in the shape of the railway may well have resulted in the arrival of these extraordinary tiles to Europe. The railway station at Sirkeci, which finally opened in 1889, has recently been restored to its full nineteenth-century splendour.

A set of eight Iznik tiles, circa AD 1565, 26.8cm diameter. Sold in London on 12 October 1988 for £130,000 ($237,900).

99

MANUSCRIPTS FOR A MILLIONAIRE

Dr Christopher de Hamel

William Waldorf Astor (1848–1919) was the classic rich American. His vast wealth brought him everything he could have wished for, including two castles and an English peerage. He was the great-grandson of John Jacob Astor from Waldorf in Germany. In 1784, at the age of twenty-one years on an immigrant ship to America, John Jacob Astor fell in with a fur dealer who told him of the money to be made by trading with the Indians. Astor decided to try his own luck. Within two years he was buying fur extensively in the Mid West and in Canada and had laid the foundation of a thriving export business through the town he called Astoria, to Europe and the Far East. Business flourished and he invested his profits in real estate in a then thinly-populated, offshore island called Manhattan. This did even better than furs. Selling out in 1834, he landed a fortune of $24 million.

This wealth was reinvested and multiplied for three generations. William Waldorf Astor, educated privately in a household of unlimited grandeur, became, while still in his thirties, American ambassador in Rome (1882–1885) and there he fell captive to Gothic art. In the taste of his age, he began buying paintings and armour and illuminated manuscripts. He was enchanted by the Villa Borghese and immediately offered to purchase its entire Renaissance balustrade. 'Including the fountains and statuary?' asked the astonished Italian owner: 'Of course', said Astor and paid.

When his father died in 1890, Astor became the richest man in America. That year, however, he moved to England. In 1893 he bought the great house at Cliveden, overlooking the Thames, for a reputed $1,250,000 from the Duke of Westminster. He furnished it royally with works of art and incorporated into it his Borghese balustrade. A decade later he bought Hever Castle, childhood home of Anne Boleyn. This was eventually inherited by his younger son whose descendants dispersed its collections at Sotheby's in 1983.

Astor himself took British citizenship in 1899 and was created Baron Astor in 1916 and Viscount Astor in 1917. His son, the second Viscount, married Nancy Langhorne, first woman member of the House of Commons, and in its time Cliveden became one of the most famous and most fashionable houses in Britain. Here affairs of state were plotted and affairs of popular scandal revealed.

William Waldorf Astor's illuminated manuscripts, of which he owned twenty-seven, were as extravagant as their collector. There were manuscripts whose previous owners included: Ferdinand I, King of Naples; the Anti-Pope John XXII, deposed in 1415; Galeazzo Maria Sforza, Duke of Milan; Albrecht of Brandenburg, Cardinal Elector of Mainz; Henri IV, King of France; Alessandro Farnese and reputedly Margaret of Valois and Jeanne of Navarre. Astor obviously enjoyed buying aristocratic kinship. These had always been rich men's books. There was a *Roman de la Rose* with 68 miniatures, a Book of Hours with 93 miniatures, and a Missal with 124 miniatures. Such manuscripts sparkle with burnished gold and Gothic miniatures and they must have looked very splendid and appropriate when shown to visitors in the library at Cliveden. Among these, however, were manuscripts of less obvious ostentation. The Sforza Book of Hours, which Astor bought in Chicago in 1888, has only five illustrations – though of extremely high quality – and it may have influenced

legc ci9 meditabit die ac nocte:
t crit tanquam lignum qu d plantatum cft
sec9 decurf9 aquarum: qu d fructum fuum dabit
in tempore fuo:

INCIPIT OFFICIV BEATISSIME
VIRGIS MARIE SECVNDV COSVE
TVDINE ROMAE CVRIE AD MA
TVTINVM · INCIPIEDO ASEPT
AGESIMA VSQVE AD PASCHA
RESVRRETIONIS VIDELICET
DIE DOMENICO DIE LVNE
ET DIE IOVIS VERSVS

Pater noster et Aue maria. totum sub silentio. Versus
Omine labia mea aperies. Et os
meum annunciabit laudem tuam.v
Eus in adiutorium meum inten
de. R. Domine ad adiuua
dum me festina. V. Gloria pa
tri et filio et spiritu sancto. R. Sicut
erat in principio et nunc et semper. et
in secula seculorum. R. Amen. laus
tibi domine rex eterne glorie Inuitatorium. ue maria gratia
plena dominus tecum. psalmus.
Enite exultemus domino. iubilemus deo salutari nostro pre
occupemus faciem eius in confessione. et in psalmis iubilem'
et. Inuitatorium. ue maria gratia plena dominus tecum. Vers.
uoniam deus magnus dominus. et rex magnus super omnes

Astor's unreadable Gothic novel, *Sforza*, which he published the following year. The fourteenth-century English Bohun Psalter was bought from the book dealers Quaritch in London perhaps for no other reason than it had belonged in the fifteenth century to Sir John Clifton (*circa* 1394–1447) whose name resembles Cliveden. No matter: these chance purchases now hold the world record prices for any Italian and English manuscripts.

In the sale of 1988, the great Netherlandish Brandenburg Hours returned to Holland, the Missal of the Anti-Pope (bought by Astor in America) went to the J. Paul Getty Museum in California, the Bohun Psalter went back for the second time to Quaritch and a little cartulary from the Augustinian Convent of Crema in Lombardy was bought back by the municipal archives in its town of origin. Doubtless the great-grandson of the fur trader had felt that by extravagantly buying ancient illuminated manuscripts he was conferring a certain ancient prestige on himself.

The effect is now reversed. These twenty-seven medieval manuscripts have undoubtedly absorbed glamour and significance by having spent a century together in the most luxurious and princely household of Lord Astor.

Opposite:
The Great Hours of Galeazzo Maria Sforza, illuminated in Milan, circa *1461–66. Sold in London on 21 June 1988 for £770,000 ($1,386,000).*

The Hours of Albrecht of Brandenburg, illuminated in Bruges, circa *1522–23. Sold in London on 21 June 1988 for £1,210,000 ($2,178,000).*

BURIED
TREASURE

On the night of 7 August 1979, Kit Williams and the writer Bamber Gascoigne buried a gold pendant in the shape of a hare on a hilltop in Bedfordshire. The treasure lay beyond the reach of metal detectors and the location was to be discovered only by following a complex series of clues hidden within the words and pictures of *Masquerade*, a book entirely written and illustrated by Mr Williams. The idea for *Masquerade* was conceived in 1976, 'Tom Maschler, Chairman of Jonathan Cape, came to see me. He had seen my paintings at the Portal Gallery in London and wanted to know if I could illustrate a children's book. I explained I was a painter and not an illustrator and anyway I wouldn't want to draw pictures for someone else's story. He suggested I wrote a story of my own, but as I had never written anything in my life I said no to that too. He left saying "I bet you can do something with books that no-one has ever done before."' These words stuck in Kit Williams' mind and eventually an idea took shape. 'I thought I would do something for my lost childhood and make a real treasure from gold and use riddles to lead people to it.'

The publication of the book, six weeks after the hare was hidden, caused a sensation. Treasure seekers came from as far afield as New York and Tokyo, applying themselves to the task of answering the riddle that would lead to the golden hare. At the height of the *Masquerade* craze, Kit Williams was inundated with 1,000 letters a day and had devotees armed with spades, often splattered in mud, arriving on his doorstep.

One man wrote to him from Switzerland saying that his family had urged him to spend their savings on a journey to a remote and dangerous clifftop in Cornwall. Taking his life in his hands, the man shinned down the cliff face and later found himself cut off by the incoming tide. A woman, who wrote to

*Kit Williams at work in
his studio in the
Cotswolds, England.*

Williams asking him to pay her fare to somewhere else in the British Isles, actually lived only one mile from where the treasure was buried. Someone was even convinced he would reach the treasure if he found out the artist's real name.

Eventually, some two and a half years after it was buried, the hare was finally discovered on the 24 February 1982 on the hilltop at Ampthill in Bedfordshire. At the end there was a race between several treasure hunters, each close to the solution.

Kit Williams had never made a piece of jewellery before designing the *Masquerade* hare. 'Although I'd worked in brass, steel and copper, my methods were unsophisticated and sometimes unconventional using old-fashioned tools like an Archimedes drill.' From one piece of gold, he cut the outline of the hare, five and a half inches from nose to tail, then sawed out and drilled the filigree work with the body. The other piece of gold was enough to make the hare's legs, ears and tail which he riveted to the body. The bells and their tongues, the chains

Kit Williams holding the Masquerade *hare before the treasure hunt.*

and the tiny animals had to be made by melting down the remaining scraps of gold, beating them into coin shapes, then cutting them out. 'The stones I chose were a ruby for the hare's eye, turquoise in the flowers on the body and a large moonstone for the back of the moon. The faces for the sun and moon are made of faience, a substance the ancient Egyptians used a lot. I had to experiment for ages because the facial expression changed so much as the faience cooled and hardened.'

Readers of the book *Masquerade*, which sold a million copies and earned Mr Williams £500,000, were beaten in the quest to unearth the gem by engineer Dougald Thompson. He later tried to create his own computer competition with the hare as prize. However, the software proved to be faulty and the quiz ended abruptly when his company Haresoft Ltd put the hare up for sale in Sotheby's.

At the Jewellery Sale in London in December 1988, in a series of expensive bounds, the 18-carat gold pendant escaped recapture by its creator Kit Williams and was finally bought by an anonymous foreign collector.

106

Fires being one of the most terrifying events in early America, volunteer firemen were consequently held in very high esteem. As important members of the community, they regularly participated in holiday celebrations and special events, like the parade held to honour the American Revolutionary hero, the Marquis de Lafayette, who arrived in New York in 1824. Eight years later, the firemen of Philadelphia held their first parade to commemorate the centennial of George Washington's birth. These colourful celebrations were held in many cities and neighbouring brigades often joined them, competing with one another for the best uniforms and engine decorations.

During the festivities, the firemen put aside their work helmets and donned handsome hats, frequently painted with company colours and insignia or decorated with portraits, patriotic symbols or slogans. Today these firehats are extremely popular items of American folk art and this selection was sold in June 1988 from the collection of Howard and Catherine Feldman.

FIREMEN ON PARADE

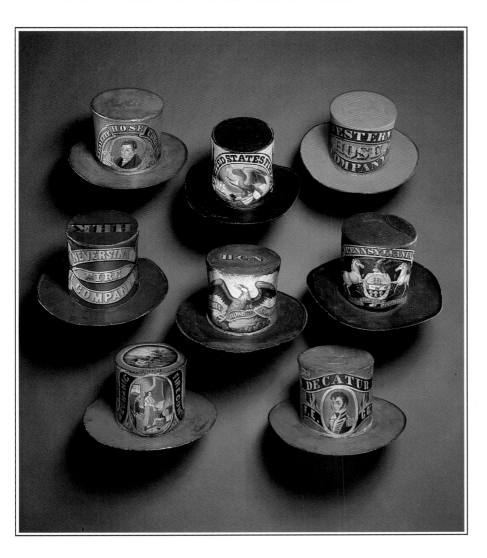

Eight rare hand-painted ceremonial parade fire hats, American, circa *1840–1850. Sold in New York on 23 June 1988 for $98,450 (£52,647).*

BRITISH PAINTINGS
1500–1850

Caroline Behr

The British Paintings sale on 16 November 1988 was anticipated to be one of the successes of the season, but surpassed expectations by making a total of £8 million ($15.2 million) and setting a new record for eight artists, including Gainsborough, Lawrence, Ben Marshall and Arthur Devis, whose portrait of Sir Thomas Cave made £275,000.

Perhaps the most eagerly awaited lot was Gainsborough's portrait of Mrs Drummond, daughter of Thomas Harley, Lord Mayor of London. Painted in 1779, it is a brilliant example of Gainsborough's late, lyrical style, with virtuoso brushwork playing over silk, lace and skin. The picture was acquired by an American in 1898, later coming into the possession of the South African mining king, Sir Joseph Robinson. It sold for £1.65 million. A charming family portrait dating from Gainsborough's years in Bath, *Mr and Mrs Dehany and Their Daughter* made £429,000.

An anonymous private buyer secured a painting of unique historic interest: Lawrence's first portrait of the Prince Regent, later George IV. Commissioned by Lord Charles Stewart and painted in 1814, it launched Lawrence on a career of royal patronage. Depicting the prince as a heroic military figure, it was received with admiration if some scepticism by contemporaries. It sold for £660,000.

The Scottish National Portrait Gallery was successful in acquiring for £29,700 a pair of portraits by David Martin of Henry Dundas, 1st Viscount Melville (1742–1811) and his wife. A celebrated Scottish statesman, Henry Dundas was a friend of Pitt, MP for Edinburgh and later Home Secretary and First Lord of the Admiralty. This lot was followed by David Allan's portrait of Dundas's children, a charming work showing them engaged in scholarly pursuits which made £44,000.

American bidders figured strongly: a painting by Romney of *The Children of Charles Boone, Esq.*, from the collection of the late James R. Herbert Boone of Baltimore, sold for £132,000 to a New York dealer. *George Washington* by Gilbert Stuart sold for £275,000, five times its estimate, to another New York gallery.

In a strong sporting section, Ben Marshall's Portrait of *Alexandre Le Pelletier de Molimide Accompanied by a Groom, Two Hunters and his Hounds* sold for double its estimate at £478,000, a record for this painter's work. The painting sold at Sotheby's in 1976 for £52,000; the current price shows the dramatic rise in demand for sporting art over the last decade.

A delightful *Prospect of the River Thames at Twickenham* by Peter Tillemans, considered by Alexander Pope to be one of 'the two best landscape painters in England', sold for £143,000 to an anonymous buyer. The owners of houses on this stretch of river read like a *Who's Who* of eighteenth-century society: Tillemans shows Pope's famous villa; the domed summerhouse belonging to Lady Elizabeth of the Foundling Hospital. The painting is the earliest extant view of Pope's villa and may have belonged to the poet himself.

An important and hitherto unrecorded large sketch by Constable, *Trees by a Stream*, sold for £333,000. Dating from the early 1820s, it may derive from Constable's stay with Sir George Beaumont at Coleorton in Leicestershire, where the artist admired the Claudes and wrote of the landscape: 'this is a lovely place indeed ... such grounds – such trees – such distances – rock and water.'

Opposite:
Portrait of Mrs Drummond *by Thomas Gainsborough, RA, oil on canvas, 126 by 100cm. Sold in London on 16 November 1988 for £1,650,000 ($3,135,000).*

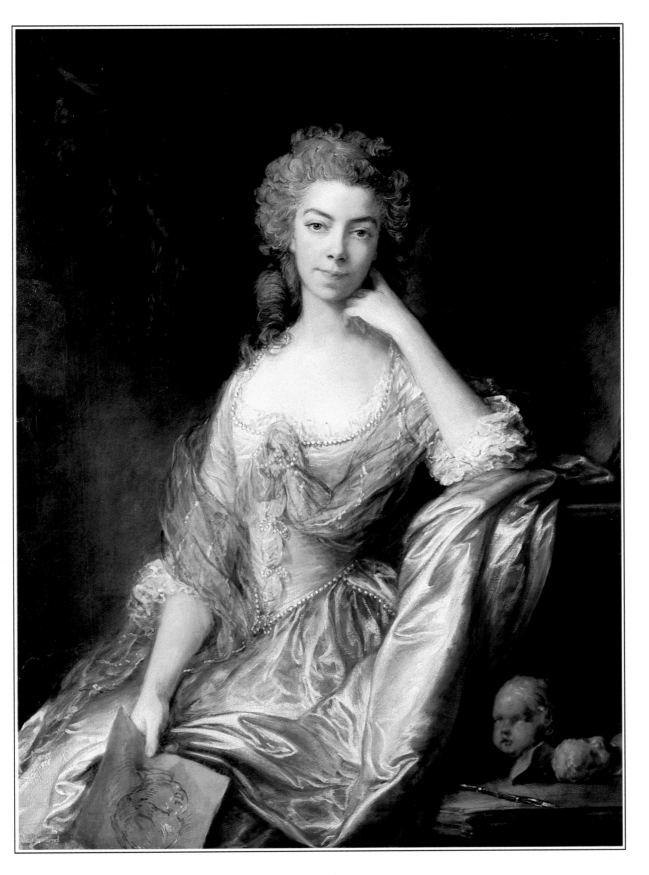

Portrait of Sir Thomas Cave, Bt. and his family in the grounds of Stanford Hall, Leicestershire *by Arthur Devis, oil on canvas, 101.5 by 124.55cm. Sold in London on 16 November 1988 for £275,000 ($522,500).*

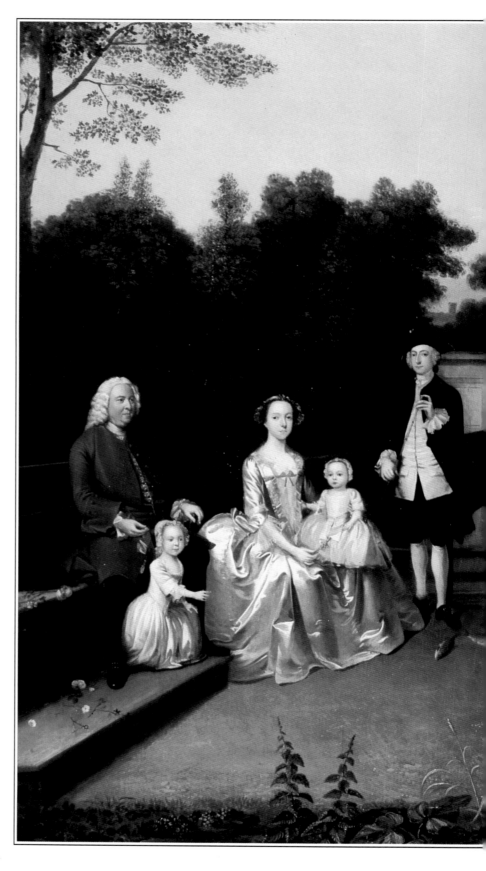

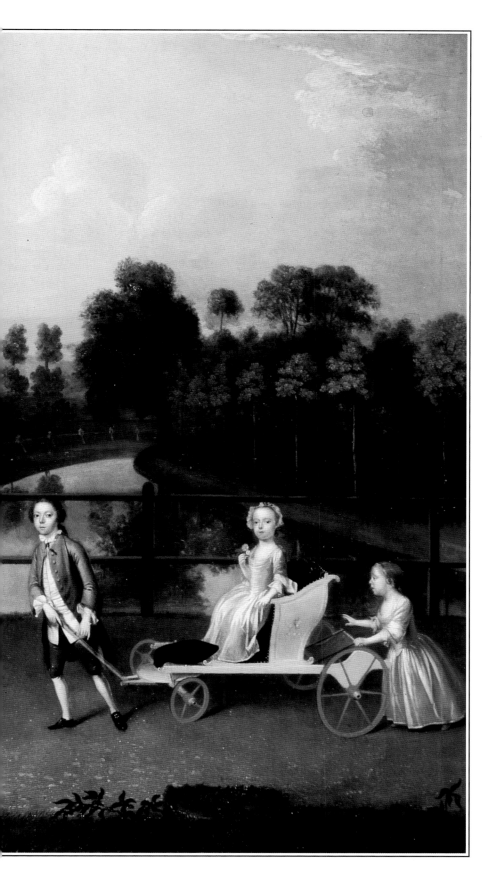

THE ELUSIVE TAMERLANE

Jay Dillon

The 'black tulip' of American book collecting is unquestionably the first edition of Edgar Allan Poe's first book, *Tamerlane*. While the appearance and content of the book is quite ordinary, its rarity is legendary.

When Poe reprinted his poem *Tamerlane* in an 1829 collection, he prefixed a cryptic note to it, saying that, 'This poem was printed for publication in Boston in the year 1827, but suppressed through circumstances of a private nature.' Thus the existence of *Tamerlane* was known to the public as early as 1829 but no copy of the book was found for thirty years. Poe's own comment implies that even he was unaware that any copies had survived. As Poe's reputation grew, so too did the reputation of his first book as a considerable treasure.

Poe was born in Boston in January 1809, the second son of David and Elizabeth Arnold Poe. He was orphaned before the age of three and fostered by a childless couple, John and Frances Allan of Richmond, Virginia. While a student in a private school in Richmond, aged twelve or thirteen, Poe wrote the verses later printed in *Tamerlane, and Other Poems*. In 1825 Poe's foster father, John Allan, inherited a large fortune and Poe undoubtedly expected to participate in this bounty. However, their relationship deteriorated when Mr Allan refused to support his son or cover his debts. Finally on 19 March 1827, Poe broke with his foster father and left the family's house for good.

Five days later Poe sailed for Boston, probably prompted by the city's reputation as a literary centre. In Boston, his financial plight soon overshadowed his literary aspirations, but in the interval between his arrival in about the beginning of April and his enlistment in the United States army at the end of May, he succeeded in having *Tamerlane* printed.

The book was a failure. It is known that Poe sent out a few copies for review, but no reviews were published and the little book was universally ignored. There is no evidence to suggest that it was ever advertised. It has been conjectured, perhaps rightly, that Poe may have been unable to pay his printer and consequently the copies were destroyed or remaindered.

Edgar Allan Poe, Daguerreotype, Providence, Rhode Island, 1848.

The circumstances surrounding the printing of *Tamerlane* are obscure. Poe did not put his name on the book, but instead simply referred to himself as 'a Bostonian'. His reason for doing this was perhaps the hope of identifying himself with Boston, then a literary Mecca. It is not known how many copies of *Tamerlane* were printed – the number forty was once confidently suggested but that seems too small and a print-run in the range of fifty to two hundred is now thought more likely.

The first known copy of *Tamerlane* was sold by an American bookseller for one shilling to the British Museum in 1860. For fourteen years that copy was thought to be unique but then in about 1874 a Boston bookseller's clerk found another in the pamphlet bin of a neighbouring shop. He bought it for fifteen cents and sold it at auction in 1892 for $1,850. A third copy came to light about three years later at Richmond and a fourth surfaced in Boston in 1917.

Thus by 1925 only four copies were known. In that year Vincent Starrett published an intriguing article in the *Saturday Evening Post* entitled, 'Have You a Tamerlane in Your Attic?' Mrs Ada Dodd of Worcester, Massachusetts, did.

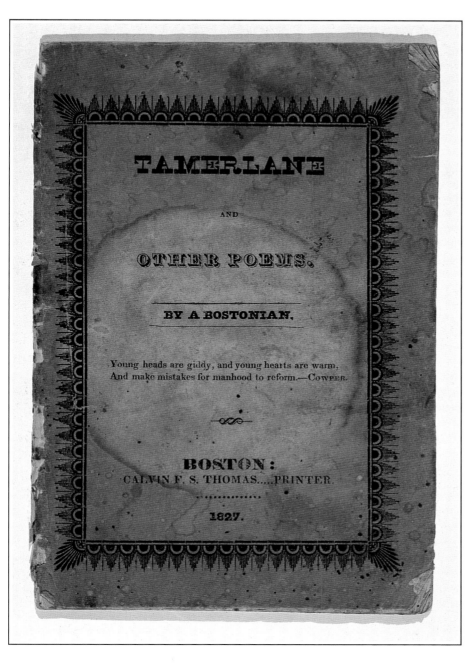

Tamerlane and Other Poems *by Edgar Allan Poe, first edition of the author's first book, 12th known copy in original printed wrappers, Calvin F. S. Thomas, Boston 1827. Sold in New York on 8 June 1988 for $198,000 (£103,125).*

So did a man in Nashua, New Hampshire. So did someone near Ridgefield, New Jersey. In all, six more copies came to light in quick succession, in the wake of Starrett's article.

No more copies were found after the beginning of the Second World War until a New York bookseller discovered one in 1954. More than thirty years elapsed until another copy was unearthed by a Massachusetts collector in a barn in New Hampshire in 1988. The collector bought *Tamerlane* for $15, believing it was worth a few thousand dollars and the next day brought it to Sotheby's where it was later sold for $198,000. Of the eleven copies previously known, nine are now in public institutions, one is lost and one will be sold at Sotheby's in January 1990, from the Library of H. Bradley Martin.

CHASING SILVERSMITHS

John Culme

Victorian silversmiths have been vilified for many things, not least their inclination to 'improve' by chasing, that is embossing plain articles of antique silver. Blameless they were not, but were they the sole culprits? Although the question is a relatively easy one to answer, the reasons behind such a fashion are worth investigating.

Collecting antique silver is a comparatively modern recreation. In fact, the appreciation of old, out-of-date pieces as worthy of any notice beyond their bullion value has been current only during the past two and a half centuries or so. Certain seventeenth-century gentlemen of leisure gathered objects for their 'cabinets of curiosities'. They collected the odd item of early silver as they might have collected quaint Eastern ivories or boxwood reliquaries; in such a setting even a stuffed crocodile would not have seemed out of place.

Horace Walpole (1717–1797), who as a schoolboy was already acquiring books for his library, may perhaps be considered as one of the first collectors in the modern sense. The various *objets d'art* with which he eventually filled his 'Gothic' house at Strawberry Hill, were amassed after 1741. His eclectic taste was informed, one suspects, as much by reading as by aesthetic judgement. In 1776, for instance, Walpole told a friend that he had 'lately been lent two delicious large volumes of Queen Elizabeth's jewels and plate', commenting that, 'She had more gold and silver plate than Montezuma.' So it was hardly suprising that when he was given three old-fashioned Apostle spoons, by then obsolete a hundred years and more, he should have shown in them an interest unusual among his contemporaries. Not long before, another in the small band of antiquaries wrote to *The Gentleman's Magazine*, stating that he had seen in his time two or three sets of Apostles, 'but at present they are scarce, being generally exchanged for spoons of a more modern form and consequently melted down'. That was in 1768.

Within twenty years the trade in certain old silver was flourishing; no longer were all categories of second-hand wares indiscriminately consigned to oblivion. Perhaps such popularity may be connected with the Grand Tour, when young men of fortune travelled in Europe to seek remains of the ancient Mediterranean world. A visitor to London, Sophie V. la Roche who in 1786 went to Jefferys & Jones' shop in Cockspur Street, confirmed that their stock included many old items: 'antique, well-preserved pieces, so Mr Jefferys said, often find a purchaser more readily than the modern. This is because the English are fond of constructing and decorating whole portions of their country houses, or at least one apartment, in old Gothic style and are glad to purchase any accessories dating from the same or a similar period.'

Oddly enough, mainly because a severely neo-classical style was then generally in fashion for modern silver, it seems that collectors preferred medieval drinking vessels and richly decorated pieces of sixteenth- and seventeenth-century silver of German or English origin. Whether a piece was one or the other hardly mattered, although there was an alarming tendency to attribute almost any fine, old item of foreign origin to that revered Renaissance master, Benvenuto Cellini. Scholarship in such matters was not advanced in the late eighteenth and early nineteenth centuries so little or no distinction was

Opposite:
A George III silver epergne by Thomas Pitts, London, 1763–64, with alternative fittings including candle branches and a figure of Ceres supplied between 1843 and 1861 by R & S Garrard & Co. Sold in London on 17 November 1988 for £48,000 ($92,640).

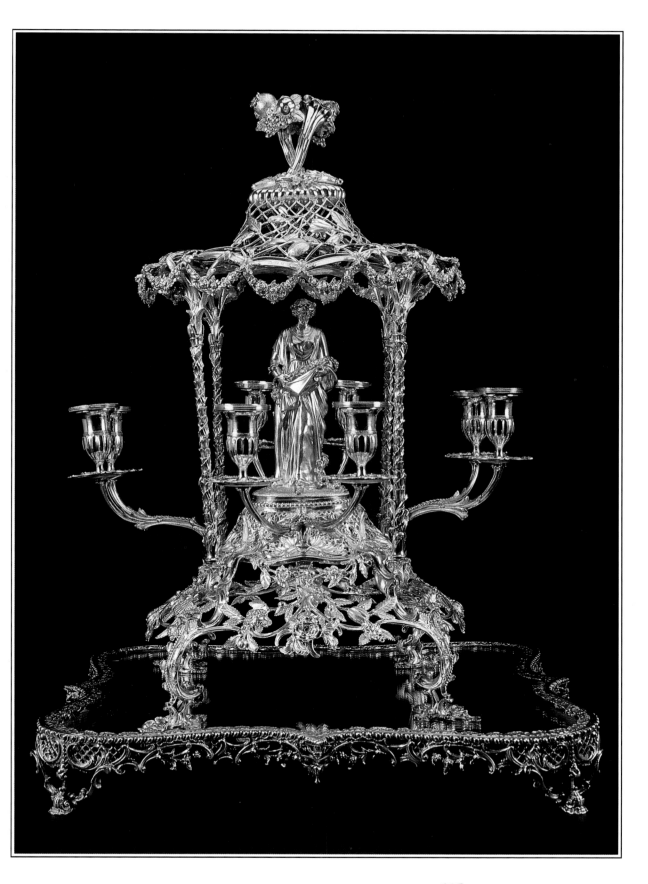

115

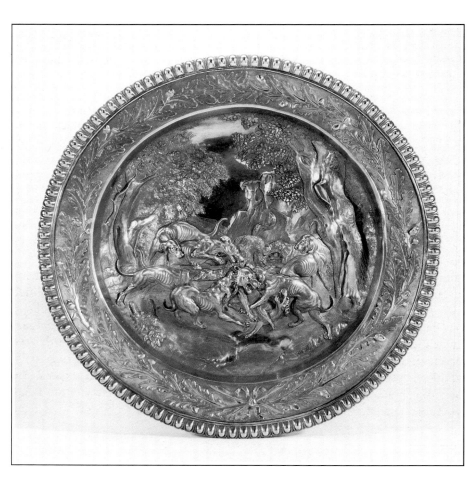

A George II silver sideboard dish by Paul de Lamerie, London, 1727–28; chased circa 1809–10, probably by William Pitts for Rundell, Bridge & Rundell. Sold in London on 17 July 1986 for £5,800.

made between the various types. Those who slavishly cherished silver for its hallmarks, delving into precise dates, sources and makers' identities, did not materialise until the early 1850s.

Growing sales of antique silver soon alerted retailers to various remunerative possibilities. This was especially true of those with wealthy customers who expected spectacular examples in return for their money. As always, demand created supply. Garrard's, the long-established firm of goldsmiths and jewellers of Panton Street, now well known for their adaptations of old wares, appear to have been one of the first to sell modern silver in consciously out-of-date styles. In at least one case – a set of salvers in George II style – ledgers verify that coats of arms were engraved 'in old ornament' as early as 1811. But such work was modest, almost insignificant, by comparison with what, in a matter of two or three years, passed through some of London's better goldsmiths' shops. To 'reproductions' which were often only fanciful interpretations of earlier objects, were now added 're-creations'. Although not outright fakes, this latter class consisted of genuine old pieces enriched by later hands to enhance the allure of their antiquity and therefore their commercial value. A number of firms besides Garrard's were 'guilty' of such practices. For instance, Rundell, Bridge & Rundell, the royal goldsmiths, whose stock of all manner of plate and jewellery was enormous, are thought to have employed the chaser William Pitts for this purpose. Three years ago Sotheby's sold a George II sideboard dish, maker's mark of Paul de Lamerie, London, 1727/28, which had been magnificently

chased about 1810 in Pitts' style with hounds savaging a wolf within a border of oak sprays. Its relevance here is based on the fact that it matched an identical item bearing Pitts' mark, London, 1809/10, also retailed by Rundell's, which was sold by Sotheby's New York, in 1972.

For sheer exuberance of design, the inspiration for which was more firmly rooted in a romantic vision of the past than any other, no goldsmith's stock at this time was as stimulating to lovers of the 'old' and 'curious' than that of Kensington Lewis (1790-1854). This mysteriously named individual, actually Lewis Kensington Solomon, appeared in the 1820s as a fashionable London goldsmith probably as much because of his charm and good looks as through his talent as a businessman. Having cunningly won the patronage of HRH the Duke of York, he contrived with his silversmith Edward Farrell to produce an astonishing group of plate in a uniquely exaggerated seventeenth-century taste. Farrell's 1822/23 're-creations' of a pair of early eighteenth-century jugs are a fine example of the genre.

Unfortunately for Lewis, the Duke of York died all too soon in 1827, leaving an embarrassment of debts and hungry creditors who were only partly mollified in seeing his collections sold at auction. Kensington Lewis, who was forced to buy back many pieces from the sale at a fraction of their original cost, limped on in business for only a few more years. Edward Farrell's skills were still employed by the trade in general until shortly before his death in 1850. Long before the middle of the century, however, the role of silversmiths as 're-creators' had become commonplace, whether or not the eventual purchaser had antiquarian interests. Furthermore, the eye of fashion had quickly shifted away from

A pair of Queen Anne silver beer jugs by Peter Harache, London, 1705–6; chased and with additions by Edward Farrell for Kensington Lewis, London, 1822–23. Sold in London on 6 February 1986 for £4,000.

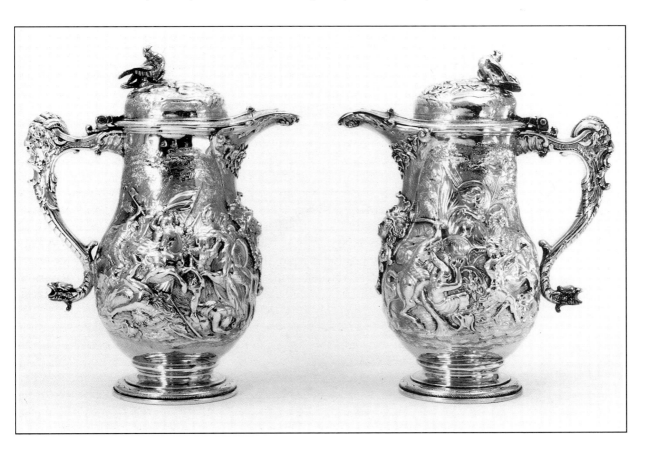

A James II silver flagon, maker's mark D in a shaped shield, London, 1685–86; chased probably during the 1820s in the manner of Edward Farrell. Sold in London on 16 July 1970 for £1,000.

pastiches of seventeenth-century patterns towards a wholesale rococo revival. In such a climate, from the mid 1820s onwards, plain old tankards and dinner plates, salvers and coffee pots were subjected to the chaser's punch with increasing enthusiasm. Flowers bloomed where none were intended; scrolls erupted on Queen Anne teapots; scalework and shells crowded the surfaces of otherwise neglected tureens. In short, chasing silversmiths who turned their attention to antique wares as alternatives to similar but more expensive modern plate, were pursuing an imaginative, not to say commercially successful way of re-cycling objects. In an earlier age, they would simply have been tossed into the melting pot.

In the light of present opinions about antique silver, such a point of view has its detractors; later decorated pieces are usually described as 'ruined' and therefore not taken seriously. Such items of minor interest – a baluster tankard of, say, 1755, complete with its embossed foliage and hunting scene executed in the 1830s – are nowadays tolerated because they are decorative and therefore appeal to a particular section of the market. But, by an ironic twist of fashion, later chasing on the more 'important' early objects is often 'de-chased' in the name of 'restoration'. All the painstakingly wrought flowers and figures of a century and a half ago are skilfully hammered back into the surface and obliterated. Were Messrs Lewis and Farrell at large today, they would surely derive some amusement from our present attitudes towards troublesome old silver. They might contemplate, for instance, the sad fate of a James II flagon of 1685/86 which appeared at Sotheby's twenty years ago, its sides richly chased, in a flamboyant manner very close to Farrell's own. Ten years later, in 1981, this same piece turned up again in London as plain and as dull as it had been before the early nineteenth-century chasing craze began.

Victorian silversmiths were indeed responsible for much 'later chasing', but in following an already well-established practice their work must be seen in the context of that of their earlier colleagues. Should Pitts and Farrell and the rest be dismissed with the same contempt which was once reserved for the Victorians?

It is unlikely that Bonnard would ever have been able to pursue his paintings of bathroom scenes, had his wife not spent several hours a day in the bath. *Nu dans la Baignoire* was painted at the time when the artist went to live at Le Cannet and married Marthe, his model for nearly thirty years. Throughout his life Bonnard continuously used the theme of the bathroom. This picture and *The Bath* in the Tate Gallery were among his first explorations of this intimate setting. They depict Marthe floating in the water and were often painted from an unusual perspective with the image radically cropped. According to the art critic André Fermiger, 'The theme of the bath which provided the occasion for some of his finest masterpieces, must be credited to his wife. Marthe, in fact, who evidently had hydrotherapeutic requirements rather unusual for the France of the period, seems to have spent her life between a tub and the mirror of her dressing room, or later in a bathroom.'

Nu dans la Baignoire sold for over twice the previous highest price ever paid for a Bonnard. According to Michel Strauss, Head of the Impressionist Department, this work was arguably the finest Bonnard to come up for auction since the 1960s.

THE ART OF THE BATHROOM

Nu dans la Baignoire *by Pierre Bonnard,* circa *1925, oil on canvas, 103 by 64cm. Sold in London on 28 June 1988 for £2,200,000 ($3,831,300).*

KHMER AND THAI SCULPTURE

Brendan Lynch

Opposite:

A monumental Khmer grey sandstone bust of the five-headed Siva, Pre-Rup, third quarter of the 10th century, 80cm. Sold in London on 14 November 1988 for £319,000 ($606,100).

A Khmer grey sandstone standing figure of a four-armed male deity, probably Vishnu, Phnom Kulen, first half of the 9th century, 123cm. Sold in London on 14 November 1988 for £209,000 ($397,100).

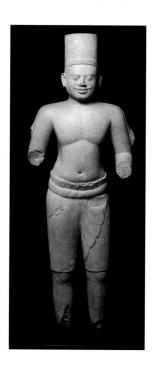

A year after the establishment of a French presence at Saigon in 1859, the great temple-complex at Angkor, north-west of Phnom Pehn, was discovered by the French naturalist, Henri Mouhot. Six years later a French mission arrived in Cambodia to conduct a survey of the jungle-encrusted ruins. Mouhot himself thought the architecture of Angkor not only comparable with but greater than the achievements of the classical world. Though various further expeditions followed, it was not until after the foundation of the École Française d'Extrême-Orient in 1898 that a firm Khmer chronology began to be established. Both before and for several years after Cambodia was granted independence in 1954, generations of French scholars and archaeologists worked at the clearance, excavation, restoration and recording of thousands of Khmer buildings dating from between the seventh and the thirteenth centuries. Museums were established in Phnom Pehn, Hanoi and Saigon but many important sculptures also went to the Musée Guimet, Paris, which today probably contains the best collection of Khmer art outside Cambodia.

Sotheby's November sale of Khmer, Thai, Indian and Himalayan Works of Art, established four world auction records. The sale included a private collection comprising twenty Khmer and Thai sculptures spanning the ninth to the fifteenth centuries. As collections of Indian or South-East Asian art rarely appear on the market, this small but fine group of sculptures created great interest and speculation amongst museums, private collectors and dealers world-wide.

The most important sculpture in the sale was a Khmer five-headed polished grey sandstone bust of the Hindu god Siva, carved in the style of the tenth-century Pre-Rup temple at Angkor. This temple was built by King Rajendravarman (AD 944–68) in honour of his parents and was completed AD 961. Following a period of Javanese overlordship in Cambodia in the eighth century, the man who became King Jayavarman II returned to exile in Java and in the early years of the ninth century established the cult of the god-kings. In erecting statues of the god-kings and the temples which housed them, Rajendravarman continued the funerary cult established by his ancestors in the previous century. The cult was started through the setting up of a *linga* (the sacred emblem of Siva which had been adopted from India) by a Brahman priest on a mountain-top at Kulen, some eighteen miles north-east of Angkor. Through this ritual, which became integral to the belief of the Khmers, Jayavarman claimed that divine kingship had been bestowed upon him directly by Siva. Having eventually achieved military domination, he re-established the Khmer dynasty by declaring himself king.

The second and greatest period of Khmer art, from the ninth to the thirteenth centuries, is referred to as the 'Angkor' period, although the actual temple at Angkor was not built until the twelfth century. Each successive king built a new temple or temple-complex, which on his death became his mausoleum. This practice has left a rich architectural heritage encompassing thousands of buildings spanning more than four hundred years.

Few monumental sculptures from the early Angkor period have survived other than those remaining *in situ*. Therefore, a tenth century, almost life sized standing figure of Vishnu, in the style of the Phnom Kulen temple, inspired considerable interest in the sale in November 1988. Though lacking the feet and

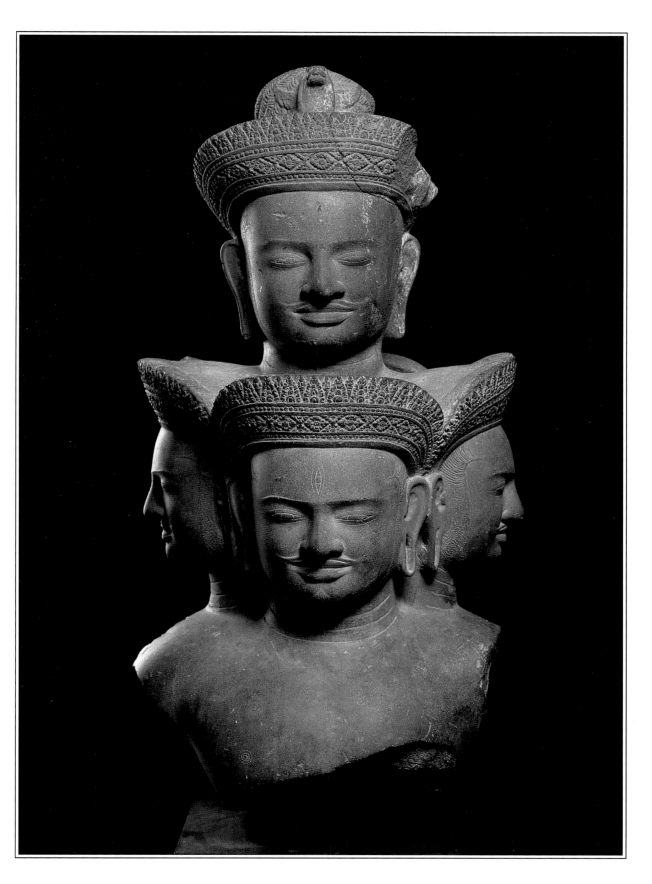

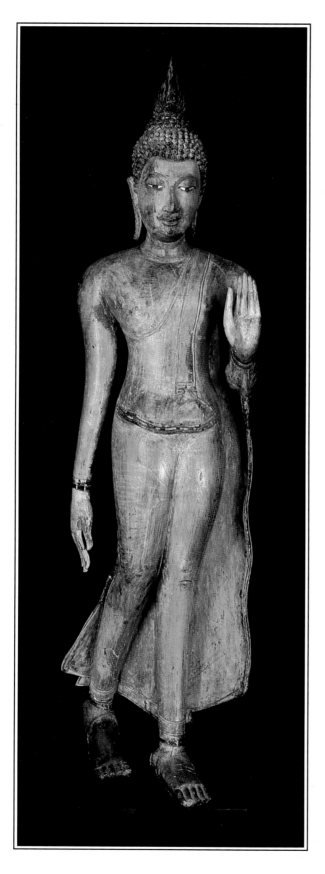

with four fragmentary arms, the figure is outstanding in terms of rarity and in quality of execution. Figures such as these were often sculpted as portraits of the rulers who commissioned them, though ostensibly they were usually images of Vishnu or Siva.

The Sukothai period, from the thirteenth to the fifteenth centuries, marked the first period of Thai art, when the classic image of the Buddha was conceived. This came about at a period when the city of Sukothai became independent from its Khmer overlords and emerged as the great Buddhist capital of most of modern Thailand. According to Buddhist literature, there are four positions suitable for the betrayal of ascetics: sitting, standing, reclining and walking. The act of walking, however, does not appear to have been rendered by Indian artists. Images of the Walking Buddha are known in stucco, slate and most commonly bronze, but few made of wood appear to have survived. Consequently, lot 60, a life size wood figure of the Walking Buddha, dating from the fifteenth century, was of great interest to collectors of Thai art and was finally sold to an American private collector. It is thought that the image of the walking Buddha may have evolved through the legend of the descent from the Tavatisma Heaven, in which the Buddha is depicted returning to earth having visited his mother in heaven during the rainy season.

The three objects described above are unique in terms of quality and rarity and are likely to be unrivalled outside the great museums of the world.

A Thai wood lifesize figure of the Walking Buddha, Sukothai, 14th–15th century, 176cm. Sold in London on 14 November 1988 for £71,500 ($135,850).

In Sotheby's traditional atmosphere of gilt frames and highly polished mahogany, the vast canvases of Abstract Expressionism and the confrontational images of Pop Art are something of an anomaly. Yet, it was contemporary art that dominated the 1988–1989 season in New York, with sales totalling in excess of $170 million and the world record price of $17.1 million paid for Jasper Johns' *False Start*, the highest ever for the work of a living artist.

These figures would be impressive in any field, but they are all the more significant for Post-War art, which only fifteen years ago was a fledgling area in the international art market. Since 1973 the contemporary market has evolved into a vibrant field that attracts an active international group of collectors, and the demand for American Post-War art has now broadened far beyond the pioneering New York collectors of the 1950s and 1960s, to include both European and Japanese bidders. During the 1970s, great contemporary works changed hands privately, but today the saleroom has become the principal venue. Over the last five years, Sotheby's has sold some of the finest works of the Post-War era – de Kooning's *Pink Lady* and *Ruth's Zowie*, Rosenquist's *F-111* and Johns' *Out the Window*, among them.

Nonetheless, there has never been a season to compare with 1988–1989, when four masterpieces of contemporary art – Johns' *False Start*, Rauschenberg's *Rebus*, Warhol's *Marilyn Monroe (Twenty Times)* and Pollock's *Number 8* all appeared on the auction market. Each brought a record price well in excess of the estimate, reflecting both the importance of the image and the intensity of the competition among collectors for works of such quality. Widely acknowledged as a seminal work in Rauschenberg's *oeuvre*, *Rebus* has been described as 'an anthology of the techniques of contemporary painting, (including) dripped paint, hard rectangles of colour, collage cloth, torn plaster, comic strip, news photo, children's drawing and graffiti.' It was purchased for $6,325,000 by Hans Thulin, a Swiss real estate developer who has publicly stated his ambition to form a collection of contemporary masterworks.

A Remarkable Season for Contemporary Art in New York

False Start *by Jasper Johns, 1959, oil on canvas, 171.5 by 134.7cm. Sold in New York on 10 November 1988 for $17,050,000 (£9,021,164).*

Rebus *by Robert Rauschenberg, 1955, pencil, fabric and paper collage on canvas, 243.8 by 331.5cm. Sold in New York on 10 November 1988 for $6,325,000 (£3,346,561).*

A New York collector paid $3,960,000 for *Marilyn Monroe*, overtaking the record $1,430,000 paid for *210 Coke Bottles* the preceding Spring. Marilyn's face has become one of the most enduring images of Pop Art, one that Warhol treated more than thirty times. This example is one of only five on such an elaborate scale and the last in private hands.

Similarly, the sale of Pollock's *Number 8* represented the final opportunity to acquire an example of one of the artist's fully developed 'drip' style. 'This painting has all the qualities I look for in Pollock's work,' said Lucy Mitchell-Innes, Director of the Contemporary Art Department in New York. 'It has a strong rhythm, clear definition and a sense of energy. The canvas has a wonderfully rich surface heavily encrusted with skeins of paint and other matter.' Its importance was recognized by a number of bidders, one of whom finally secured the painting for $11,550,000.

The greatest drama, however, was reserved for the sale of *False Start*. Executed in 1959, *False Start*, marked a new direction in Johns' work, a movement away from the imagery of targets, flags and numbers and a development of a new painterly style and abstract use of colour that contrasted

with the tighter surfaces and specific use of colour in earlier paintings. The bidding began at $3 million and quickly passed the $3.6 million paid for *Out the Window* in 1986, the $4.18 million for *The Diver* in May 1988, and the $7 million for *White Flag* just a day earlier. The electrifying duel between a bidder in the room and another on the telephone ended in victory at $17 million for the former, a dealer representing a New York private collector.

It was especially fitting that this extraordinary year included works from the collections of Mr and Mrs Victor W. Ganz, the late Karl Ströher, and the late Edwin Janss, Jr., each of whom had been an early and determined supporter of contemporary artists, Mr and Mrs Ganz focused on Johns, Rauschenberg and Stella, incorporating works into their superb Picasso collection in the 1960s. Each of these artists, in his own way was indebted to Picasso.

Karl Ströher, chairman of the Wella Hair Products Corporation in Germany, is generally credited with bringing American Pop Art to a broader, European audience. After World War II, Mr Ströher resumed collecting, focusing at first on early twentieth-century artists but turning to contemporary art in the 1960s. In 1966 he toured the major New York museums and galleries and visited a number of artists – Lichtenstein, Warhol and Oldenburg among them – in their studios. On his return to Germany, he arranged a national tour for his Pop Art acquisitions which he complemented with European works, particularly those of Joseph Beuys, in an effort to show the latest developments internationally. The nineteen works consigned by his daughter this spring were representative of the larger Pop Art collection, much of which was acquired by the museum in Frankfurt. Included were two Warhols, *Red Jackie* and *Flowers*, four Lichtensteins and the most important group of Oldenburg's sculpture ever to appear at auction. Several of these, including *Bacon and Egg*, which brought a record $495,000 at the sale, had been part of *The Store*, the famous environment Oldenburg created in a storefront on Second Street in New York.

Edwin Janss, Jr., a land developer in Southern California, was simultaneously attracted to an entirely different vein in contemporary art. He began with a Sam Francis and went on to acquire an exceptionally diverse group of paintings and objects which nonetheless related to one another in a distinctive way. The connection was through Janss himself, as his daughter Dagny Janss Cocoran has observed, 'Each painting revealed a part of Ed's personality. Each is strong and sure, focused, deep, and carefully considered. And each is mysterious, not easily known, a bit surreal. The consistency of the man and the collection is rare indeed'. The most important work, and one of Mr Janss's greatest treasures, was Francis Bacon's *Study for Portrait of Van Gogh II*, 1957, one of six paintings inspired by Van Gogh's *The Painter on the Road to Tarascon*, which sold for $5,830,000. Of great interest as well was David Hockney's *A Grand Procession of Dignitaries in the Semi-Egyptian Style*, an early work that presages the artist's fascination with the theatre. An American private collector purchased this painting for $2,200,000.

The 1988–1989 season saw a significant number of major contemporary paintings appear at auction virtually simultaneously and this great concentration of work was easily and eagerly absorbed in intensely competitive bidding. The season will thus be long remembered as a landmark in the development of the contemporary market, a year of records for the work of more than forty individual artists, but, more significantly, a year of confidence and enthusiasm among collectors and of new price levels in a range of areas in the field.

Opposite:
Study for Portrait of Van Gogh II *by Francis Bacon, 1957, oil on canvas, 198 by 142.2cm. Sold in New York on 2 May 1989 for $5,830,000 (£3,293,785).*

A MARBLE HEAD: ANCIENT OR MODERN?

Andrew Cypiot

In November 1988, Sotheby's exhibition galleries were humming with the commotion of the seasonal sales of Impressionist and Modern Paintings and Sculpture. Displayed amid the Monets and the Picassos was a stylized head, slender, almost sleek, its features rendered with a minimalist touch.

The sculpture might have been a modern work in the manner of Brancusi or Arp or perhaps a Modigliani in stone. Overlooked by many auction-goers in the crowded galleries, was the description: 'Cycladic Marble Head of a Goddess, Early Bronze Age II, Early Spedos, *circa* 2600–2500 BC' The origin of the sculpture did not escape Edward Merrin, a well-known dealer in ancient art, who purchased the head for $2,090,000, a record price for a classical antiquity. Describing the head as 'the definitive Cycladic piece' Mr Merrin justified his record bid: 'To get the world's finest example of anything for that price is a bargain.'

The fragmentary head is a masterwork of Cycladic sculpture – delicate white marble objects carved in the post-Neolithic period, 3200–2000 BC, on the Greek islands known as the Cyclades in the Aegean Sea. Almost nine inches in height, the head is one of the largest on record and must have come from a full figure which stood at least three and a half feet tall. The body would have had an attenuated torso with arms folded one above the other across the chest; its waist, thighs and calves would have been modelled separately in undulating outline and its feet pointed and extended. Most unusually, traces of the pigment that define facial features remain. The head, just a fragment of the original figurine, nevertheless remains a beautiful work of art.

The Cycladic head on exhibition in New York.

130

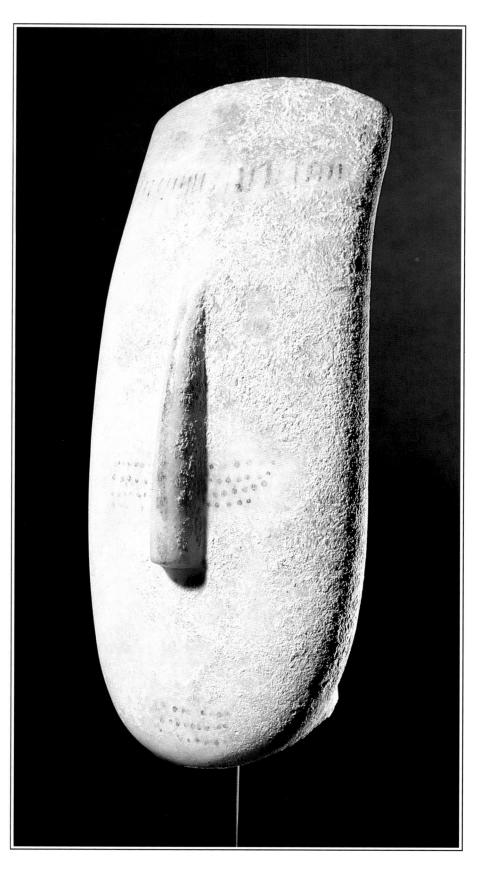

A Cycladic head of a goddess, Early Bronze Age II, Early Spedos, circa *2600–2500 BC, marble, 22cm high. Sold in New York on 2 December 1988 for $2,090,000 (£1,077,320).*

ONE OF THE FEW

D.J. Erskine-Hill

Hurricane P 3166 shuddered under a torrent of point blank cannon fire and broke off into an earthward dive. Inside, Squadron Leader Peter Townsend grappled desperately with the controls, the pain from a serious foot wound the least of his worries. With petrol showering his uniform, the terrible prospect of being trapped in a burning cockpit must have been vividly apparent. Assuring himself that a crash landing was out of the question, Townsend flung back the shattered canopy and clambered out at 1,400 feet. Swaying towards the Kent countryside he saw two housemaids in a garden, staring open-mouthed. In a characteristic tone he called out, 'I say! would you mind giving me a hand when I get down?'.

Townsend was fortunate to avoid some tall oaks and finally came to rest amongst a clump of fir saplings. Having convinced the Home Guard and a policeman of his nationality, everyone adjourned to the Royal Oak, Hawkhurst, for drinks all round. He was eventually waved off by a 'wonderfully friendly little crowd'. That night a surgeon took a 20mm cannon shell out of his left foot. As Townsend passed out under the anaesthetic, he could faintly hear the sirens wailing – he was in Croydon General Hospital. Meanwhile, villagers in Hawkhurst had put his parachute on display and raised £3 in as many hours for the Spitfire Fund – not much consolation for a wounded Hurricane pilot!

Nearly fifty years later, the sale of Group Captain Peter Townsend's war medals was to benefit an entirely different cause – a trust fund for children who are the victims of war and persecution. The Group Captain felt that the sale of his wartime decorations would be, if only a symbolic gesture, at least a positive one towards alleviating the sufferings of youthful victims of political and military conflict. Thus on 10 November 1988 his impressive D.S.O., D.F.C. (and bar) Group sold to a private collector for £22,000. This was a peace-time gesture of typically generous proportions: as one of Churchill's famous 'Few', Peter Townsend had given everything but his life.

Prior to being shot down over Kent in August 1940, he had already been at the sharp end of Goering's *Luftwaffe*. Having intercepted a lone raider off Southwold in early July, he proceeded to pump over 200 bullets into his target before himself falling victim to the Dornier's rear gunner. The subsequent explosion in the cockpit ruined his Hurricane's coolant system and Townsend took to his parachute. Lucky to be spotted, he was 'fished out of the water by the good ship *Finisterre*, a trawler out of Hull'. Sodden but unhurt, he was landed at Harwich. After a nip of rum and change of clothes, Townsend was 'back in form' for a patrol that evening.

At this stage it would be appropriate to remind ourselves that Townsend personally accounted for eleven enemy aircraft, as well as damaging many others. On 3 February 1940, he became the first of our pilots to down a raider over English soil. On another occasion he led his squadron of twelve Hurricanes against a force of 250 raiders over the Thames Estuary. Three of the latter fell to his guns in little more than an hour. Even after he had been shot down for a second time and had a big toe amputated, Townsend was back with the squadron within three weeks. It was statistics like these which won him a reputation second to none for courage.

Peter Townsend by Captain Cuthbert Orde.

By the time Peter Townsend was ordered off operations in the summer of 1941, he had completed no less than 300 patrols, ninety-five of them at night and on each occasion he was well aware that 'Old Man Death' was just around the corner. Despite the terrible responsibilities of a Squadron Command, he displayed qualities of a 'gallant, determined and courageous fighter'. No.85 Squadron was the first to be credited with reaching treble figures in conclusively destroyed enemy aircraft. And there can be little doubt that this achievement was directly attributable to Townsend's personal character and example having instilled into his pilots and ground staff a 'spirit of tremendous keenness and devotion to duty'. His unflagging zeal and leadership epitomized the very spirit that won the most important conflict of the Second World War. By the time Hitler had called off the proposed invasion of England, Townsend was safely established as part of the legend of the Battle of Britain.

After service as an equerry to King George VI and then to Queen Elizabeth II, he became an air attaché in Brussels and since 1956 has been travelling and writing. During the last ten years Townsend has produced several books which draw attention to the plight of some of the world's young, in particular the victims of war. He was initially approached by the sponsors of the United Nations' 'Year of the Child' Appeal in 1979 and travelled the world over to speak to the children in person. Moved by their tales of suffering and fortitude, Townsend went on to write a book about a teenage girl belonging to the 'Boat People', who was the sole survivor of a shipwreck on a deserted reef. In 1984 he followed this up with a book about a teenage Nagasaki boy who was seriously maimed by the bomb. As a direct result of these experiences, Townsend finally decided to part with his medals. 'They were lying around in a bag at the bottom of a drawer and I thought it would be sensible to put them to use.'

The D.S.O., D.F.C. (and bar) group awarded to Group Captain Peter Townsend. Sold in London on 10 November 1988 for £22,000 ($41,580).

THE LARGEST QUR'AN LEAF IN THE WORLD?

Dr David James

It is not unusual for single Qur'an pages to sell for high prices, but what was so special about this one in particular? The answer quite simply, is that the page in question is of enormous size – 184 by 115cm. It is believed to be in the hand of the most famous bibliophile of fifteenth-century Iran, Prince Baysunqur – grandson of Tamberlaine – who was renowned for his ability in the art of calligraphy. The page which was sold in Sotheby's on 10 October 1988, achieved the world record price for a single manuscript page.

Copies of the Qur'an, Islam's Holy Scripture, were often written in thirty separate volumes: if one volume was read each day the Qur'an could be completed in the course of a month. Volumes often became detached and through frequent usage pages became loose; consequently, there have always been odd volumes and pages in existence, quite a number of which have come up for auction in recent years. Such is the admiration for Arabic calligraphy, especially in the Middle East, that pages and other parts of Qur'ans have already found a ready sale among collectors.

There is no positive evidence that Baysunqur who died in 1433, was the calligrapher who copied out the huge Qur'an, but there is a strong tradition to that effect. According to tradition, Baysunqur copied out the Qur'an for the tomb of his grandfather Tamberlaine, or Timur as he is known in the East, where it remained until the eighteenth century when it was dismembered and dispersed.

Timur was the last of the great Central Asian warlords to deserve the title 'World Conqueror'. His armies invaded Persia, Russia and India in the East: in the West they came as far as what are now Turkey and Damascus. Timur captured Damascus in 1401 and it was there that the famous Arab historian Ibn Khaldun met him.

Timur died while on his way to invade China in 1405 and was taken back to Samarkand, his capital, to be buried in the Gur-i Mir mausoleum which he had built to receive the body of one of his grandsons.

For most of the first half of the fifteenth century Samarkand was governed by another of Timur's grandsons, Ulugh Beg, and it was he who ordered a massive slab of green jade to be placed over the spot in the mausoleum where Timur had been interred. As well as making this and other additions to the mausoleum, Ulugh Beg improved several existing buildings in Samarkand and ordered many new structures to be erected, the most famous of which was his astronomical observatory. One addition made by Ulugh Beg to an existing building was that of a huge marble Qur'an reading-stand which was placed in the great mosque of Samarkand, which Timur had begun in 1399. This stand was originally inside the covered area of the mosque, which is known today as the Bibi Khanum Mosque, but in 1875 it was moved to its present location in the centre of the vast courtyard. The size of this stand is 2 by 2.30m, which corresponds almost exactly to the size of two of the large Qur'an pages. In other words, an open copy of a Qur'an, each page of which was roughly 184 by 115 cm, would have almost filled the reading stand. It seems probable, therefore, that if the Qur'an was made for use in Samarkand, it would have been for the great mosque, rather than for the mausoleum.

134

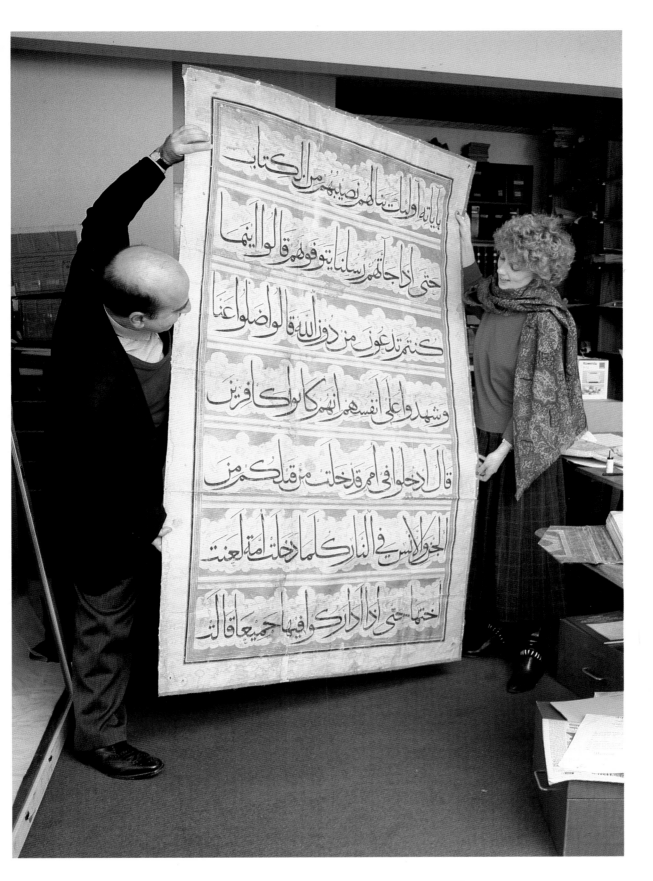

Baysunqur, the presumed calligrapher, is certainly known to have worked on inscriptions of gigantic size. On the arch of the Gawhar Shad Mosque in Mashhad, Iran, is a long and beautiful inscription which was produced and signed by him in 1418. This inscription is in *Thulth*, a style for which Baysunqur was famous. The text of the Qur'an page is in *Muhaqqaq*, a style for which he was equally well known.

The page consists of seven lines of text, superbly written, by an accomplished master. Despite the precision and almost faultless perfection of the script, it would have been copied without any mechanical aids other than guidelines impressed in the paper before the scribe began his work. The panels around the text would have been ruled after the completion of the text. The floral sprays and gold illumination, which appear on the page, were added in the nineteenth century at the request of a later owner. An unusual feature of the page is that the text occurs on one side alone: the reverse side is covered with a rough 'collage' of papers, which appear to be nineteenth century. All the surviving pages from the manuscript have been treated in this way and we can presume that it was done to strengthen them. It has been suggested that the pages were glued together to form a roll, but this seems unlikely. There are no examples of complete copies of the Qur'an written in this manner in the fifteenth century and such a roll, in any case, would have been of enormous size.

According to several Persian authors who have investigated the question, the Qur'an remained in Samarkand until the middle of the eighteenth century when Nadir Shah, a chief of the Afshar tribe, who had become ruler of Persia, occupied the city. Nadir Shah attempted to force open the tomb of Timur but without success: the great block of jade cracked in half and Nadir Shah gave up his attempt. At the same time the Qur'an was taken from Samarkand, either by the soldiery, from whom Nadir Shah later recovered such pages as he could find, or else by the Afshar leader himself, who took them back to Persia.

Some of these pages were later placed in the tomb of Sultan Ibrahim at Quchan, which was destroyed in an earthquake. The surviving portions were taken to Mashhad where they became part of the Astan-i Quds shrine library. By means and routes which are still unclear, a number of pages and fragments of pages, found their way into other public collections in Iran and into certain private ones. One or two pieces, including the present one, came to the West. There is still research work to be done on the surviving pages in order to increase our knowledge of the circumstances of their origin, though it seems unlikely at this stage that a full account of their origin and history will ever be forthcoming. Like many other ancient manuscripts and works of art, they will continue to hold onto their secrets.

A large eighteenth-century Whieldon-type teapot, estimated at £5,000 to £7,000, sold at Sotheby's London for an astonishing £14,300. The owner, Mrs Norah Ambrose, a Liverpool pensioner, had inherited it from her mother-in-law and was unaware of its potential value. It came to auction after being discovered by Sotheby's ceramics expert David Battie on the BBC's *Antiques Roadshow*.

In April 1988 the first of the 1989 series was recorded in Liverpool and amongst the 4,500 hopefuls who attended was Mrs Ambrose. She unpacked the teapot in front of David Battie who decided that it was sufficiently interesting to televise. During the recording he told her that it was of Whieldon type, made in Staffordshire in about 1760, and was very rare because of its size. Mrs Ambrose proved to be undaunted by the bank of cameras and lights and explained how her family had poured tea from it for the farm workers and that the pot had spent the last few years wrapped in a tablecloth on top of her wardrobe. Despite being thinly potted in a cream-coloured earthenware body, it was in very good condition, only slightly chipped with the tip of the serpent-head spout missing. She had considered it of very small value and was not a little surprised when David suggested that it was worth £150. She was amazed when he told her that it could fetch £1,000 and was totally disbelieving when he raised the estimate to £5,000.

Mrs Ambrose subsequently decided to sell the pot and approached Sotheby's, who included it in a sale of early English pottery and porcelain. The market for good eighteenth-century English pottery is very strong at present and Peter Williams, another Sotheby's English ceramics expert, comments: 'The semi-translucent "tortoiseshell" glaze of Mrs Ambrose's pot is typical. This piece was unique because of its size and a particularly well made and attractive example of its type.' Whieldon ware, associated with Staffordshire potter Thomas Whieldon (1719–1795), was immensely popular in the 1760s and 1770s and represents the beginning of industrial pottery production in England.

An exceptionally large Whieldon-type teapot, circa *1760, surrounded by other Whieldon Wares. Sold in London on 18 October 1988 for £14,300 ($26,455).*

Marcel Jeanson's Birds

George Gordon

By the time Marcel Jeanson's birds roosted for the last time under Sotheby's wing, at the Sporting d'Hiver in Monte Carlo in June 1988, it was after a lengthy migration around the world. As part of a programme of exhibitions in Sotheby's offices, the birds visited Geneva, Stuttgart, London, New York and Paris before their final flight south to the Riviera. Their vivid plumage and startlingly lifelike quality astonished all those who saw them. Not least vociferous in his praise was a blue and gold macaw named Joey who appeared with his owner at the exhibition in London. His recognition of Barraband's 180-year-old portrait of one of his ancestors was expressed in a highly vocal manner.

Joey's forebear was one of the parrots painted in watercolour by Jacques Barraband in preparation for plates to François Le Vaillant's ornithological survey *Histoire Naturelle des Perroquets.* This work was published in Paris from 1801 onwards together with its sequels devoted to jays, birds of paradise and toucans. Apart from these watercolours, little survives of Barraband's work. This is not surprising, since the watercolours occupied a substantial part of his short working life and represent the triumph of his art. Since nearly all these watercolours were in Marcel Jeanson's possession, and until last spring had not been seen by anyone outside his immediate family, their reappearance caused quite a sensation. Their scientific accuracy has not been matched before or since by any ornithological artist and the brightness and sharpness of their colours has not been dimmed by exposure to light. Barraband's parrots, toucans, birds of paradise and other birds seem larger than life, though they are in fact life-size.

Their extraordinarily bright colours make them seem disturbingly alive. This is an intriguing paradox, because most if not all of his specimens were dead. Some of the most lifelike of his birds show plumage in which changes in colour are evident that only take place after death.

Jeanson's second great ornithological treasure was his group of watercolours on vellum by Nicolas Robert (1614–1685). So rarely have watercolours survived virtually unblemished from the seventeenth century, that the characteristic reaction to them is one of disbelief. As vellum is an extremely unstable medium and degrades, stains and blemishes usually appear fairly quickly. Robert used very fine vellum, which, apart from some slight crinkling, has not suffered any deterioration. More importantly, Jeanson's Roberts have not been exposed to light and consequently the colours have not faded at all, nor has the paint flaked or cracked. Not only are the paintings in superb condition, they are also extremely rare. Robert watercolours appear very rarely on the market because as *Peintre du Roi* to Louis XIV, most of his output was for the royal scientific collection, known as the *Vélins du Roi.*

These can be seen today in the Museum d'Histoire Naturelle in Paris. Of the works by Robert that do occasionally come on the market, nearly all are botanical, so birds by him are very rare birds indeed.

As the only other existing assembly of works by Robert, the *Vélins du Roi* make an interesting comparison with those in the Jeanson Library. They have their origins in a collection of watercolours started by Louis XIII's brother, Gaston d'Orléans, who employed several artists to record the rare plants that he was assembling in his garden at Blois. By the time he started working for the Duc d'Orléans in the early 1640s, Robert's reputation was already established. He had spent two years in Italy working on a set of fifty-five botanical engravings entitled *Fiori diversi ... intagliati da Nicolo Robert, francese* – a project which brought him early renown. Of the artists working at Blois, Robert's talents were quickly recognised. As the botanist Antoine de Jussieu wrote in 1729: '*Entre plusieurs dessinateurs et peintres en miniature qu'il (Gaston d'Orléans) avoit employés pour ce sujet, aucun ne réussit mieux que Nicolas Robert, dont personne n'a pu égaler le pinceau.*'

Cock of the Rock *by Jacques Barraband, circa 1800, gouache and watercolour on vellum, 52 by 39cm. Sold in Monaco on 16 June 1988 for FFr299,700 (£28,543; $49,950).*

By the time of his death in 1660, Gaston d'Orléans' collection of *vélins*, watercolours on vellum, consisted of five large folio volumes. Robert was responsible for much of their contents, which included watercolours of animals and birds as well as plants. Because Gaston lacked male issue, the collection passed to his nephew, Louis XIV. The event was described in verse by Gaston's secretary, the poet De Bouillon:

> Les fameux vélins de Gaston
> Furent plus glorieux encore
> Et formèrent l'un des rayons
> Du Roi-Soleil à son aurore.

The king's minister, Colbert, is sometimes given credit for effecting this legacy; it was certainly he who ensured that the collection continued to expand and it was he who had Nicolas Robert appointed *Peintre ordinaire du Roi* pour la miniature in 1666. Robert's contract stipulated that he was required to paint a minimum of fifty-four *vélins* per year; above this number he was paid on a pro rata basis. In practice he presided over a large workshop which, under his supervision, produced a large number of *vélins* every year, of which only a proportion were from his own hand.

Most of Robert's botanical subjects were supplied by the Jardin des Plantes in Paris and the birds came from the Ménagerie at Versailles. In view of the number of exotic species depicted, most of these were probably dead specimens. Robert did not work exclusively for the King. He executed commissions for Colbert and he made engravings after his own drawings, published in collaboration with other artists. Nonetheless, most of the last twenty-five years of his life were devoted to his Royal employment. It is surprising that such a

Opposite:
Red-sided Eclectus *by Jacques Barraband, circa 1800, gouache and watercolour on vellum, 52 by 39cm. Sold in Monaco on 16 June 1988 for FFr166,500 (£15,857; $27,750).*

A Blue Jay *by Jacques Barraband,* circa *1800, gouache and watercolour on vellum, 52 by 39cm. Sold in Monaco on 16 June 1988 for FFr166,500 (£15,857; $27,750).*

Opposite:
A Blue-cheeked Amazon *by Jacques Barraband,* circa *1800, gouache and watercolour on vellum, 52 by 39cm. Sold in Monaco on 16 June 1988 for FFr122,100 (£11,629; $20,350).*

large and grand group as those owned by Marcel Jeanson should exist apart from the Royal collection and without any surviving evidence of an independent commission.

On his death in 1685 Robert was succeeded as *Peintre du Roi* by Jean Joubert (1643–1707), who with his successor Claude Aubriet (*circa* 1665–1742), supervised the further enlargement of the collection which, by Louis XIV's death in 1715 numbered more than six thousand *vélins* contained in sixty-four volumes. It continued to expand throughout the seventeenth and eighteenth centuries with contributions from artists such as Gérard van Spaendonck and P.J. Redouté. Now known as the Vélins du Muséum after its present home, the Museum d'Histoire Naturelle in Paris, it is still being added to by artists working in the traditional medium of watercolour on vellum. The principal difference between Robert's *vélins* and those of his latter-day successors is that it is no longer possible to obtain the fine vellum used in the seventeenth century!

Few if any of the Robert *Vélins du Roi* have finished landscape or foliated backgrounds. In most cases a few strokes of the brush, probably added by a member of the workshop, suffices. In contrast most of the Jeanson birds are seen in well-planned landscape settings or perched on branches. It is clear that these are, in most cases, by the same hand as the principal subject and executed with the same attention to detail. These differences, in format and in background, suggest that the Jeanson *vélins* had a different purpose than the *Vélins du Roi* and were probably intended for a private client rather than as part of the Royal scientific collection.

While it is not possible to distinguish with absolute certainty between Robert's work and that of his workshop, many of the *Vélins du Roi* dating from Robert's time are of markedly superior quality and it is reasonable to assume that these are Robert's own work. Others are of variable quality and it is possible to discern certain distinct hands among them. The composition of the Jeanson *vélins* mirrors that of the much larger Royal group.

The works by Robert in the Jeanson Library belong to a different world from his Barrabands. Although they are surprisingly accurate, and were inspired by the prevailing passion for scientific enquiry and record, their appeal is more aesthetic than naturalistic. Robert's birds are frozen into immobility, their bright colours applied in a decorative pattern, in a technique that is reminiscent of the miniaturist painter. Their world is that of the *wunderkammer,* in which precious natural objects, such as minerals and jewels are admired and appreciated in the same way as exquisitely executed works of art.

There existed no perceived dichotomy between art and science in Robert's day. Both were seen to enrich mankind and the artist and scientist pursued a common cause. Robert may be seen as the creator of objects of delight and wonder through which his patrons were able to appreciate the wonders of the natural world.

91

Bweraband

CERAMICS BY TWENTIETH-CENTURY ARTISTS

On a sunny October morning Melanie Clore, Sotheby's youngest director, took the rostrum and made auction history. She staged the first sale ever entirely devoted to ceramics by major twentieth-century artists. Ceramics painted by these artists had in the past always been incorporated into the sales of paintings and sculpture. The 104 lots ranged from the decorative whimsy of Marie Laurencin to a platter courtesy of Lucio Fontana, though the main body of the sale was the exuberant plates and pitchers of Picasso.

At first glance these works may appear to be a somewhat frivolous exercise in the decoration of ordinary domestic objects like jugs, vases and plates. Ceramics did however offer many of these painters new and stimulating challenges. The opportunity to work with different materials and methods allowed them to be more experimental than in their established mediums. By working with objects that were familiar to everyone they could create art forms that were more accessible and less élitist.

In 1907 the ceramicist André Metthey opened up his Asnières studio near Paris to the painters he had met through the dealer Ambroise Vollard. With Metthey's technical guidance, most of the distinguished Nabis and Fauves like Vuillard, Vlaminck, Derain, Luce and Matisse worked with ceramics from 1907 until 1909. The public response to an exhibition of these ceramics held in the Salon d'Automne in 1907, was so enthusiastic that it set the trend for future work between ceramicists and artists.

Such a collaboration was formed between Raoul Dufy and the Catalan ceramicist Joseph Llorens Artigas, who also worked closely with Joan Miró and Georges Braque on the execution of their ceramics. Of this relationship with Dufy, Artigas said: 'I started up in France and worked out of doors on my very plain stoneware with Raoul Dufy, an artist who was full of life, imagination and talent; Dufy knew how to put decoration in the right place and soon knew all the secrets of enamelling.'

In the catalogue of the Dufy exhibition held at the Hayward Gallery in London in 1983, Dora Perez-Tibi wrote: 'Artigas and Dufy experimented with shapes together; then the ceramicist would mould them, let them dry then fire them for a first time as biscuitware. Once this firing was completed, the pieces were dipped in a white glaze then covered with a transparent enamel. Dufy would intervene at this stage. Sometimes he created an 'esgrafiat' or incised pattern with a painted tool, more often he would brush on the enamels prepared by Artigas; who liked to mix them himself, grinding and measuring them, disdaining the pure commercial enamels. Thus the tones revealed in the firing

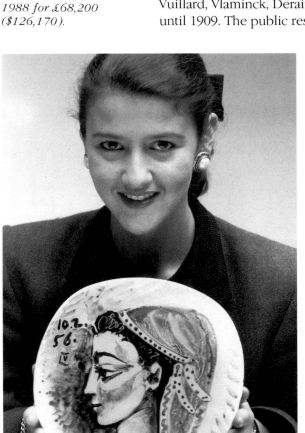

Melanie Clore, Director in the Impressionist and Modern Art Department, holding Pablo Picasso's Portrait de Jacqueline, *dated 10.2.56. IV, stamped* Madoura plein feu, *unique ceramic, hand-painted and glazed, 25cm. Sold in London on 19 October 1988 for £68,200 ($126,170).*

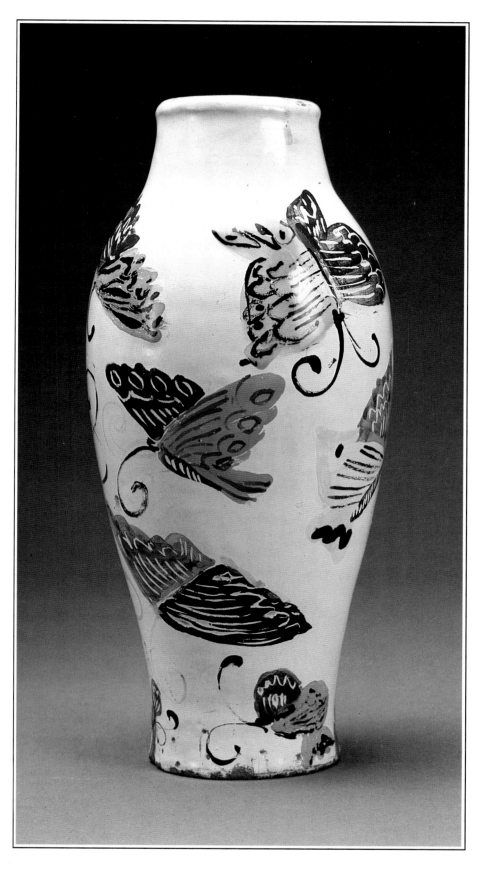

Vase aux Papillons *by Raoul Dufy, signed, marked with the artist's fingerprint, dated 14.8.25, and signed with Artigas monogram on base, height 33.5cm. Sold in London on 19 October 1988 for £36,300 ($67,155).*

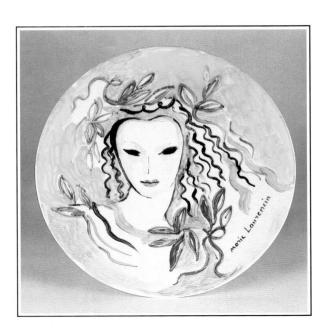

Tête de Jeune Fille by Marie Laurencin, hand-painted and glazed plate, signed and dated 13 Août 1953, 31.6cm diameter. Sold in London on 19 October 1988 for £165,000 ($305,250).

constituted the references for his palette – dazzling colours of red, bright blue, green, saffron yellow, ochre and deep black. Having been decorated, the vases were submitted to a second firing at around 1300 degrees centigrade, lasting twenty-four hours.'

The two vases sold in this sale, along with a vase decorated with the portrait of Ambroise Vollard in the Musée d'Art Moderne, Paris, illustrate the diversity and competence of Dufy's decoration.

Perhaps the most innovative ceramics to be executed by an artist this century were those produced by Picasso. In 1946 Picasso befriended George and Suzanne Ramié, who owned and ran the Madoura pottery at Vallauris. The following summer he took up working with ceramics, setting up a studio for himself with the Ramiés and working there regularly until 1966.

What makes Picasso's ceramics so interesting is his inventive use of materials and forms. Rather than treating plates and plaques as flat planes simply to replace canvases, he utilised the shapes themselves and the clay to transform them into paintings or sculpture with three-dimensional aspects. He frequently used the coloured border which corresponds to the outside of the actual plate to define a face or the rim to represent the circumference of the bullring. He modelled vessels and jugs so that a large wine pourer or vase would be transformed into a sculptural representation of a head. This transformation of the pot into a head has its sources in the ancient Greek and Roman cultures. For example, fifth-century Attic heads of women and negroes which are also vessels, are objects Picasso would almost certainly have seen both in the Louvre and in museums in Provence.

In addition to throwing and remodelling shapes to echo his imagery, Picasso incised the clay or used colours and glazes to highlight certain areas of an image. He often only partially glazed a plate or left the clay material untouched to suggest or accentuate a detail of a face or a sunlit area of sand in a bullring.

Not only is the idea of transformation which Picasso brings to his ceramics (such as re-creating a vase into the sculpture of an animal) connected with his interest in the classical world but also his use of mythological images. Picasso's use of classical mythological figures dates from his visit to Italy in 1917 when he was associated with Cocteau and the *Ballets Russes*. The strength of his ceramics lay not only in his ability to use his techniques and materials to create his pottery but in the way he transformed a plate, pot or vase into a painting or sculpture without losing sight of the object with which he was working.

A tiny gold coin weighing just over four grams which was in the Sale of Coins and Paper Money in 1988, caused a sensation amongst collectors of Islamic coins and established a world record price of £165,000. It was a dinar struck under the first Islamic dynasty, the Umayyads, in the year 77 of the Muhammadan calendar, the *Hijra*. The issue is considered to be the most important of all Islamic coins as it established the general pattern for Muslim coinage up until modern times.

COINS OF ISLAM

Tom Eden

AH 77 – equivalent to AD 696 – was the year in which the Caliph 'Abd al-Malik, after some years of experimentation, finally introduced a coin which found great favour with the followers of Muhammad. In the earliest days of Islam, Byzantine and Sasanian coins with additional arabic legends had rather unsatisfactorily served the Muslim world's monetary needs. The new coin was of a primarily religious type and dispensed entirely without any form of portraiture. It carried Qur'anic inscriptions affirming the Islamic doctrine and challenging the theological claims of Christianity. The obverse and reverse legends emphasise the oneness of God and reject the Christian belief of Jesus as the Son of God and the doctrine of the Holy Trinity: 'There is no God but God. He is unique and has no associate ... God is one. God is eternal. He begets not nor is He begotten.' The obverse marginal inscription then establishes the role of Muhammad: 'Muhammad is the messenger of God who sent him with guidance and the religion of truth that he might make it supreme over all other religions.'

The reverse margin records the date of the coin. Dinars of AH 77 are exceptionally rare and it has therefore been conjectured that they were introduced late in the year since subsequent dates are remarkably common by comparison. Alternatively, they may all have been patterns or trials never intended for general circulation.

The front (left) and back (right) of a dinar of the Caliph 'Abd al-Malik dated AH 77 (AD 696). Sold in London on 29 September 1988 for £165,000 ($293,700).

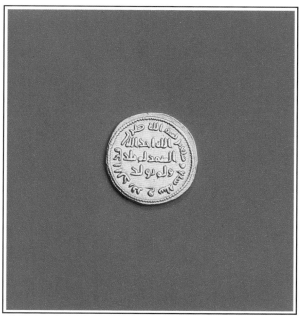

AN IMPRESSIVE COLLECTION

Susan Morris

In the mid-1970s the British Rail Pension Fund perplexed their pensioners and stunned fund managers by announcing that they would invest in art. Although bold, the decision was far from unconsidered – at the time inflation in Britain was very high, the stock market low, the property market uncertain. Art seemed a viable alternative. The fund spread its risk over a wide area – furniture, silver, ceramics, tribal art, Japanese art and other fields – but Impressionist painting was naturally a major outlay.

The British Rail Pension Fund's judgement was triumphantly vindicated on 4 April 1989, when twenty-five items from their Impressionist and Modern collection (outlay £3.4 million) made £35.2 million at the start of a sale which totalled £68.8 million, a record for an Impressionist sale in London. The British Rail Pension Fund's investment had grown at a rate of 20.1% per annum (11.9% when adjusted for inflation). A portfolio of shares invested at the same time could have expected to yield 7.5% per annum after inflation.

British Rail invested at the beginning of a decade which has seen a spectacular rise in prices for Impressionist paintings. They have become an international currency and make headlines whenever exceptional examples come to auction, arousing far more excitement, for example, than Old Master paintings. In building up their collection, the Pension Fund was advised by Michel Strauss, head of Sotheby's Impressionist Department in London. 'I steered them towards strong, characteristic, fine quality examples by major artists,' he says. They were prepared to be patient; the finest paintings attracted stiff competition in the saleroom, so perhaps half of the Fund's bids were successful. They bought mainly at Sotheby's, but also from other auction houses and private sources.

In building up any collection, luck and timing are important. British Rail's quest coincided with the sale of some superb collections, including the Robert von Hirsch Collection at Sotheby's in 1978. From it came Camille Pissarro's *Paul Cézanne*, the earliest portrait of Cézanne by another artist, painted in 1874 when the two painters were working together at Pontoise. Cézanne is shown in Pissarro's studio swathed in his winter working clothes, against a background of paintings and posters: one of Pissarro's landscapes, and a caricature of the Realist painter Courbet, who influenced both Pissarro and Cézanne. Not only is it a very fine, characterful portrait, but it is an important art-historical document and the identity of the sitter makes it compelling for any collector in this field. British Rail paid £330,000 for the painting in 1978; it sold for £1.32 million. Renoir's rather more suave portrait of Cézanne in city dress, 1880, made £1.43 million. 'It was fascinating seeing both portraits together in the saleroom for the first time,' Michel Strauss comments. 'They were bought by the same buyer.'

The prices for a Van Gogh drawing and a Cézanne watercolour, also bought by British Rail from the von Hirsch collection, surprised even Michel Strauss. The superb late Cézanne, *Nature Morte au Melon Vert*, was bought for two and a half times its high estimate at £2.53 million and Van Gogh's *Mas à Saintes-Maries* made £2.31 million against an estimate of £2 million. It is a work of great vitality, a product of Van Gogh's response to his first sight of Mediterranean France at Saintes-Maries-de-la-Mer near Arles. He wrote to his brother, 'I am convinced that I shall set my individuality free simply by staying here.'

Opposite:
Portrait de Paul Cézanne *by Camille Pissarro, 1874, oil on canvas, 73 by 59.7cm. Sold in London on 4 April 1989 for £1,320,000 ($2,389,200).*

The viewing days before an Impressionist sale always have an undercurrent of excitement. Prospective bidders throng the galleries and television crews roam about, filming and conducting impromptu interviews with experts. All the visitors were drawn to the spot in the Wilson Gallery where hung Renoir's *La Promenade*, one of the first and freshest flowerings of Impressionism, painted four years before the first Impressionist exhibition in 1874. It shows a young man and woman strolling in a wood, their figures filtered in a dappled green light, completely integrated into the landscape. The sense of spontaneity and enjoyment of nature makes it a key work of the new movement – it sold for £10.34 million, more than double the previous record for a Renoir. The victorious bidder was the London dealer John Baskett and there was much excited speculation as to whom he was representing. Very often the name of a buyer remains a secret, but in this case it was soon revealed as the Getty Museum, which is building up a superb collection of Impressionist works.

A magnificent late Monet, *Santa Maria della Salute et le Grand Canal, Venise*, 1908, realised £6.71 million (it cost the British Rail Pension Fund £253,000 ten years ago). 'People buy paintings from every period in Monet's career,' says Michel Strauss, 'but to do exceptionally well they have to be colourful and appealing subjects, like this one.' By 1908 Monet was a highly successful artist, the struggles of his early Impressionist years long forgotten. He stayed in Venice at a palazzo belonging to a relative of the painter John Singer Sargent, before moving to the elegant Grand Hotel Britannia, on the Grand Canal opposite the Salute.

Monet made studies of the church in different lights, taking it as a central motif, as he had earlier built a series round Rouen Cathedral. In Venice he

Nature Morte au Melon Vert *by Paul Cézanne, 1902–1906, watercolour and pencil, 31.5 by 47.5cm. Sold in London on 4 April 1989 for £2,530,000 ($4,579,300).*

Opposite:
La Promenade *by Pierre-Auguste Renoir, signed and dated '70, oil on canvas, 81.3 by 65cm. Sold in London on 4 April 1989 for £10,340,000 ($18,715,400).*

Santa Maria della Salute et le Grand Canal, Venise *by Claude Monet, 1908, oil on canvas, 72 by 91cm. Sold in London on 4 April 1989 for £6,710,000 ($12,145,100).*

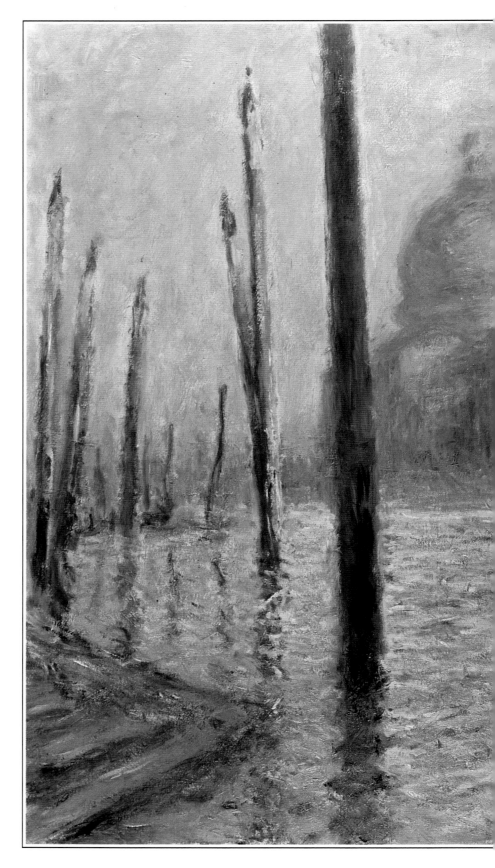

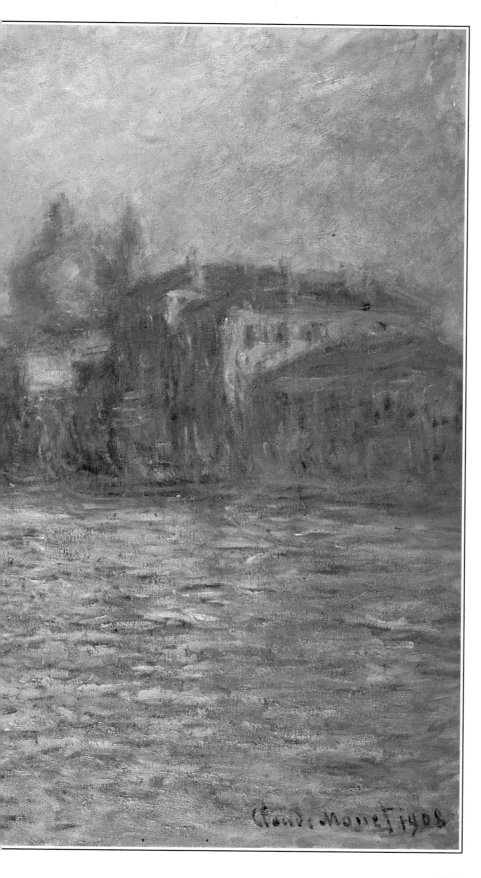

Roses Aimé Viebert by Henri Fantin-Latour, signed and dated '90, oil on canvas, 44.5 by 48cm. Sold in London on 4 April 1989 for £484,000 ($876,040).

abandoned objectivity and evoked an iridescent dream-city as dazzling and romantic as a Turner.

British Rail's great 'bargain' must be the Matisse bronze *Deux Negresses*, 1908. Inspired by a photo of two Tuareg women in an ethnographic magazine, it reflects French artists' interest in African art and culture during the first decade of this century, famously shown in Picasso's *Demoiselles d'Avignon*, 1907. *Deux Negresses* is Matisse's only sculpture group of two figures – bought by British Rail for £58,240 in 1977, it sold for £1.76 million, four times the estimate and thirty times the price British Rail paid. The sum is an indication of the strength of the market for modern sculpture.

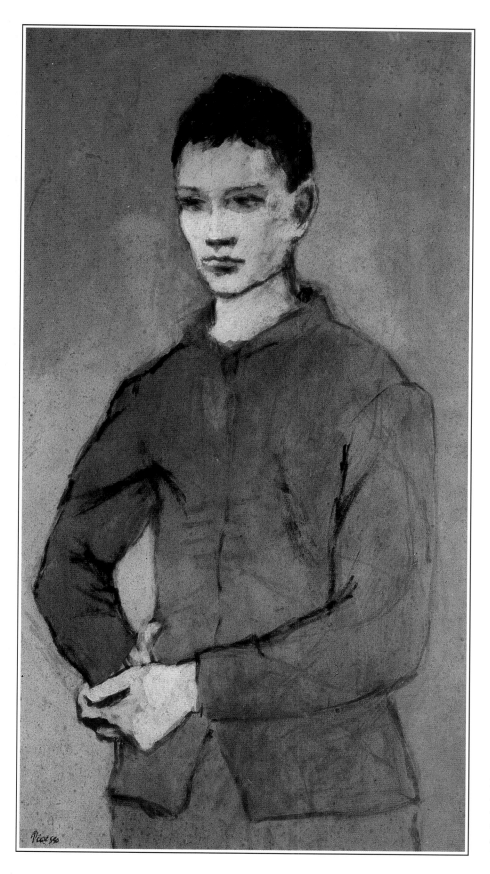

Le Garçon Bleu *by Pablo Picasso, 1905, gouache on board laid down on panel, 100 by 57cm. Sold in London on 4 April 1989 for £3,960,000 ($6,811,200).*

Overleaf:
Deux Negresses *by Henri Matisse, 1908, bronze, height 47cm. Sold in London on 4 April 1989 for £1,760,000 ($3,027,200).*

155

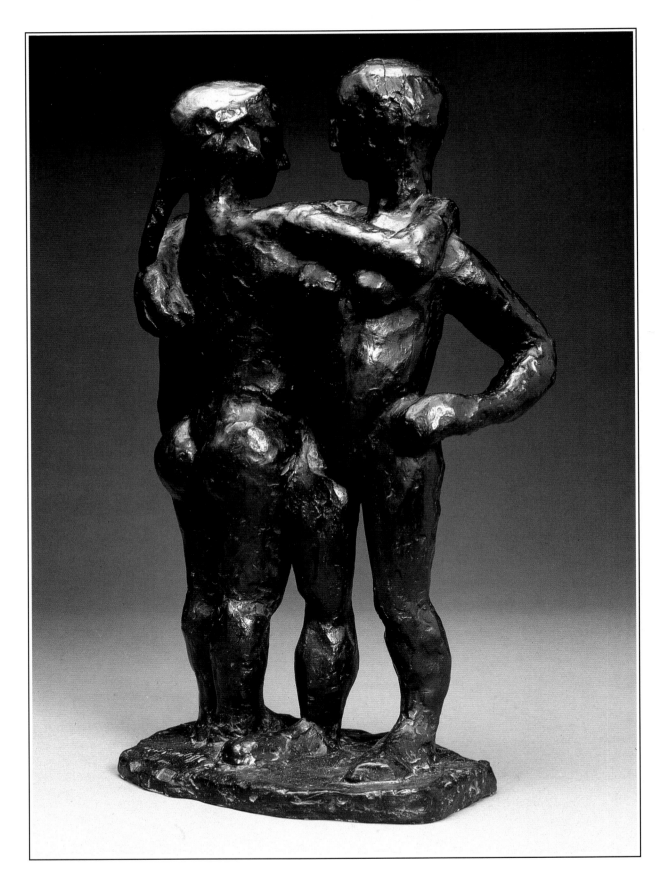

Made in Augsburg in the early seventeenth century, this rare elephant automaton is handsomely outfitted in Turkish regalia.

Turbanned figures circle the turret as the entire ensemble glides forward at a stately pace. The mahoot raises his sword to lead the beast who bats his eyes as he moves.

It was one of only three automata to be included in the Clockwork Universe Exhibition at the Smithsonian Institution in 1980.

THE ELEPHANT AUTOMATION

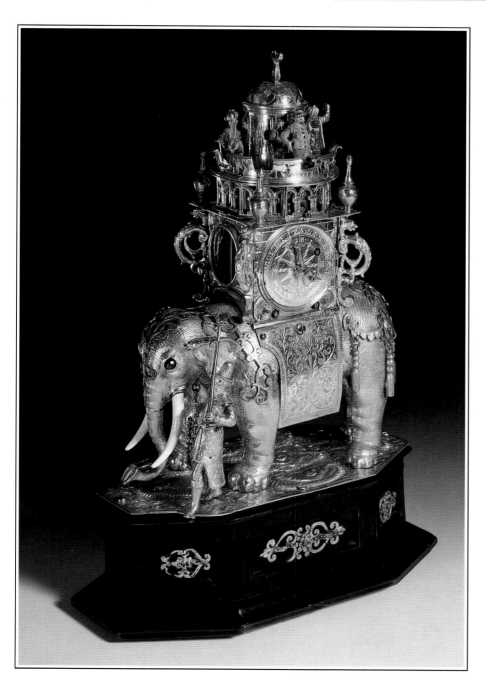

A rare German gilt-metal elephant automaton, Augsburg, early 17th century, 27.5cm high. Sold in New York on 18 February 1989 for $101,200 (£53,830).

PRINCIPAL OFFICERS, EXPERTS AND REPRESENTATIVES

The Rt. Hon The Earl of Gowrie
Chairman, Sotheby's UK and International
John L. Marion
Chairman, Sotheby's North America
Diana D. Brooks
President, Sotheby's North America
Timothy Llewellyn
Managing Director, Sotheby's UK and International
Julian Thompson
Deputy Chairman, Sotheby's UK and International (Asia)
Simon de Pury
Deputy Chairman, Sotheby's UK and International (Europe)

American Decorative Arts and Furniture
Leslie B. Keno
William W. Stahl, Jnr
Tel: New York 606 7130
Tel: New York 606 7110

American Folk Art
Nancy Druckman
Tel: New York 606 7225

American Indian Art
Dr Bernard de Grunne
Tel: New York 606 7325

American Paintings, Drawings and Sculpture
Peter B. Rathbone
Tel: New York 606 7280

Antiquities and Asian Art
Richard M. Keresey
Tel: New York 606 7328
Felicity Nicholson (Antiquities)
Tel: London 408 5111
Brendan Lynch (Asian)
Tel: London 408 5112

Arms and Armour
Michael Baldwin
Tel: London 408 5318
Florian Eitle
Tel: New York 606 7250

Books and Manuscripts
Roy Davids
Tel: London 408 5287
David N. Redden
Tel: New York 606 7386
Dominique Laucournet
Tel: Paris 33(1) 42 66 40 60

British Paintings 1500-1850
James Miller
Tel: London 408 5405
Henry Wemyss (Watercolours)
Tel: London 408 5409

British Paintings from 1850
Simon Taylor (Victorian)
Tel: London 408 5385
Janet Green (20th Century)
Tel: London 408 5387

Ceramics
Peter Arney
Tel: London 408 5134
Letitia Roberts
Tel: New York 606 7180

Chinese Art
Carol Conover
Tel: New York 606 7332
Mee Seen Loong
Tel: New York 606 7332
Arnold Chang (Paintings)
Tel: New York 606 7334
Julian Thompson
Tel: London 408 5371
Colin Mackay
Tel: London 408 5145
Conor Mahony
Tel: London 408 5147

Clocks and Watches
Tina Millar (Watches)
Tel: London 408 5328
Michael Turner (Clocks)
Tel: London 408 5329
Daryn Schnipper
Tel: New York 606 7162

Coins and Medals
Tom Eden (Ancient and Islamic)
Tel: London 408 5315
James Morton
(English and Paper Money)
Tel: London 408 5314
David Erskine-Hill
(Medals and Decorations)
Tel: London 408 5315
Mish Tworkowski
Tel: New York 606 7391

Collectables
Dana Hawkes
Tel: New York 606 7424
Hilary Kay
Tel: London 408 5205

Contemporary Art
Hugues Joffre
Tel: London 408 5400
Lucy Mitchell-Innes
Tel: New York 606 7254

European Works of Art
Elizabeth Wilson
Tel: London 408 5321
Florian Eitle
Tel: New York 606 7250

Furniture
Graham Child
Tel: London 408 5347
George Read (English)
Tel: New York 606 7577
Thierry Millerand
(French and Continental)
Tel: New York 606 7213
Robert C. Woolley
Tel: New York 606 7100
Alexandre Pradère
Tel: Paris 33 (1) 42 66 40 60

Glass and Paperweights
Lauren Tarshis
Tel: New York 606 7180
Perran Wood
Tel: London 408 5135

Impressionist and Modern Paintings
David J. Nash
Tel: New York 606 7351
John L. Tancock
Tel: New York 606 7360
Marc E. Rosen (Drawings)
Tel: New York 606 7154
Michel Strauss
Tel: London 408 5389
Julian Barran
Tel: Paris 33 (1) 42 66 40 60

Islamic Art and Carpets
Richard M. Keresey (Works of Art)
Tel: New York 606 7328
William F. Ruprecht (Carpets)
Tel: New York 606 7380
Prof. John Carswell
Tel: London 408 5153

Japanese Art
Annette Alvarez
Tel: New York 606 7338
Neil Davey
Tel: London 408 5141

Jewellery
David Bennett
Tel: London 408 5306
John D. Block
Tel: New York 606 7392
Nicholas Rayner
Tel: Geneva 41 (22) 32 85 85

Judaica
Jay Weinstein
Tel: New York 606 7387

Latin American Paintings
Anne Horton
Tel: New York 606 7290

Musical Instruments
Charles Rudig
Tel: New York 606 7190
Graham Wells
Tel: London 408 5341

19th Century European Furniture and Works of Art
Christopher Payne
Tel: London 408 5350
Elaine Whitmire
Tel: New York 606 7285

19th Century European Paintings and Drawings
Alexander Apsis
Tel: London 408 5384
Nancy Harrison
Tel: New York 606 7140
Pascale Pavageau
Tel: Paris 33 (1) 42 66 40 60

Old Master Paintings and Drawings
Julien Stock
Tel: London 408 5420
Elizabeth Llewellyn (Drawings)
Tel: London 408 5416
George Wachter
Tel: New York 606 7230
Nancy Ward-Neilson
Tel: Milan 39 (2) 783911
Etienne Breton
Tel: Paris, 33 (1) 42 66 40 60

Oriental Manuscripts
Nabil Saidi
Tel: London 408 5332

Photographs
Philippe Garner
Tel: London 408 5138
Beth Gates-Warren
Tel: New York 606 7240

Portrait Miniatures, Objects of Vertu, Icons and Russian Works of Art
John Stuart (Icons)
Tel: London 408 5325
Julia Clarke (Vertu)
Tel: London 408 5324
Haydn Williams (Miniatures)
Tel: London 408 5326
Heinrich Graf von Spreti
Tel: Munich 49 (89) 291 31 51
Gerard Hill
Tel: New York 606 7150

Postage Stamps
John Michael
Tel: London 408 5223

Pre-Columbian Art
Stacy Goodman
Tel: New York 606 7330

Prints
Susan Pinsky
Tel: New York 606 7117
Ian Mackenzie
Tel: London 408 5210

Silver
Kevin L. Tierney
Tel: New York 606 7160
Peter Waldron (English)
Tel: London 408 5104
Harold Charteris (Continental)
Tel: London 408 5106
Dr Christoph Graf Douglas
Tel: Frankfurt 49 (69) 740787

Sporting Guns
James Booth
Tel: London 408 5319

Tribal Art
Dr Bernard de Grunne
Tel: New York 606 7325
Sabine Dauwe
Tel: London 408 5115

20th Century Applied Arts
Barbara E. Deisroth
Tel: New York 606 7170
Philippe Garner
Tel: London 408 5138

Vintage Cars
Malcolm Barber
Tel: London 408 5320
Dana Hawkes
Tel: New York 606 7424

Western Manuscripts
Dr Christopher de Hamel, FSA
Tel: London 408 5330

Wine
David Molyneux Berry, MW
Tel: London 408 5267

UK AND IRELAND
London
Tel: (01) 493 8080
Telex: 24454 SPBLON G

Chester
Richard Allen
Tel: (0244) 315531
Telex: 61577 SOBART G

Sussex
W. L. Weller, FRICS, FSLVA
Tel: (040381) 3933
Telex: 87210 GAVEL

Manchester
Tim Wonnacott
Tel: (061) 833 1818

**South and South West
of England, Midlands and
South Wales**
John Harvey (Cheltenham)
Tel: (0242) 510500
George Kidner (Bournemouth)
Tel: (0202) 294425
Mary Fagan (Basingstoke)
Tel: (0256) 780639
The Hon. Lady Butler
(Warwick)
Tel: (0926) 651950

Devon and Cornwall
John Tremlett
Tel: (0392) 833416

East of England
Christopher Myers (Cambridge)
Tel: (0223) 845222
Lady Victoria Leatham,
George Archdale (Stamford)
Tel: (0780) 51666
Sara Foster (Norfolk)
Tel: (0328) 700032
The Lord Cranworth (Suffolk)
Tel: (047 335) 581

North of England
John Phillips,
Henrietta Graham (Harrogate)
Tel: (0423) 501466/7
Susan Yorke (Clitheroe)
Tel: (0200) 41520
The Earl of Carlisle, MC, FRICS
(Brampton)
Tel: (069 77) 3666
Matthew Festing
(Newcastle upon Tyne)
Tel: (091) 2818867

Scotland
John Robertson (Edinburgh)
Tel: (031) 226 7201
Anthony Weld-Forester
(Glasgow)
Tel: (041) 221 4817
Marquess of Huntly
(Aberdeenshire)
Tel: (0333 02) 4007

Ireland
William Montgomery,
Henrietta Reade (Newtownards)
Tel: (024 774) 668
William Montgomery,
Anne Dillon (Dublin)
Tel: (01) 711786 or 711431
Julia Keane (Waterford)
Tel: (058) 54258

Channel Islands
Daan Cevat, MBE (Guernsey)
Tel: (0481) 38009

UNITED STATES
New York
Tel: (212) 606 7000
Telex: 232643 (SPB UR)

Atlanta
Virginia Groves Beach
Tel: (404) 233 4928

Baltimore
Aurelia Bolton
Tel: (301) 583 8864

Beverly Hills
Barbara Pallenberg,
Lisa Hubbard,
Christine Eisenberg,
Eleanore Phillips Colt
Tel: (213) 274 0340

Boston
Patricia Ward
Tel: (617) 247 2851

Chicago
Helyn Goldenberg,
Gary Schuler
Tel: (312) 664 6800

Dallas
Mary Lide Kehoe
Tel: (214) 521 8455

Hawaii
Andrea Song Gelber
Tel: (808) 732 0122

New Orleans
Debe Cuevas Lykes
Tel: (504) 523 7059

Newport
Marion Oates Charles,
Betsy D. Ray
Tel: (401) 846 8668

New York City
Mrs Watson K. Blair,
Virginia Guest,
C. Hugh Hildesley,
Lee Copley Thaw,
Alastair A. Stair
Tel: (212) 606 7442

Palm Beach
Hope P. Kent,
Robert V. Ruggierio
(Trusts and Estates),
Susan Sencer
Tel: (407) 833 2582

Philadelphia
Wendy T. Foulke
Tel: (215) 751 9540

San Francisco
Teresa Hess-Nageotte,
Mrs Prentis Cobb Hale,
Mrs John N. Rosekrans
Tel: (415) 561 8409

Santa Fe
Julie Michel
Tel: (505) 982 1637

Washington
Sara Dwyer, Marion Oates Charles,
Penne Percy Korth,
Joan F. Tobin
Tel: (202) 363 5544

CANADA
Toronto
Christina Orobetz (President)
Tel: (416) 926 1774

Montreal
Susan Travers
Tel: (514) 934 1879

Vancouver
Kenzie Selman (Associate)
Tel: (604) 731 5857

CENTRAL AMERICA
Mexico
Suzy De Gilly
(Public Relations Associate)
*Tel: 52 (905) 511 3768 or 525
4263*
Françoise Reynaud
(Art Consultant)
Tel: 52 (905) 545 6917

LATIN AMERICA
Argentina
Mallory Hathaway de Gravière
(Buenos Aires)
Tel: 54 (1) 804 9347
William R. Edbrooke
(Buenos Aires)
Tel: 54 (1) 393 0831

Brazil
Walter Geyerhahn
(Rio de Janeiro)
Tel: 55 (21) 222 7771
Heloise Guinlé (Rio de Janeiro)
Tel: 55 (21) 552 5769
Cornelius O. K. Reichenheim
(São Paulo)
Tel: 55 (11) 282 1599 or 0581
Pedro Correa do Lago (São Paulo)
Tel: 55(11) 282 3135

FAR EAST
Hong Kong
Suzanne Tory
Tel: 852 (5) 248121

Taiwan, ROC
Rita Wong, (Taipei)
Tel: 886 (2) 755 2906

Japan
Kazuko Shiomi (Tokyo)
*Tel: 81 (3) 504 1111, Ext.
2005*

Singapore
Quek Chin Yeow (Singapore)
Tel: (65) 732 8239

EUROPE
Austria
Dr Agnes Husslein (Vienna)
*Tel: 43 (222) 524772 or
524773*

Belgium
Count de Limburg Stirum
(Brussels)
Tel: 32 (2) 648 00 80

Cyprus
Rita C. Severis (Nicosia)
Tel: 357 (2) 461410

Denmark
Baroness Hanne Wedell-
Wedellsborg (Copenhagen)
Tel: 45 (1) 135556

France
Julian Barran,
Alexandre Pradère,
Anne de Lacretelle,
Princesse Laure de Beauvau Craon
(Paris)
Tel: 33 (1) 4 266 4060

Germany
Dr Christoph Graf Douglas
(Managing Director Germany;
Frankfurt-am-Main)
Tel: 49 (69) 740787
Johannes Ernst
(Frankfurt-am-Main)
Tel: 49 (69) 740787
Ursula Niggemann (Cologne)
Tel: 49 (221) 23 52 84/85
Tatiana von Hessen, Karen Wobbe
(Hamburg)
Tel: 49 (40) 33 75 53
Heinrich Graf von Spreti (Munich)
Tel: 49 (89) 2913151

Holland
John Cann, John Van Schaik
(Amsterdam)
Tel: 31 (20) 27 5656

Hungary
Mme. Gyöngyi Éri (Budapest)
Tel: 36 (1) 123647

Italy
Andrea Amadesi
(Managing Director, Italy; Milan)
Tel: 39 (2) 783911
Michael Thomson-Glover
(Florence)
Tel: 39 (55) 2479021
Yolanda Galli Zugaro (Milan)
Tel: 39 (2) 783911
Giuseppe Ceccatelli (Rome)
*Tel: 39 (6) 678 1798 or
678 2734*
Laura Russo (Turin)
Tel: 39 (11) 544898

Liechtenstein
Henriette Huber-von
Goldschmidt-Rothschild
Tel: 41 (75) 249 14

Luxembourg
Charlotte van Rijckevorsel
Tel: 352 77436

Monaco
Léon Leroy
Tel: 33 (93) 30 88 80

Norway
Ingeborg Astrup (Oslo)
Tel: 47 (2) 1472 82

Portugal
Frederico Horta e Costa (Estoril)
Tel: 351 (1) 65 71 61

Continued overleaf

Representatives continued

Spain
Edmund Peel (Madrid)
Tel: 34 (1) 522 2902
Rocio Tassara,
Luis Monreal Tejada (Associate;
Barcelona)
Tel: 34 (3) 215 2008 or 2149

Sweden and Finland
Hans Dyhlén (Stockholm)
Tel: 46 (8) 101478 or 101479

Switzerland
Simon de Pury
(Chairman Switzerland; Geneva)
Tel: 41 (22) 732 85 85
Nicholas Rayner (Geneva)
Tel: 41 (22) 732 85 85
Ully Wille (Zurich)
Tel: 41 (1) 202 0011

Israel
Rivka Saker, Daniella Luxembourg
(Tel Aviv)
*Tel: 972 (3) 223822 or
246897*

AUSTRALIA
Robert Bleakley (Sydney)
Tel: 61 (2) 332 3500
Ann Roberts (Melbourne)
Tel: 61 (3) 529 7999

ACKNOWLEDGEMENTS
We gratefully acknowledge the
contributions of Lynn Stowell
Pearson and Nina Moore of
Sotheby's New York in the
compilation of this book.

Picture credits
All photographs © Sotheby's
except the following:
Alan Zale/
The New York Times (p.8);
Helaine Messer (pp.21 and 130);
The Mansell Collection (p.30);
Cartier (p.32);
H.G. Conway (p.45);
Michael Schwartz/
New York Post (p.48);
The Kobal Collection (p.49);
Metro-Goldwyn-Mayer, Inc. (p.50);
Warner Brothers Pictures.
Inc., Ren. (p.51);
Dorothy Wilding (p.60);
Louis A. Warren Lincoln Library
and Museum, Fort Wayne,
Indiana (p.68);
U.P.I./Bettman Newsphotos (p.79);
Gamma/Raphael Gaillarde (p.90);
Tara Heinemann (p.106);
American Antiquarian
Society (p.112).

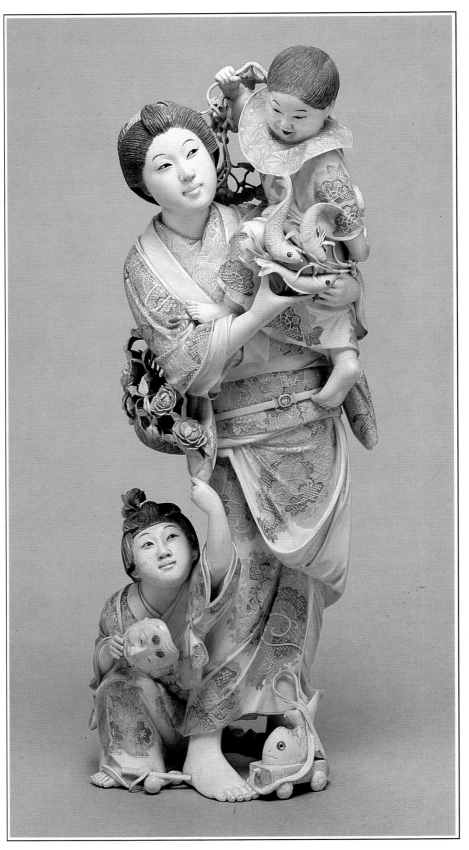